HISTORIC PHOTOS OF
NEW JERSEY

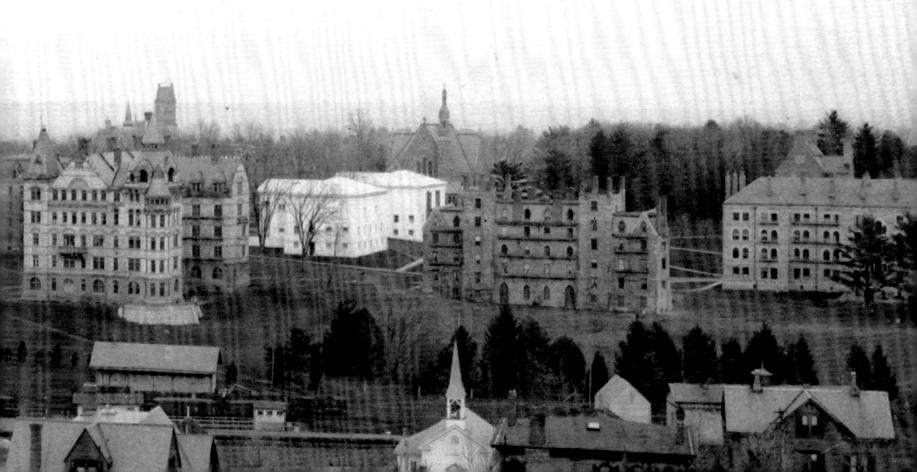

Turner Publishing Company
200 4th Avenue North • Suite 950
Nashville, Tennessee 37219
(615) 255-2665

www.turnerpublishing.com

Historic Photos of New Jersey

Copyright © 2010 Turner Publishing Company

Library of Congress Control Number: 2009933011

ISBN: 978-1-59652-561-0

Printed in China

10 11 12 13 14 15 16 17—0 9 8 7 6 5 4 3 2 1

Contents

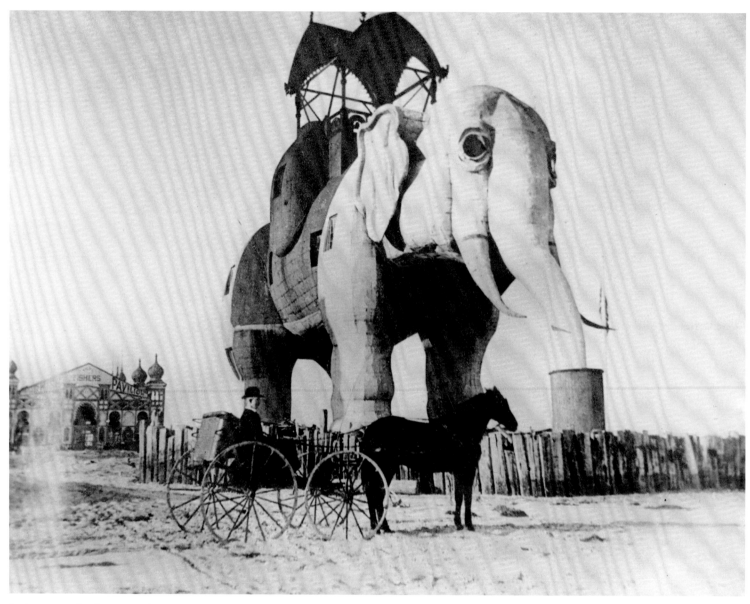

Seeking to unload some undesirable beachfront real estate lots (at high tide they were unreachable) in South Atlantic City in 1881, James Lafferty, Jr., hit upon the idea of constructing a six-story wooden elephant as a way of attracting visitors to the area. The elephant certainly did attract people, who came solely to see it and had no interest in seaside real estate. Overextended, Lafferty was forced to sell the elephant in 1887.

ACKNOWLEDGMENTS

This volume, *Historic Photos of New Jersey,* is the result of the cooperation and efforts of many individuals and organizations. It is with great thanks that we acknowledge the valuable contribution of the following for their generous support:

Library of Congress
New Jersey State Archives; Department of State

The writer would also like to thank Pat King-Roberts for valuable contributions and assistance in making this work possible:

———————

With the exception of touching up imperfections that have accrued with the passage of time and cropping where necessary, no changes have been made. The focus and clarity of many images is limited by the technology and the ability of the photographer at the time they were taken.

The quotation on p. 111 is from Leonard C. Bruno, *The Tradition of Technology: Landmarks of Western Technology in the Collections of the Library of Congress* (Library of Congress, 1997).

INTRODUCTION

New Jersey has always been a state with two very different and distinct personalities. Considering how it developed, perhaps that is highly understandable. In the state's early colonial history, a large part of the state was sold in 1674 to the Quakers, after a bout with the usual unpleasantnesses between the English and Dutch that characterized the region. This created the unusual situation of two states within a state—East Jersey and West Jersey. They were both New Jersey . . . yet they weren't. New Jersey remained schizophrenic until 1702, when the two Jerseys were finally joined back together as one. However, it would not be the last time loyalties were divided.

The American Revolution produced the next big litmus test. Like the other colonies involved in the fight, New Jersey had some citizens who wanted to stay close to Mother England and others who wanted to cut the apron strings completely and go it alone. But New Jersey added an extra pinch of spice to the mixture when its royal governor, William Franklin, decided to favor the Tories. Perhaps not unusual in and of itself, but Franklin was the son of Benjamin Franklin—one of the most ardent of Patriots.

The next test of New Jersey's loyalties soon followed. In 1776, the state's first constitution granted the right to vote to both widows and non-whites, thus creating a serious chasm between its liberality and the severe restrictions of its sister colonies on voting privileges. The state fell into line in 1807, by restricting the vote to white males only. But New Jersey had allowed its divided self to peek out from behind the curtain once again.

Early in the nineteenth century came another test. Farms covered the state, so much so that one day New Jersey would become known as the Garden State. One of the Founding Fathers had other ideas. Alexander Hamilton, enthralled with the power and majesty of Passaic Falls, decided to base his manufacturing initiative for the new nation at the falls, using the water as a source of power. And so this most agricultural of states found itself the industrial nerve center of the United States. Two different and distinct personalities—it was becoming a theme.

Even the state's Atlantic coastal region developed in two distinct manners. In the north, Long Branch owed its

development largely to people from New York, while Cape May in the south leaned heavily toward Philadelphia and points south. The Shore would continue to develop along those lines over the years.

At the time of the bloody Civil War, the first decade captured in the photographs in this book, New Jersey once again showed that it was of two minds. The state firmly supported the Union—except that it cast its ballots against Abraham Lincoln, who strongly favored preserving the Union, in 1860. Four years later New Jersey voted against reelecting Lincoln, thus becoming the only free state to reject Lincoln twice.

Two separate and distinct personalities. Loyalties torn and divided between a great city to its north and a great city to its south. Trouble enough to drive any state kicking and screaming into the deep dark night. Fortunately, the people of New Jersey—strong, independent, proud—have always known who they were and what they were about. It is these people and their accomplishments that the images in this book celebrate.

—Russell Roberts

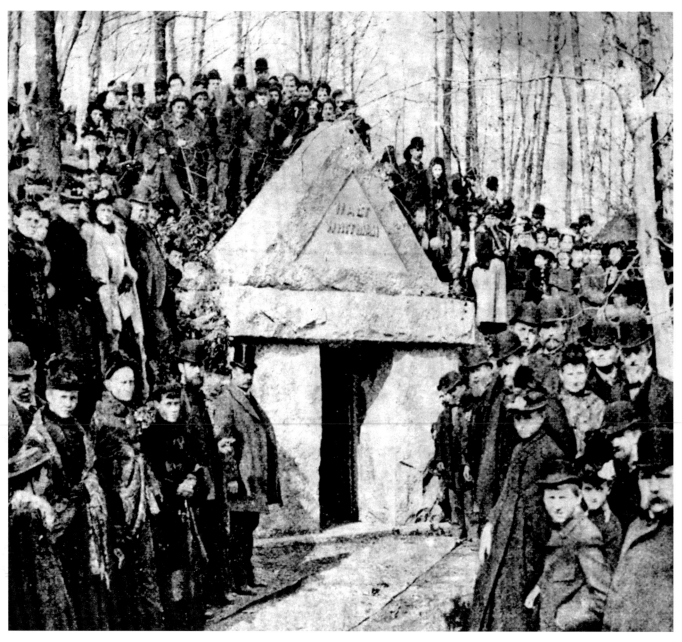

Realizing that he was gravely ill, Walt Whitman chose this site for his tomb in Camden's Harleigh Cemetery on Christmas Day, 1890. In a race against time, Whitman more than once journeyed to the site from his Mickle Street home to check on the progress of his tomb builders. Occasionally he read the workmen scraps of his poetry. The tomb was completed just before Whitman's death on March 26, 1892.

THE MODERN STATE EMERGES

(1865–1899)

At long last, the devastating Civil War was over. More than 76,000 New Jersey citizens went marching off to that war, and a number exceeding 5,700 did not return. Those who did, however, found a state much different from the one they had departed. The New Jersey the troops had left was almost completely agricultural. Farming dominated the state from one end to the other, and working the soil was the preeminent occupation. Only in Newark, Jersey City, and Paterson did manufacturing prevail.

With the need for war materiels that could be manufactured in the state, the conflict jump-started New Jersey's industrial heart, and it kept beating at a furious pace after the war was over. The railroads grew frantically—tracks linking the various regions of the state jumped from 1,125 miles in 1870 to 1,684 miles in 1880—and with that growth the railroads transformed the state. The population exploded in the north, in areas like Hudson County, where the population soared from 9,000 in 1840 to 386,000 by 1900 as workers queued into the cities in search of jobs. Trenton, formerly a sleepy state capital on the Delaware River, jumped from 6,000 residents in 1850 to more than 57,000 in 1890 as industries like rubber and ceramics poured into the city and plants like the Roebling wire rope company shifted into high gear.

Every part of the state shared in this surging growth. The glass industry flocked to Millville in the south. Camden grew at a skyrocketing pace. The Atlantic coast, primarily a howling wilderness with the exception of Long Branch in the north and Cape May in the south, became dotted with resorts, including one called Atlantic City that soon everyone knew about.

There was still agriculture. Ten minutes from any large urban area, rolling farmlands could easily be found. The Garden State was still the Garden State. But increasingly now, it was the urban and developed state as well. As the nineteenth century came to a close, New Jersey was emerging in its modern and familiar form.

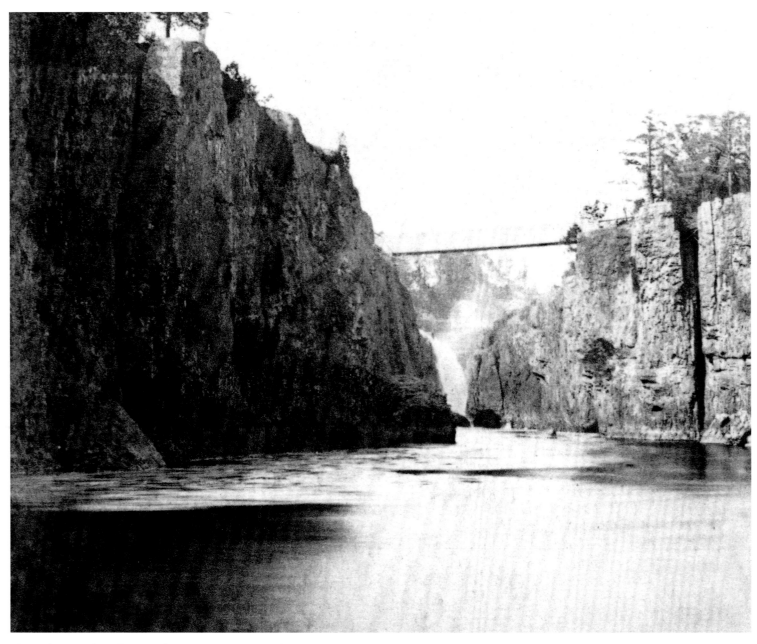

Alexander Hamilton first saw the Passaic Falls during the American Revolution when he stopped near them for lunch. The power of the thundering water made such an impression that later, as Treasury Secretary, he chose the site as the home of America's first industrial complex—the Society for Establishing Useful Manufactures. Shown here in 1869, the falls would power S.U.M. cotton mills, the manufacture of steel and railroad locomotives, the silk industry, the manufacture of early aircraft engines, and other products of American industry. The S.U.M. would also give rise to the city of Paterson.

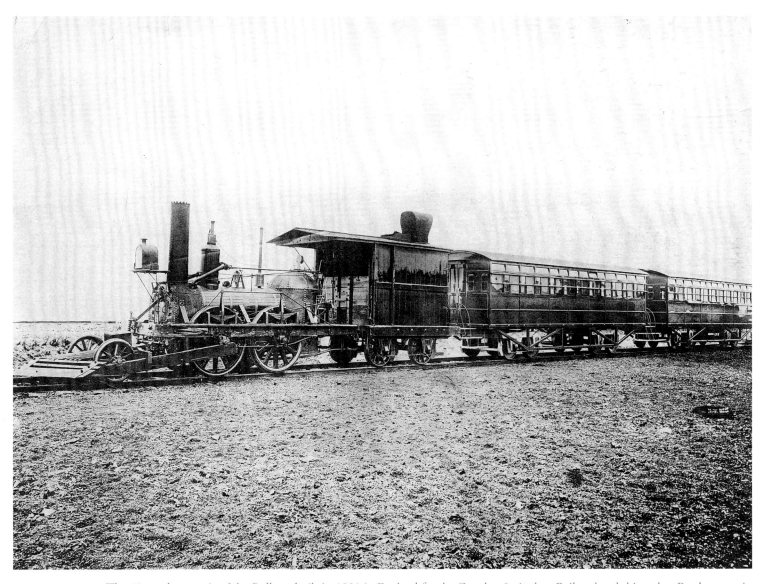

The 10-ton locomotive *John Bull* was built in 1831 in England for the Camden & Amboy Railroad and shipped to Bordentown in crates without directions for reassembly. There it was put together by 23-year-old Isaac Dripps, who used a whiskey barrel on a flatcar for the water supply and a leather hose made by a local shoemaker to bring the water to the boilers.

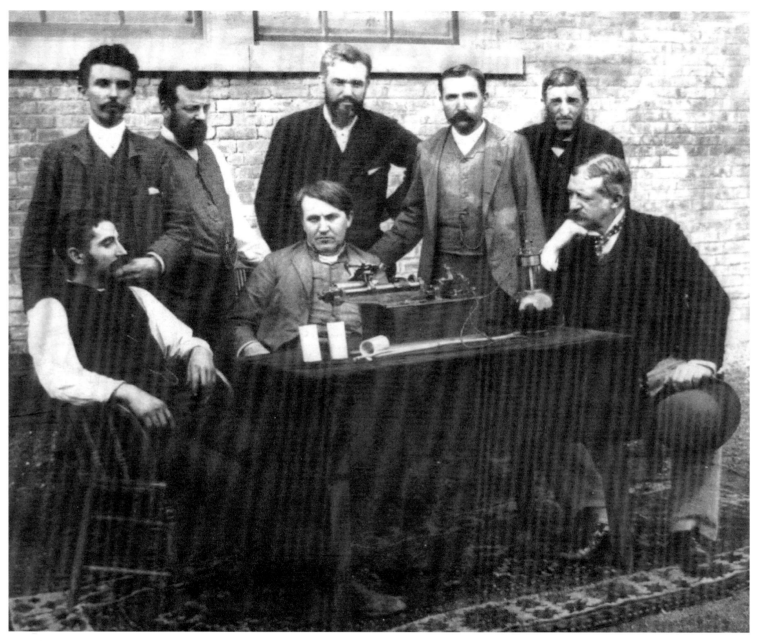

Both Thomas Edison and the tiny village of Menlo Park were unknown when he relocated there in 1876. But over the next six years, in a burst of creativity the likes of which the world had rarely seen before, he and his dedicated team produced approximately 400 inventions for patent, earning him recognition as the "Wizard of Menlo Park." Among those inventions was the phonograph.

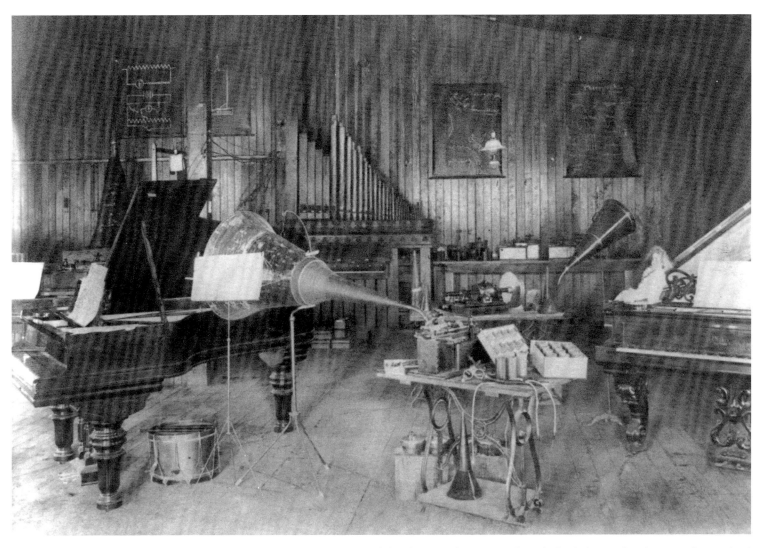

Shortly after he moved to Menlo Park, Thomas Edison invented the phonograph. Not merely a playback device, the phonograph contained two needles: one was used for recording and the other used for playback. When a person spoke into the mouthpiece, the sound vibrations were indented on a cylinder by the recording needle. The phonograph brought both Edison and Menlo Park worldwide fame.

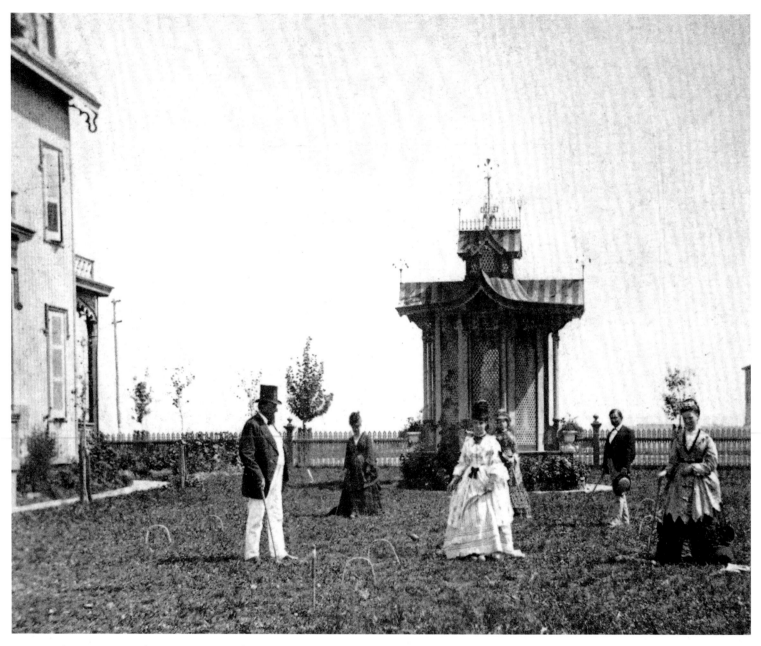

In 1875, the resort town of Cape May was undergoing one of its periodic rebirths. The Civil War had wiped out its Southern clientele, but now money was flowing into the resort for a new venture: the construction of opulent summer vacation "cottages" as places for society's elite to while away the time playing lawn games like croquet. Three years later, a devastating fire would ravage the town.

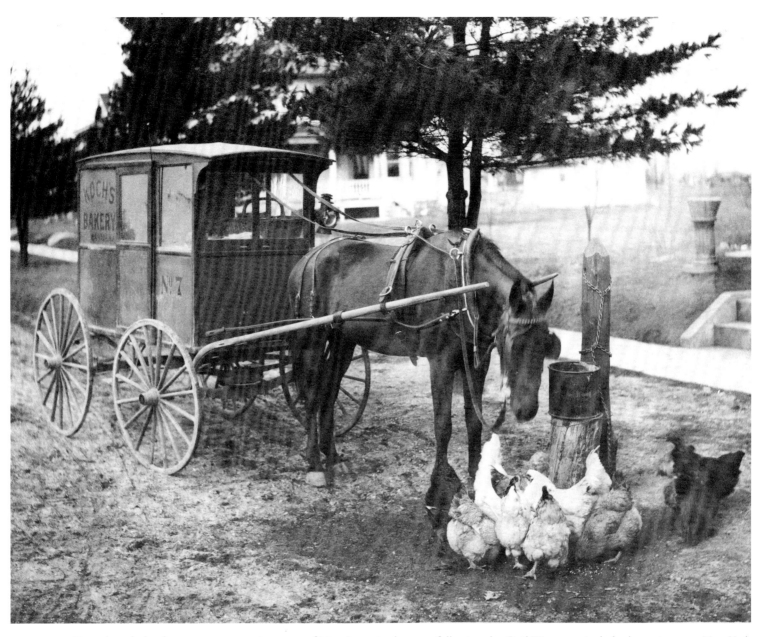

Even though development was sweeping parts of New Jersey in the years following the Civil War—particularly the region near New York City, in places like Newark and Jersey City—there was still a place for horse-and-buggy home delivery. Often the horses knew the route better than the drivers, and sleepy drivers could often catch 40 winks trusting that the horse would know when and where to stop.

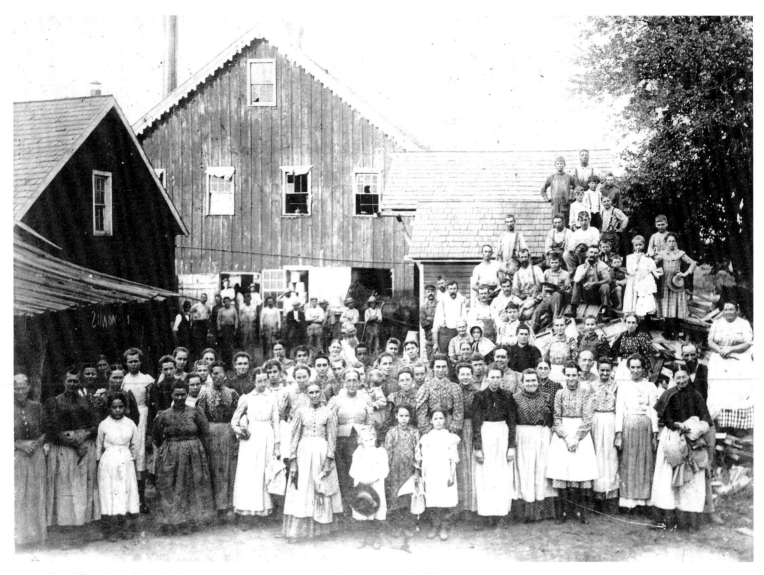

Located in Salem Township, the Canton Canning Factory opened in 1881. Its chief function was canning tomatoes. Canton was the largest canning operation in the county at the time, packing 40,000 cans a day. Of course, someone had to peel those tomatoes, which is where many of these women found a role to play.

This is the Ellis Cook house in East Hanover, photographed between 1880 and 1890. Cook was a tavern owner and farmer who maintained a bridge over the Passaic River. Since his house was halfway between Newark and Sussex counties, it was known as the Halfway House. Travelers received free passage across the bridge if they spent the night at the tavern. Cook subsequently served with distinction in the American Revolution, and later was active in New Jersey politics.

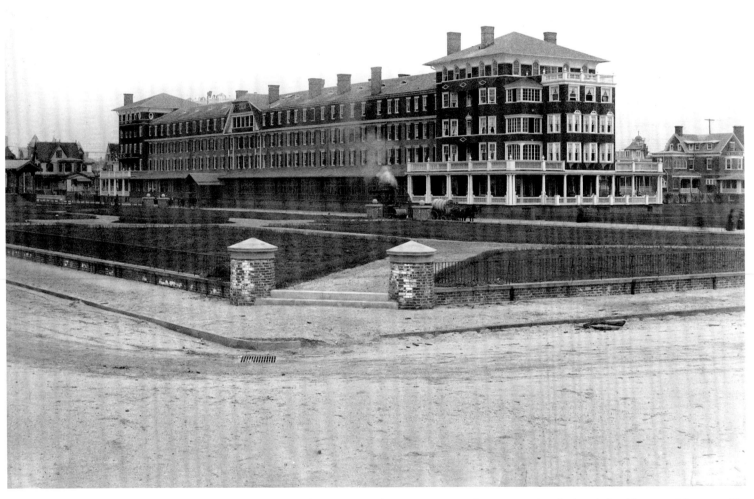

By the 1880s, Atlantic City was the premier resort on the East Coast, boasting a string of sumptuous hotels that defined luxury with names like the Dennis, the Marlborough-Blenheim, and the Brighton (pictured here). The infamous cocktail known as the Brighton Punch was supposedly so potent that even the hardest-drinking male could handle no more than three. Women were limited to just two drinks a day.

In 1880 the Orange Lawn Tennis Club was founded, just six years after lawn tennis came to America. Six years later it was the site of this event—the first United States national tennis championships. The OLTC was also one of 19 organizations that joined together to form the U.S. Lawn Tennis Association to standardize the game's rules.

Following Spread: Beginning in 1890, the Baltimore & Ohio Railroad began operating the deluxe Royal Blue Line trains, in conjunction with the Reading Railroad and the Central Railroad of New Jersey. The name was meant to signify the ultimate in luxury train travel, and Royal Blue cars were paneled in mahogany, had modern heating and lighting, fully enclosed vestibules, and were painted a rich "royal" blue with gold leaf trim.

Members of the Elwell and Watson families, both of whom were involved in New Jersey canning operations in the nineteenth century. In 1847, Harrison Woodhull Crosby of Jamesburg, New Jersey, successfully processed tomatoes in tin cans. He is considered the first American to "tin" tomatoes commercially. For that he owed a debt of gratitude to Colonel Robert Gibbon Johnson of Salem, who in 1820 supposedly ate tomatoes in public to prove that they were not poisonous.

Despite its urban character, New Jersey has the nickname "Garden State." No one knows how the nickname came to be. One story has Abraham Browning of Camden at the 1876 Centennial Exhibition in Philadelphia comparing New Jersey to an immense barrel filled with good things to eat and open at both ends. He referred to New Jersey as the Garden State, and the name stuck.

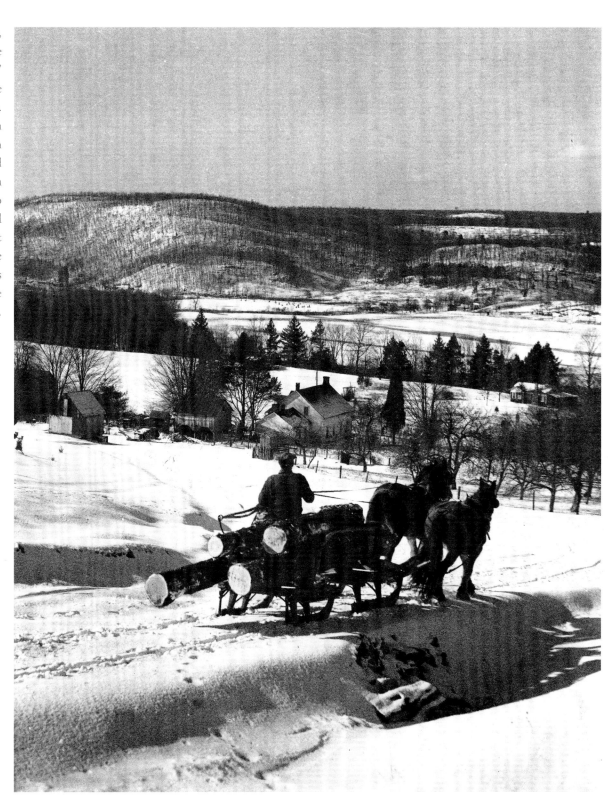

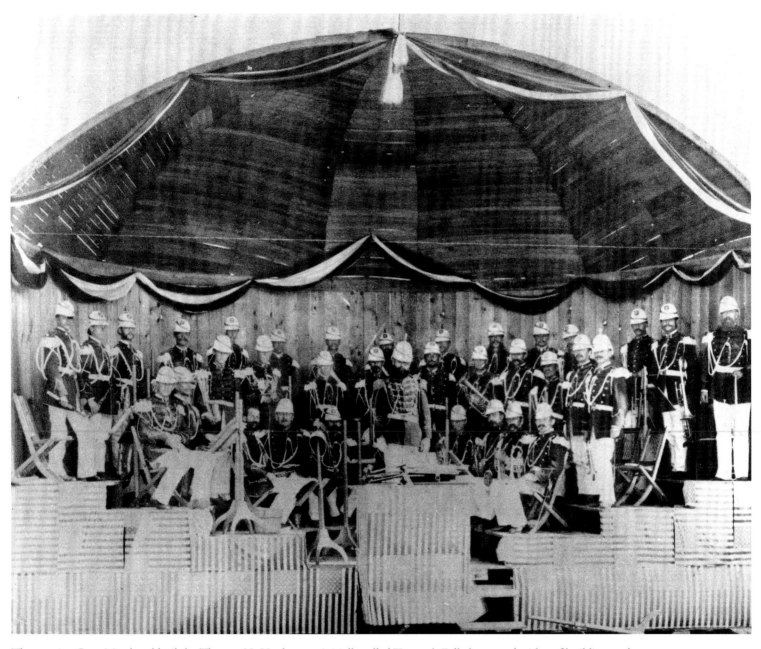

The massive Cape May hotel built by Thomas H. Hughes was initially called Tommy's Folly because the idea of building such a structure down the shore was thought to be insane. After Hughes was elected to Congress they changed the name to Congress Hall, and by then the hotel was becoming wildly popular. Frequent Cape May visitor John Philip Sousa loved Congress Hall so much that he wrote the "Congress Hall March" in its honor.

According to legend, Walt Whitman was in the midst of a heated argument with his brother in Camden when he excused himself, walked around the corner, and bought this house on Mickle Street. The Good Gray Poet lived there for the rest of his life, despite efforts by his friends to get him to buy another home. (He used the money raised instead to buy his tomb.)

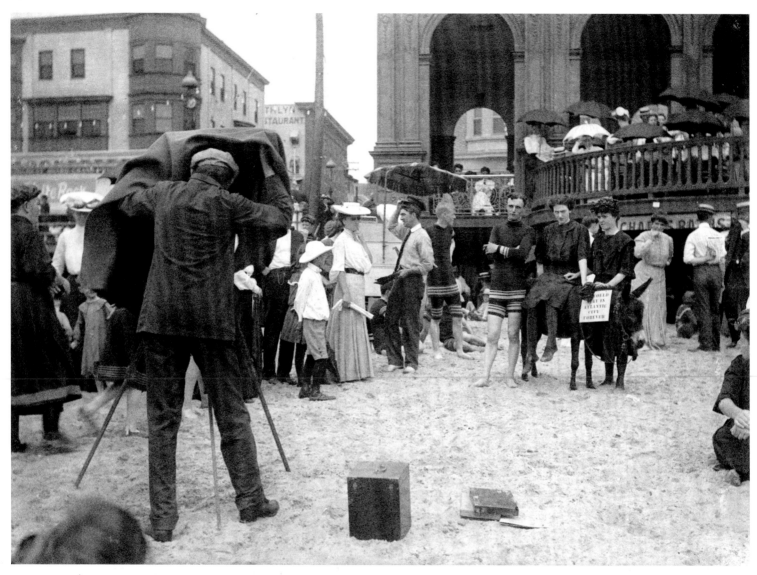

Next to the Boardwalk, the beach was possibly the most popular attraction in Atlantic City. From the 1880s onward, donkeys were nearly as prevalent on the beach as humans, patiently posing as people mounted them, attached a wagon to them, and in general found myriad ways to include them in both candid and staged photographs.

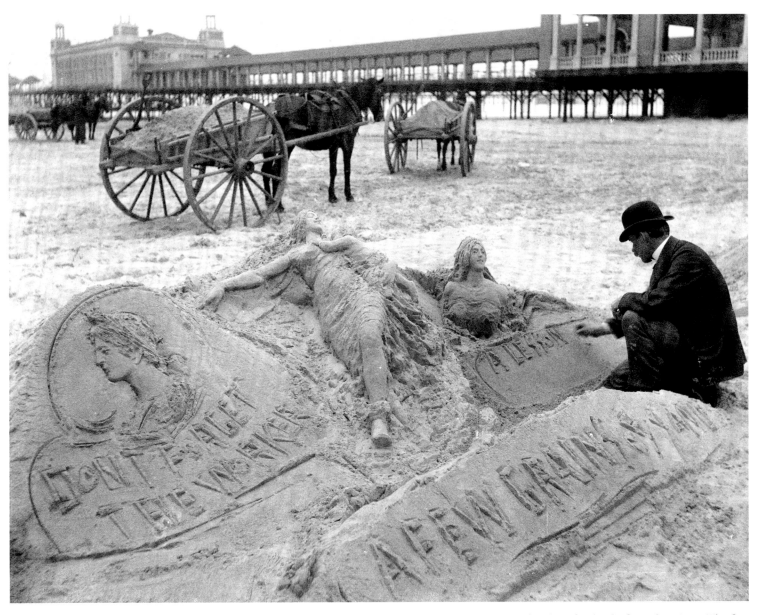

Sand artists plied their trade on the Atlantic City beach as a way to gain notoriety and make a few bucks from donations. The first known sand artist was Philip McCord in 1897. From there the business exploded, with artists depicting everything from Woodrow Wilson and the Kaiser to religious and civic themes to famous paintings like *Washington Crossing the Delaware*. By 1944, Atlantic City artists had become so numerous they were deemed a nuisance and the craft was officially banned.

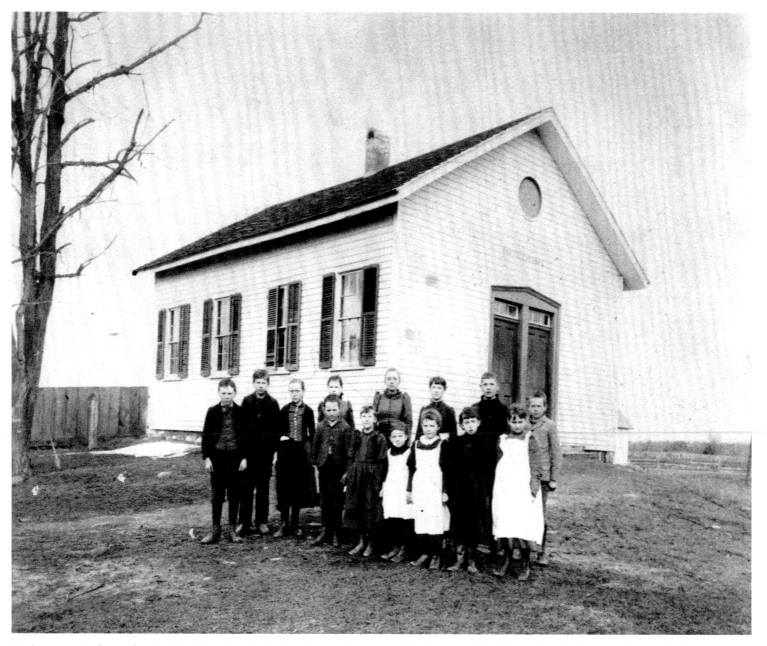

Students pose in front of a school in Metuchen in the late nineteenth century. Clara Barton of Red Cross fame had a lot to do with furthering public education in New Jersey. In the 1850s, despondent and at loose ends, she established a free public school in Bordentown for all students of both sexes—not just those who could pay. The schoolhouse still stands today.

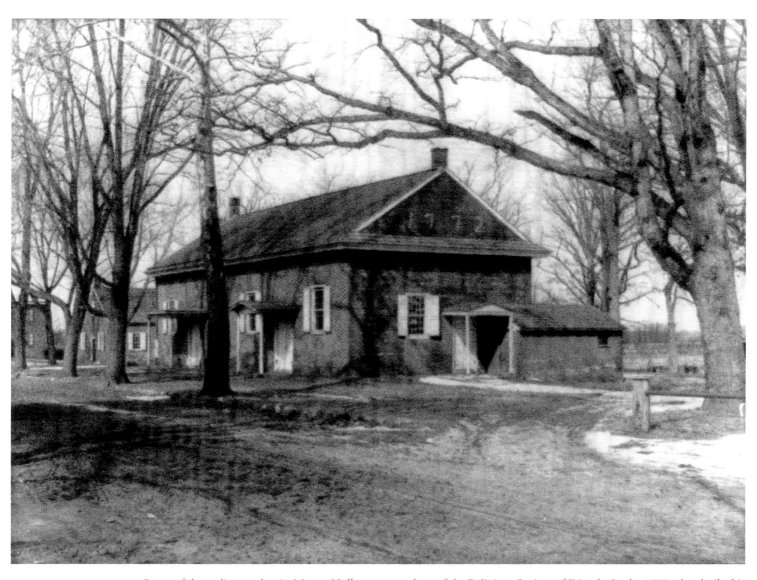

Some of the earliest settlers in Mount Holly were members of the Religious Society of Friends. In the 1770s they built this meetinghouse there. During the American Revolution, the building was occupied by Hessian soldiers and the British Army of Sir Henry Clinton, who used it as their commissary department and whose butchers left cleave marks behind. By the time of this 1896 photograph, a gallery had been added to the one-story building.

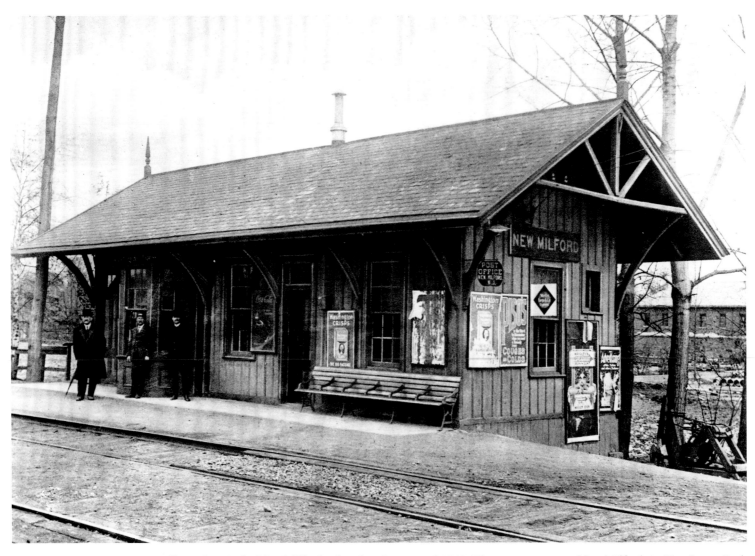

Shown here is the New Milford railroad station around 1900. There once were two New Milfords in New Jersey. Both applied for a post office in 1828. As the story goes, a clerk in Washington, D.C., approved the first New Milford's application. But when he came upon a second New Milford, he crossed out "New" and wrote "West" in its place.

A State Invincible

(1900–1919)

As the nineteenth century gave way to the twentieth, New Jersey had reason to look forward to the coming years with optimism and confidence. Everywhere one looked, the state was hard at work. Cities like Newark, Jersey City, Paterson, and Camden were industrial powerhouses. Farms were harvesting produce as quickly as the crops could be gathered. The shore region was developing into a getaway spot for one and all. Opulent summer "cottages" were being built at Cape May in the state's southernmost end. Was there anything that could slow New Jersey down? Unlikely.

Morris County seemed to epitomize one end of the state's prosperity. In 1900, America's business and financial leaders, seeking relief from New York City, gazed across the Hudson and saw Morris County, with its rolling hills, unspoiled roads, and green pastures. They started building so many vast pleasure palaces in the county that soon it was said that more millionaires lived within a one-mile radius of the Morristown Green than anywhere else in the world.

The other end of the story could be seen in Atlantic City. Not just a resort for the rich, Atlantic City was the place for everyman—and every man (and woman too) came by the thousands. The city's year-round population soared from 8,000 in 1885 to 37,500 in 1905. One needn't be a big shot to enjoy Atlantic City—one just had to dream big. Packed trains continually roared into the city, filled with folks carrying carefully wrapped sandwiches for lunch in shoe boxes, thus giving rise to the "Shoe-Box Set," soon to be shortened to the all-around slang term for visitors: "Shoebees."

New Jersey cities were becoming known for their industrial production. Paterson was "the Silk City." Trenton had so many ceramic companies that it was called the "Staffordshire of America" after the town in England known for its pottery. Indeed, Trenton had so much industrial production that "Trenton Makes, the World Takes" would one day be proudly advertised on the side of a city bridge and it wasn't a boast—it was fact. Even tiny Fort Lee was getting into the act with something called silent motion pictures. Soon the small town was the center of the silent film universe.

The War to End All Wars that followed just made New Jersey's industries run hotter. Walt Whitman had once called Camden "a city invincible" because of its ceaseless industry. But maybe he didn't go far enough, for all of New Jersey during these years did indeed seem "a state invincible."

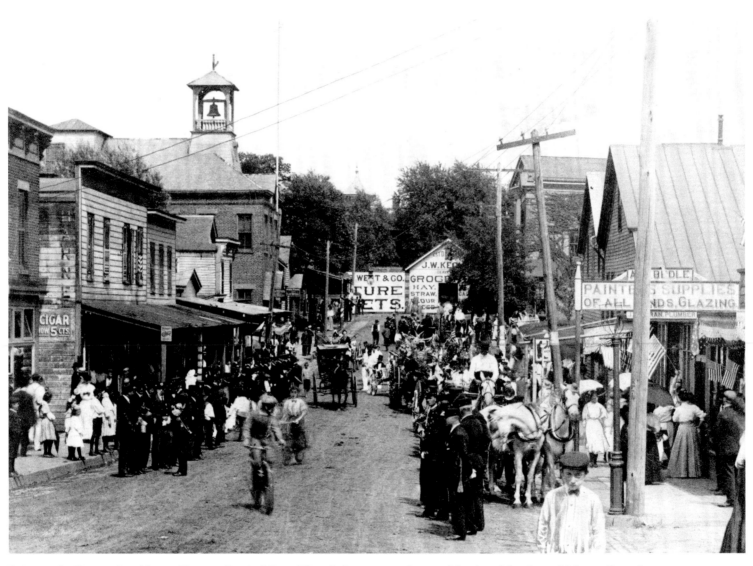

In 1900, the Keyport Band began Keyport Carnival Days. The whole town was decorated for the celebration, which usually took place in August. Among the festivities, as shown here, was an inspection of the Keyport Fire Department.

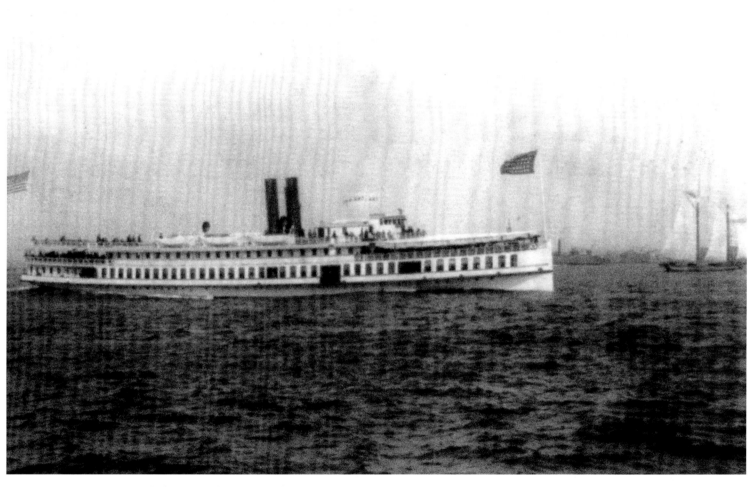

Long before the railroad, steamships were the travel mode of choice for thousands to get to the Jersey Shore, particularly in the north, and ships continued in service even after the trains came. The Central Jersey Railroad built a pier at Atlantic Highlands in 1882. The service was advertised as "the Swift Way Across the Bay."

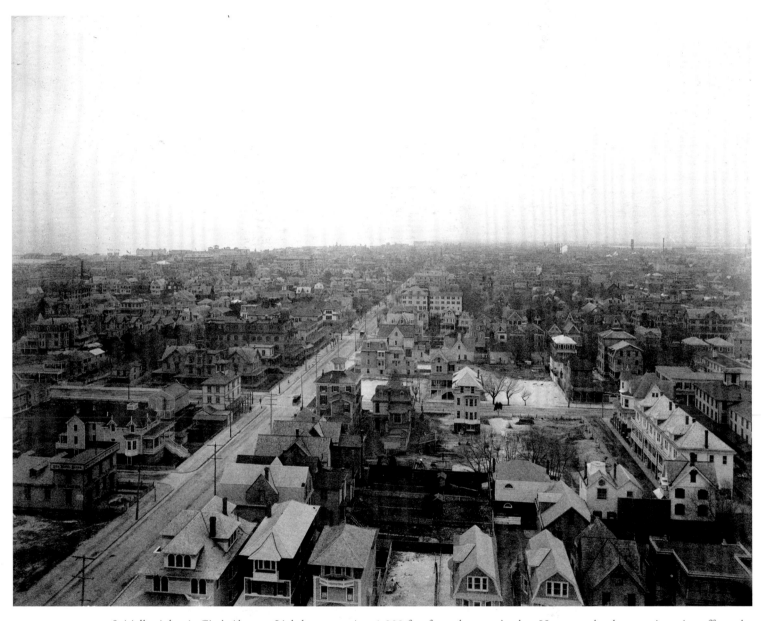

Initially, Atlantic City's Absecon Lighthouse was just 1,300 feet from the water's edge. However, thanks to anti-erosion efforts the ground around the lighthouse had built up. The rapidly growing city swallowed up the available land, surrounding the lighthouse with a sea of buildings and leaving it several blocks from the ocean. By 1900, when this view from the lighthouse was recorded, it was surrounded by buildings whose lights blended in with the lighthouse's beacon.

Absecon Lighthouse was built only after Atlantic City founder Dr. Jonathan Pitney waged a protracted campaign on its behalf. First lit in 1857, the light soon reduced the number of shipwrecks in the area. Here in 1900, its usefulness as an aid to navigation was ending, but the lighthouse would return to life in a second career—as a tourist attraction.

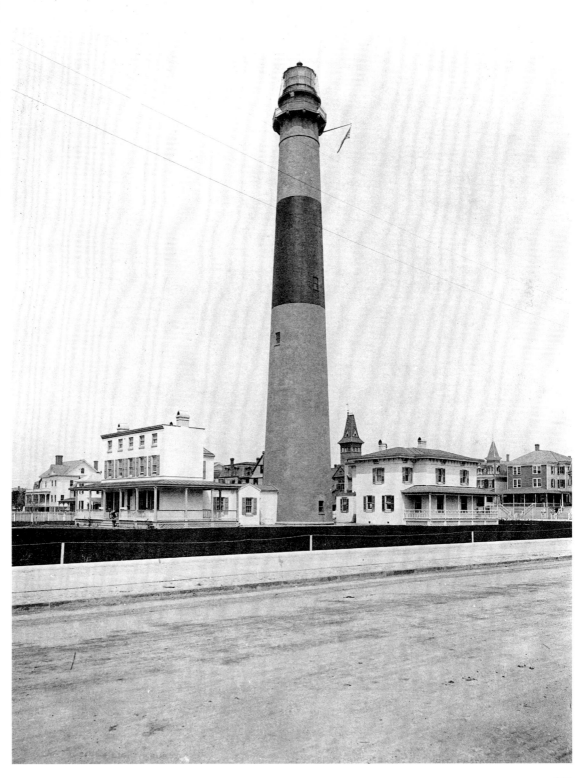

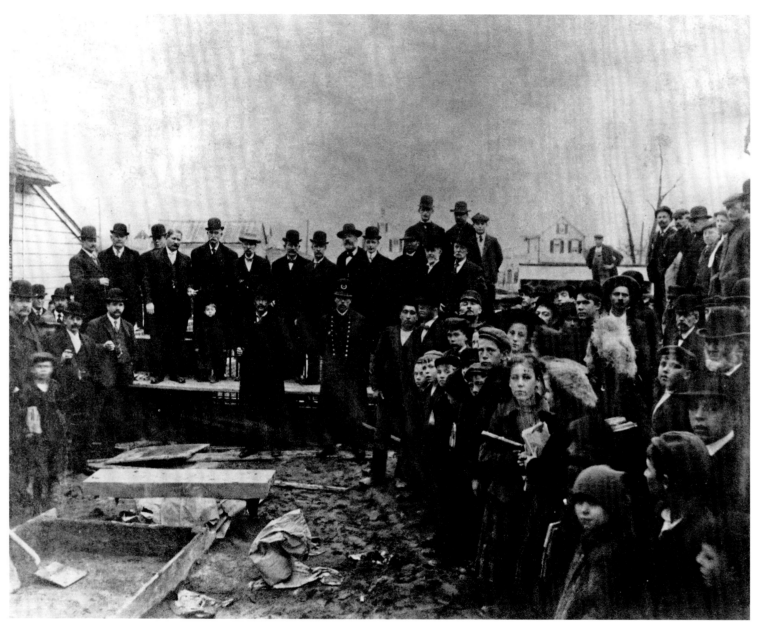

When South River was founded, it was originally known as South River Landing. Subsequently it became Willettstown and then Washington (in honor of George), before finally settling on the name South River in 1870. The town was once an important shipping and transportation stop between New York and Philadelphia.

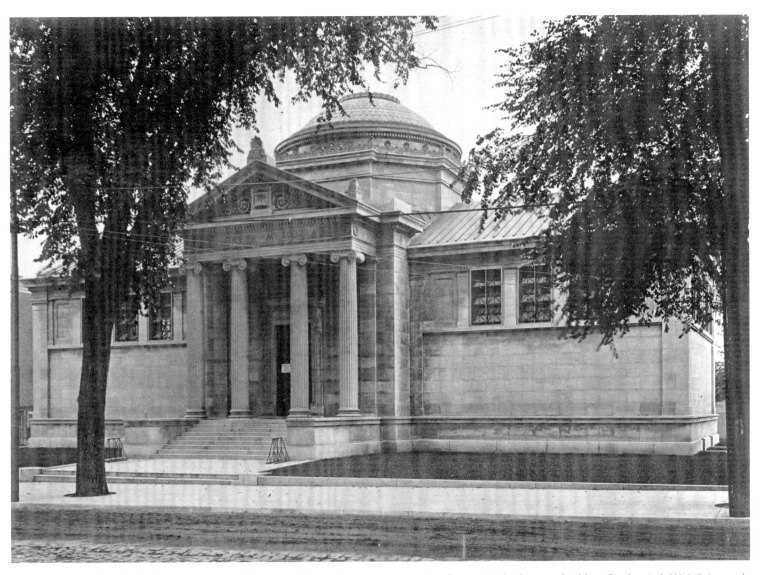

Joseph W. Stickler was one of the city of Orange's most generous benefactors. He built a new building for the city's Y.M.C.A., made financial gifts to the Orange Memorial Hospital, the Orange Orphan Home, and the Women's Christian Temperance Union, and also built and equipped the hospital's dispensary building. In 1900, he built this library in Orange as a memorial to his late son, at a cost of $100,000 (the equivalent in 2008 of more than $2 million).

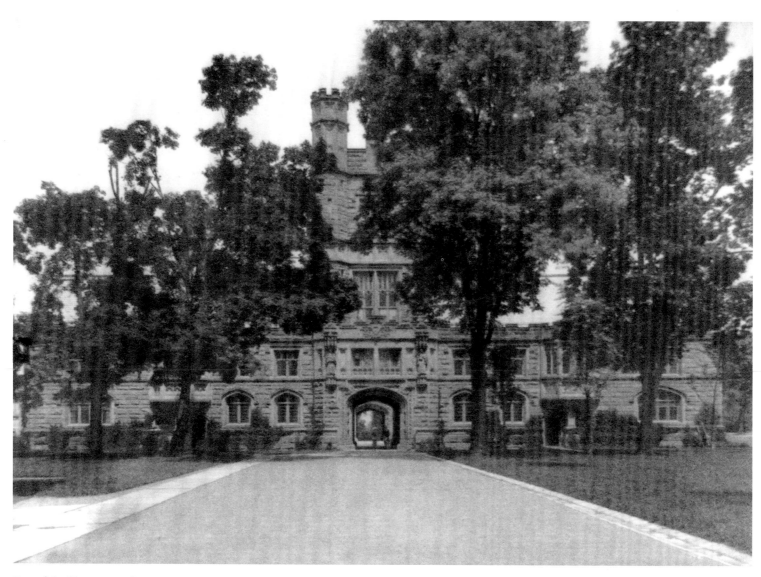

Part of the library complex at Princeton University in 1903. At this time the complex consisted of two libraries—Chancellor Green, which served as a reading room, and recently constructed Pyne Library, which had book stacks, seminar rooms, and offices. The two were connected by a passageway called the Hyphen.

Bathing suit styles would change over the years, but as shown here in 1903, change had yet to come to Atlantic City. Men in bathing suits were banned from going shirtless and women in bathing suits were required to cover their legs with stockings. For a time, the city even employed censors to cruise the beaches, ready to fine those who violated morality standards.

This is a bridge in Morris County in 1904 near Swede's Mine. Located on the north side of the Morris Canal near Dover, Swede's was an important iron ore mine in the mid nineteenth century. The mine was worked continuously for 20 years, until it closed in 1875. It was abandoned permanently in 1882.

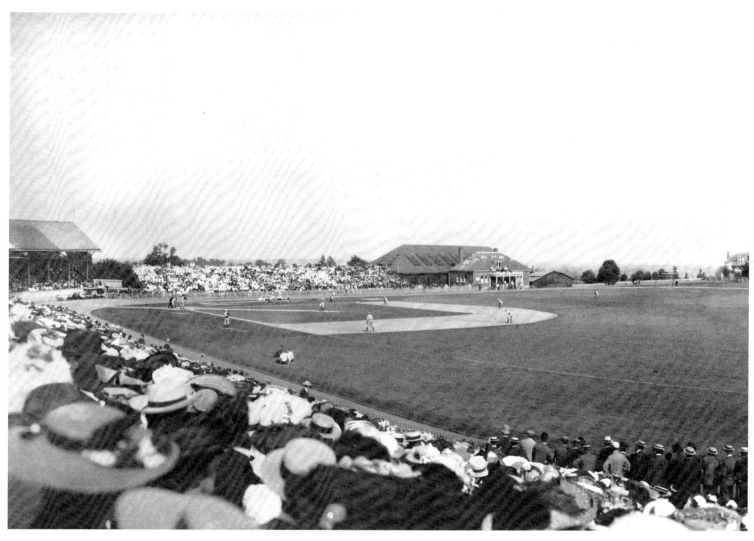

Many people believe that the modern game of baseball was conceived in Hoboken, New Jersey, in the 1840s. By 1904, when this photograph of a game between Yale and Princeton was taken, the game's popularity had spread from the professional playing fields of the American and National leagues to the collegiate ranks.

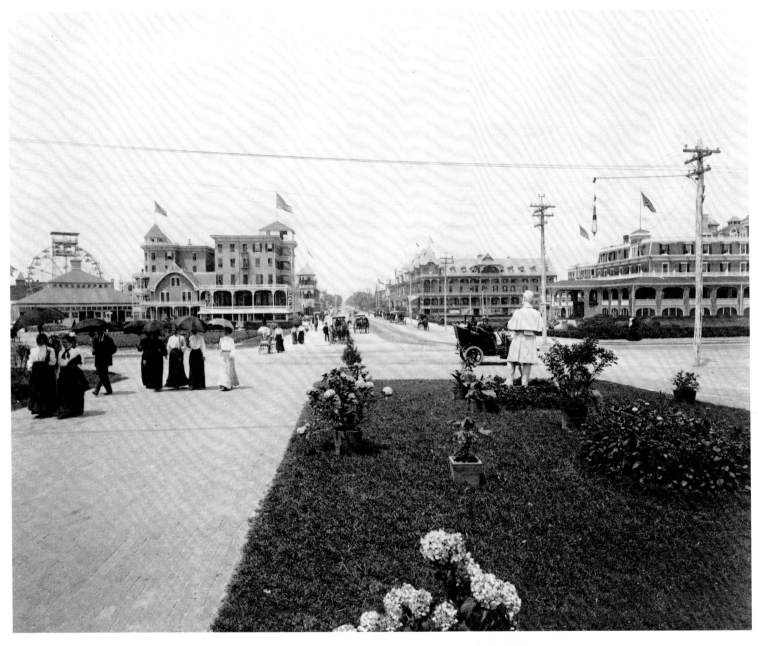

Asbury Park was founded by brush manufacturer James A. Bradley in the early 1870s. Although he had no training as a city planner, Bradley designed a community with plenty of parks and wide, tree-lined streets that would rival Atlantic City in coastal popularity by 1904. As a period book stated, "The place has been laid out with good taste, many natural features of beauty having been skillfully utilized."

On June 15, 1904, 183 members of Princeton University's Class of 1904 graduated on Class Day, the 157th commencement exercise held at the school. University president Woodrow Wilson led the ceremonies, with Princeton resident and former United States president Grover Cleveland in attendance. One of the speeches given during the commencement was "Will Europe Disarm?"—a question that World War I would soon answer.

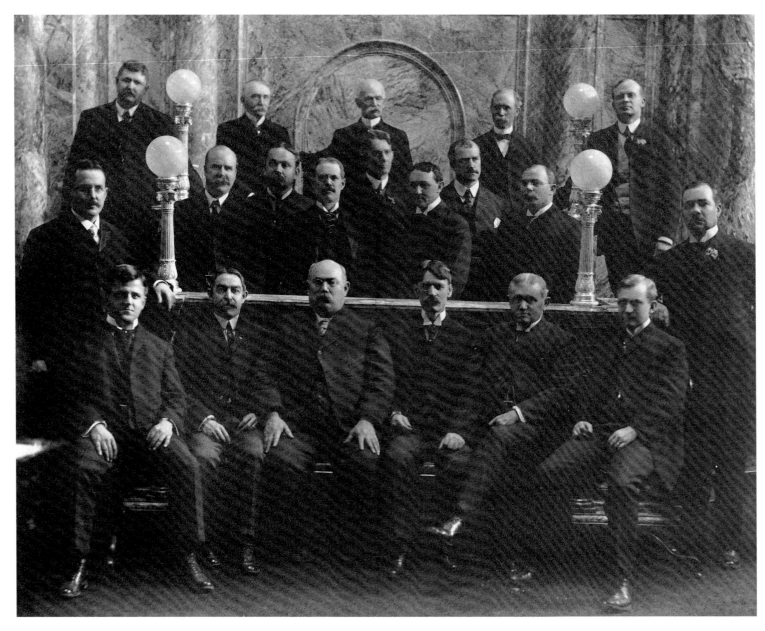

The New Jersey State Senate was established in 1844 and is one of two legislative chambers in New Jersey. The State Senate is headed by a president, although here in 1905 two Senate presidents are pictured: Joseph Cross of Union County, who resigned on March 30, and William J. Bradley of Camden County, who succeeded him.

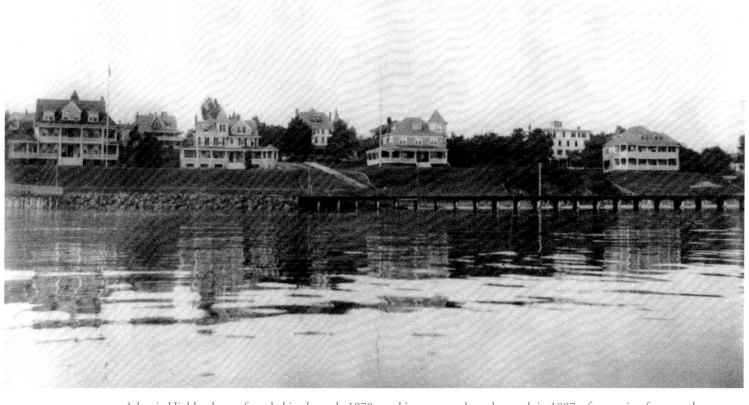

Atlantic Highlands was founded in the early 1870s, and incorporated as a borough in 1887, after serving for several years as a Methodist camp meeting town. Sparked by the Atlantic Highlands Association, which included Methodist Church members, the town developed along Victorian lines, with many stately and elegant structures, as this 1905 shorefront image attests.

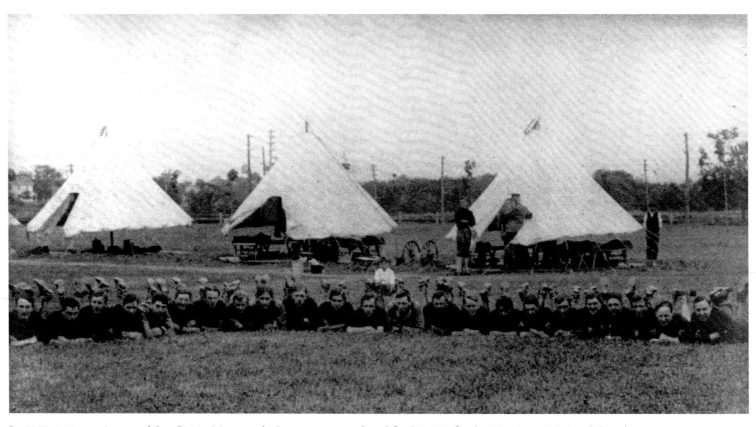

In 1887, 120 acres in coastal Sea Girt in Monmouth County were purchased for $51,000 for the New Jersey National Guard, which established a training camp there. Here New Jersey governors often spent the summer months. "Each day began with a bang as the morning gun was fired," remembered Governor Franklin Murphy, "and from then . . . regimental and company drills, the guard mount, evening parade, the occasional review . . . have kept my interest in the life alert."

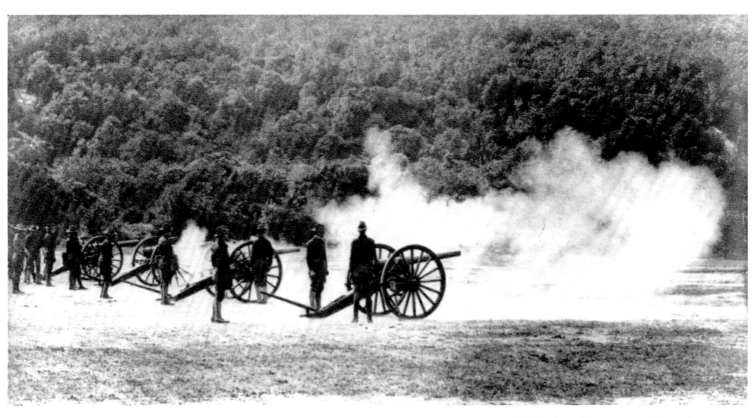

In 1868, the state legislature created the New Jersey National Guard. The Guard helped quell riots in Camden and Jersey City in 1871, helped maintain order during railroad riots in 1877, and in 1898 was mustered for service in the Spanish-American War. The Guard is shown here in 1905.

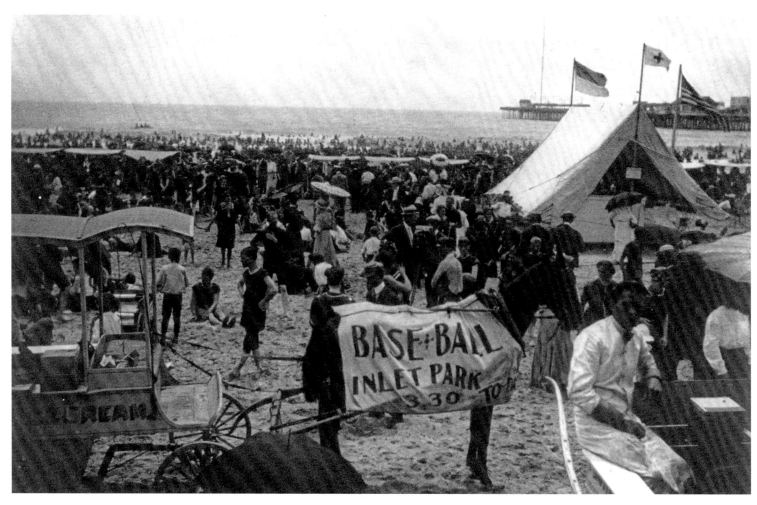

"Atlantic City . . . must have a rush, a mob, a regular overflowing jam in order to make things pay" an observer wrote, and quite often it did on the beach. Popular postcards of the era showed jam-packed beach scenes with captions like "$5.00 Reward if you can find me in this crowd of bathers." One of the hazards of allowing horses and donkeys on the beach: horse manure.

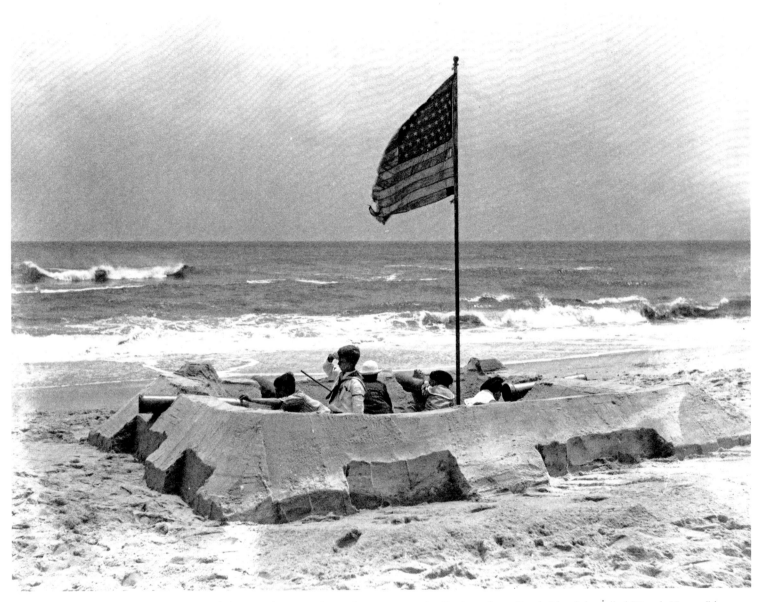

It was initially suggested that Beach Haven, located on narrow, 18-miles-long Long Beach Island, be called "Beach Heaven" because its salt air and the absence of pollen dramatically relieved symptoms of hay fever. Founded in 1874, the town's rapid growth was sparked by the railroad. Today it is the largest community of several on the island, and a town whose beach is a great place to build a sand fort, no matter what the year.

A bustling steamship service made Atlantic Highlands easily accessible and helped it grow. A long pier built into the Raritan Bay made it easy for steamers from New York to reach the area with passengers. Leslie's Beach, shown here, was a popular recreation destination in the town.

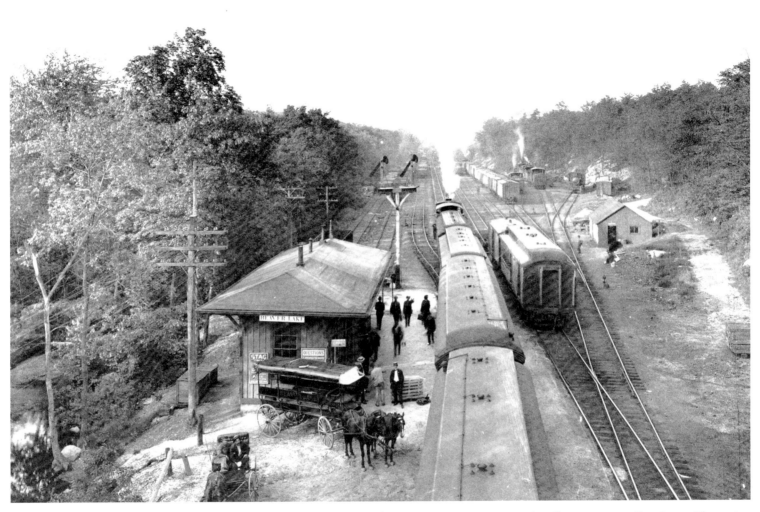

Beaver Lake in Sussex County—New Jersey's northernmost county—was once a bustling passenger railroad stop. The station was built for the New York, Susquehanna & Western Railway and offered commuter service to and from New York City. This service was discontinued in the 1960s. The railroad station still exists today, although it is extremely dilapidated.

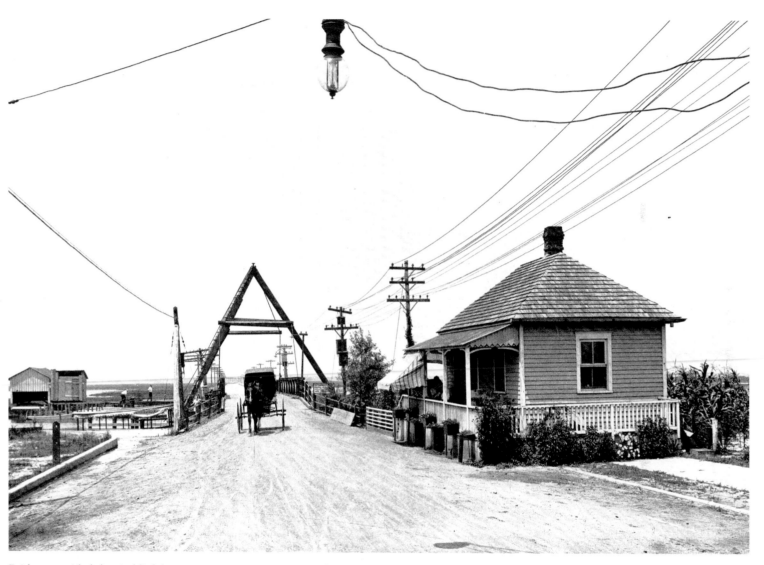

Bridges provided the vital link between many New Jersey coastal regions—such as Sea Isle City, shown here—and the mainland because often these areas were located on islands. Sea Isle City was founded by Charles K. Landis, who also founded Vineland, New Jersey. His original plan was to develop a town to rival Venice, Italy, with fountains, canals, and other Venetian-style features.

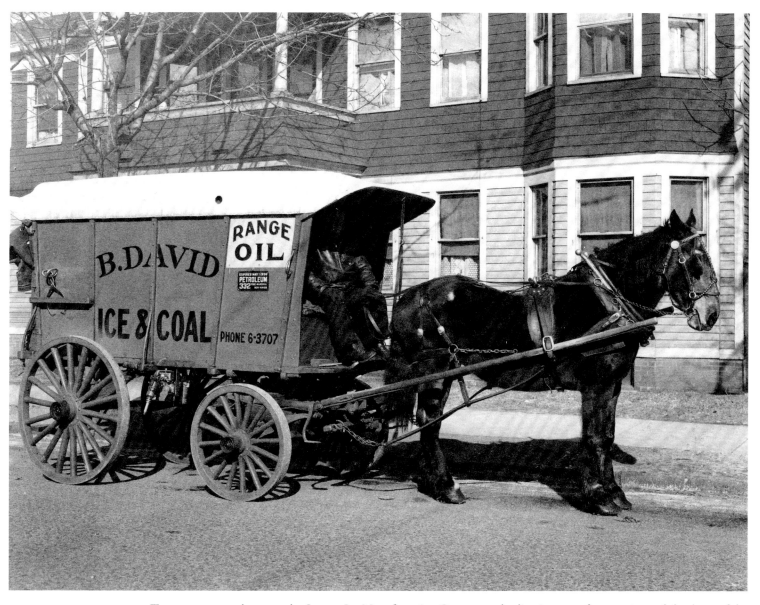

Trenton was once home to the Saxony Ice Manufacturing Company, a leading ice manufacturer. Around the dawn of the twentieth century, manufactured ice began replacing natural ice in American homes, providing a source of ice year-round. Ice delivery would become commonplace.

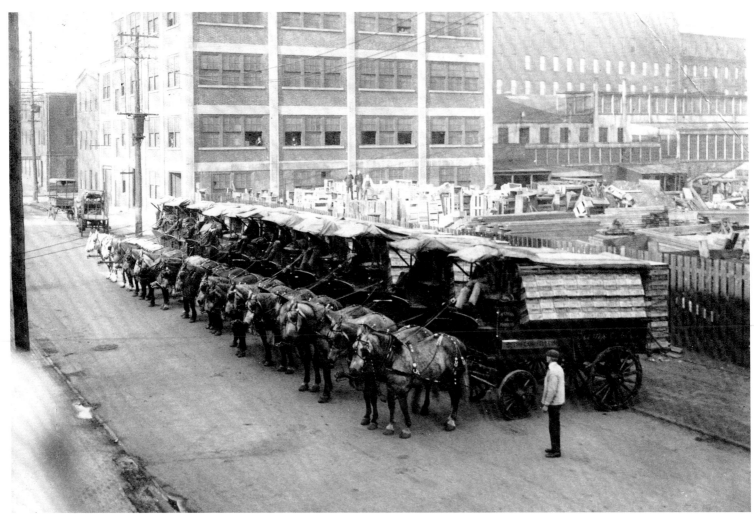

Teams of Belgian and Percheron horses prepare to deliver their wagonloads of Campbell's Soup Company products. Each wagon carried 304 cases, which provided the horses with quite a heavy load to haul.

Early settlers to the region that became Montville called an area stream "Owl Kill" (Dutch pronunciation: Uyle-Kill) because of the many owls that occupied nearby trees and fed on the mice on the ground below. Colonial troops used the region's roads to move between the Hudson River and Morristown during the American Revolution. Montville Township was incorporated in 1867. Shown here in the early twentieth century, the town was bucolic and prosperous.

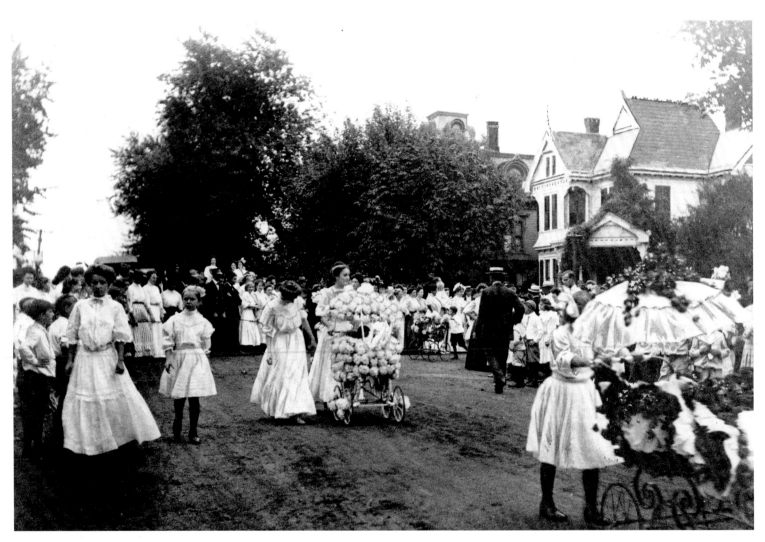

The Baby Parade began in Asbury Park, New Jersey, and was soon such an enormous success (who can fail to love a procession of cute, dressed-up babies?) that other towns rushed to emulate it, including the town of Keyport shown here. It was the success of the Baby Parade that Atlantic City hoped to match with its Miss America Pageant.

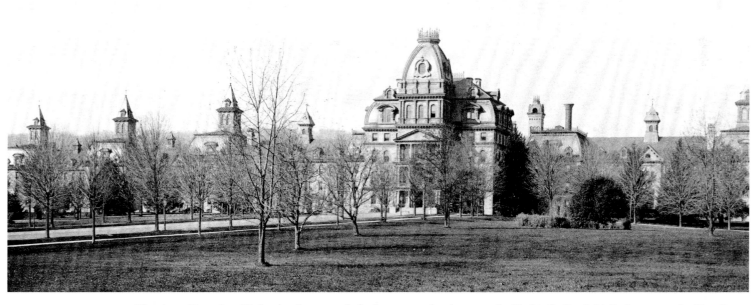

Thanks to Dorothea Dix's relentless crusade for better care for the mentally ill, this facility initially known as the New Jersey State Lunatic Asylum at Morristown was opened in 1876 to relieve severe overcrowding at the state's only other asylum in Trenton. By 1907, the name had been changed to the New Jersey State Hospital at Morris Plains, and would soon be changed again to Greystone Park.

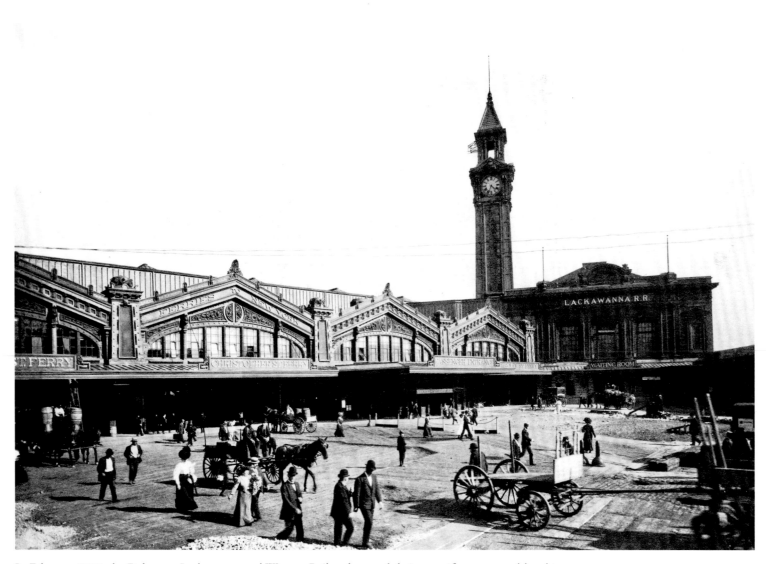

In February 1907, the Delaware, Lackawanna and Western Railroad opened their magnificent, ground-breaking new terminal in Hoboken. The Hoboken Terminal contained a Greek Revival–style waiting room, Tiffany stained-glass, and a 225-foot-tall clock tower. It was considered a landmark in the development of American transportation because it combined rail, ferry, streetcar, and pedestrian services.

Just three years before this 1907 panorama was recorded, the town of Dover had established the first trolley car service in New Jersey. Initially known as Old Tye and Beamans, the town acquired the name Dover around 1792, when Moses Hurd arrived in the area from Dover, New Hampshire, to work at a forge. The forge would play a significant role in the construction of the Morris Canal in 1830.

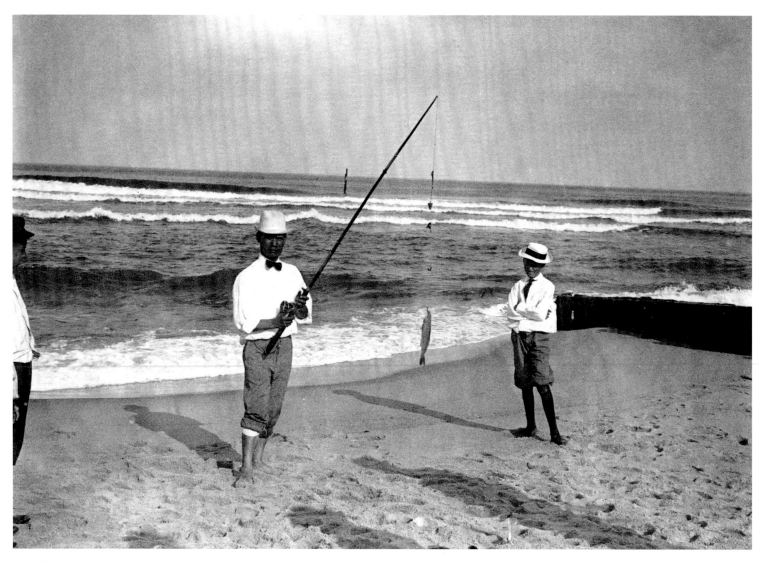

Initially Belmar on the Jersey Shore was named Ocean Beach. It was designed as a Methodist camp meeting town by a group of businessmen who felt that Ocean Grove, the original camp meeting town located to the north, was growing too crowded. Here in the early twentieth century, Belmar's religious roots were fading as it gained popularity as a resort. Many decades later, Bruce Springsteen's band would take their name from Belmar's E Street.

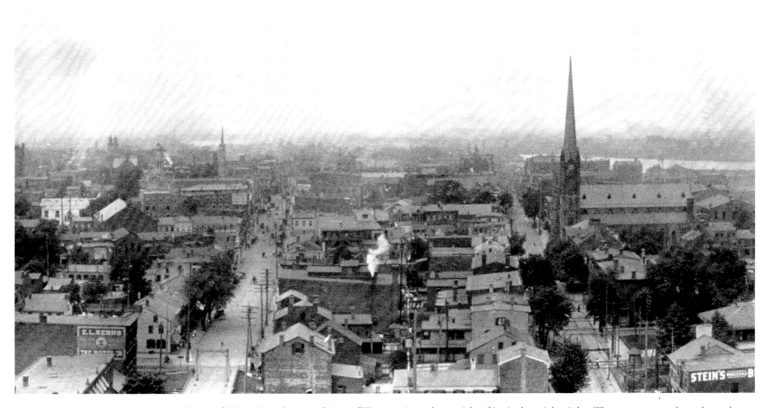

It is 1909, and New Jersey's capital city of Trenton is at the zenith of its industrial might. There are more than three dozen iron manufacturers, the city's pottery industry is so strong Trenton is called the Staffordshire of America, and the John A. Roebling wire rope company is a global powerhouse. In that year a Trenton company built a 600-pound, 50-gallon bathtub for President William Howard Taft, whose weight would reach 335 pounds by 1913.

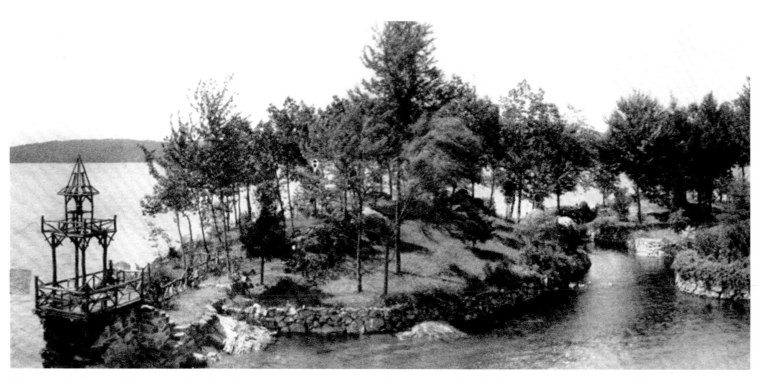

Covering 4.2 square miles, man-made Lake Hopatcong is the largest lake in New Jersey. It has always been a popular recreation spot for its 35 miles of shoreline and natural beauty, such as the area called the Isles shown here. In 1908, a Newark schoolteacher built the popular Bertrand Island Amusement Park at the lake. Miss America 1937, Bette Cooper, began her title quest by becoming Miss Bertrand Island.

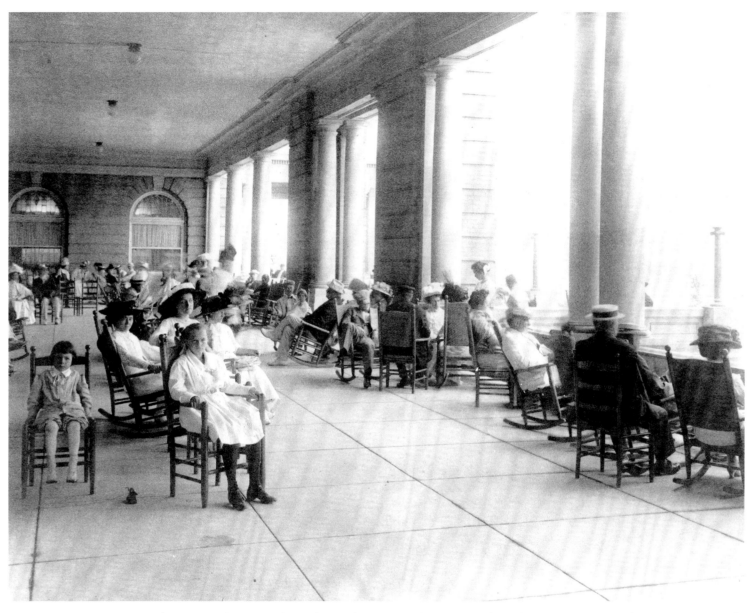

When it opened in 1908, the opulent multi-story Hotel Cape May (shown here) was supposed to be the cornerstone of a "new" Cape May. Guests at the ceremonies for its grand opening included the governor of New Jersey. Several months later, however, the hotel abruptly closed.

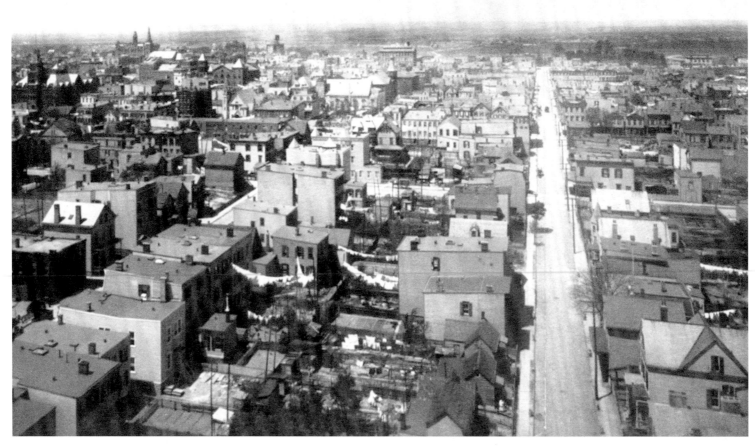

Densely populated Hudson County in the northern part of New Jersey played a crucial role in the state and nation in the first decades of the twentieth century. After processing at Ellis Island, immigrants went to the terminal of the Central Railroad of New Jersey in Jersey City. From there they either bought train tickets to other parts of the country or settled in the area to take advantage of its plentiful jobs.

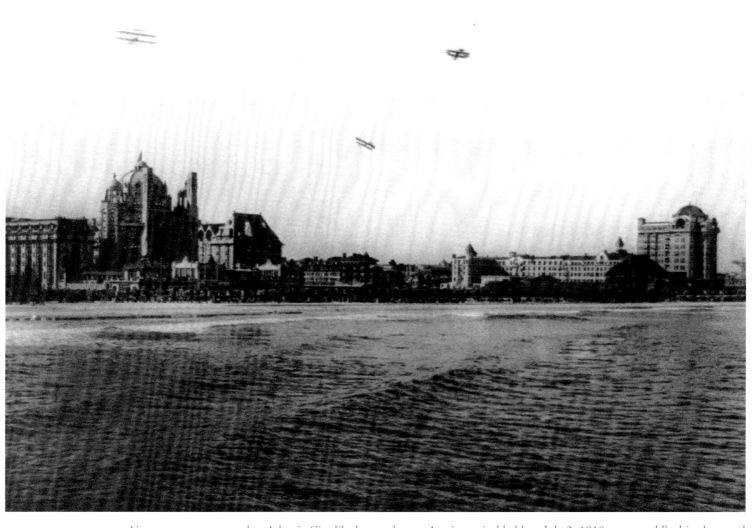

Air stunts were attracted to Atlantic City like bees to honey. An air carnival held on July 2, 1910, set a world's altitude record (6,175 feet). During the same event aviation pioneer Glenn H. Curtiss not only set a speed record, traveling 50 miles in 1 hour and 14 minutes, but also demonstrated aerial bombing by peppering a yacht with oranges.

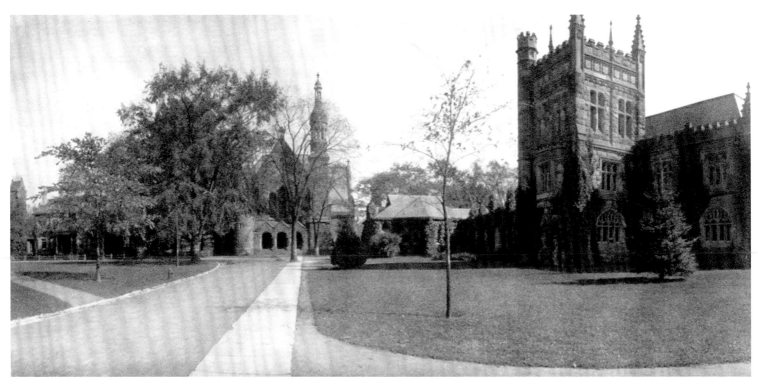

The beauty of the Princeton University campus, with its varied architectural styles and pastoral settings, lingers long. Fifty years after he graduated, Norman Thomas wrote, "Princeton's beauty, present before our eyes or in memory, has been a part of life's wealth that cannot be taken away."

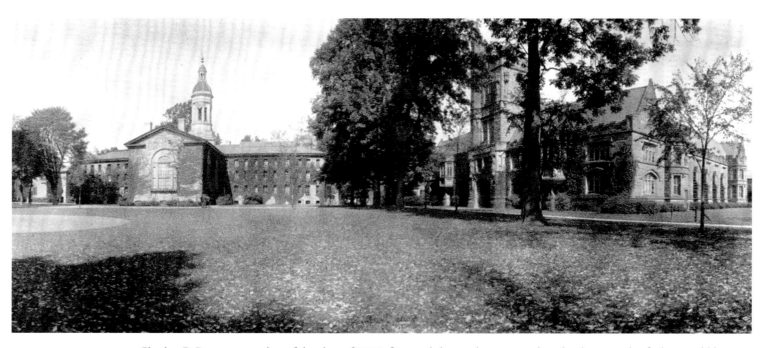

Charles C. Beatty, a member of the class of 1775, first used the word *campus* to describe the grounds of what would become Princeton University. In his novel *This Side of Paradise,* Princeton student F. Scott Fitzgerald wrote, "I think of Princeton as being lazy and good-looking and aristocratic—you know, like a spring day."

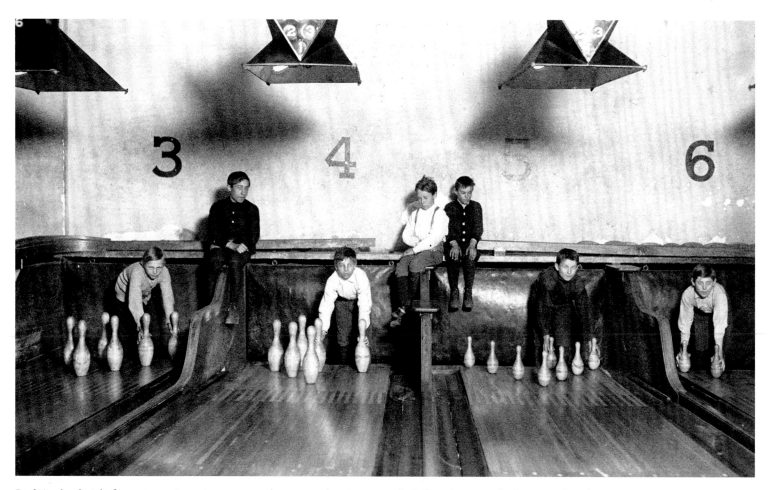

Back in the days before automation, pin setters used to set up the pins manually before the start of a frame, as these boys are doing in a Trenton bowling alley around the first decade of the twentieth century. According to a Trenton history from 1958, "Bowling alleys were installed early in Trenton."

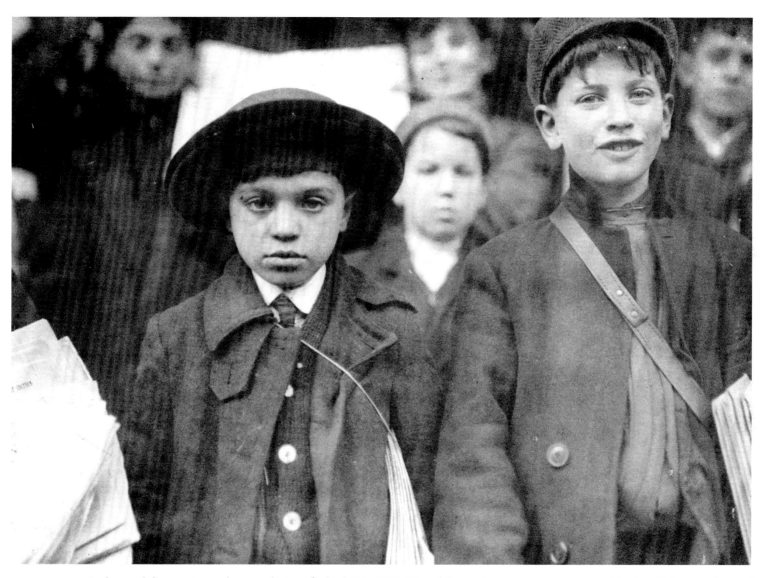

As the state's largest city, with a population of 347,469 in 1910, Newark boasted numerous newspapers sold primarily by squadrons of boys who spent long days hawking their wares on street corners. During a time in which almost everyone got their news from a newspaper, Newark had such papers as the *Evening News, Sunday Call, Evening Journal,* and the *Star* (which ultimately became the *Star-Ledger*).

The still-active Lake Hopatcong Yacht Club (shown here on the lake in the early twentieth century) was founded in 1905. The group's historic clubhouse was built in 1910 in the Adirondack style, and is listed on both the State and National Registers of Historic Places.

The modern game of baseball spread like wildfire over the Garden State, as it did over the rest of the United States. These people are playing ball in Madison, which would one day become the birthplace of ace right-handed pitcher Don Newcombe.

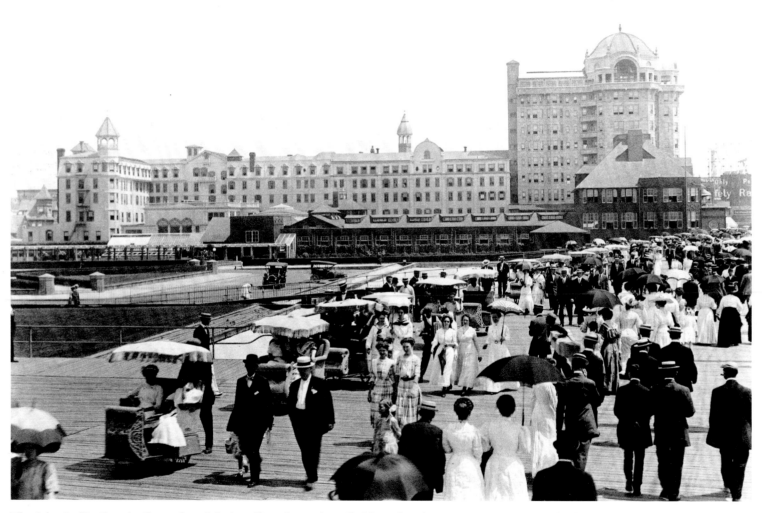

The Atlantic City Boardwalk was famed for its rolling chairs, also called "temples of contentment" and "citadels of restful travel." One needn't be rich to ride one, and consequently everyone did. Well-heeled riders included Henry Ford, who was known as a bad tipper, and Diamond Jim Brady, who would always generously tip $10 or more.

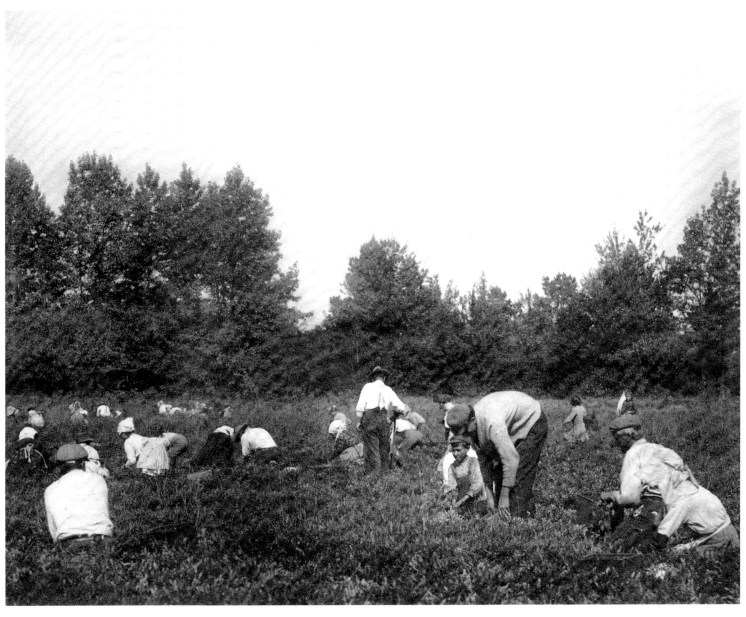

Cranberry growing and harvesting has been part of Burlington County for centuries. Called "pakim" (noisy berry) by the Lenni-Lenape, cranberries were considered so important in New Jersey that in 1789 the state legislature decreed that anyone picking cranberries before October 10 could be fined 10 shillings.

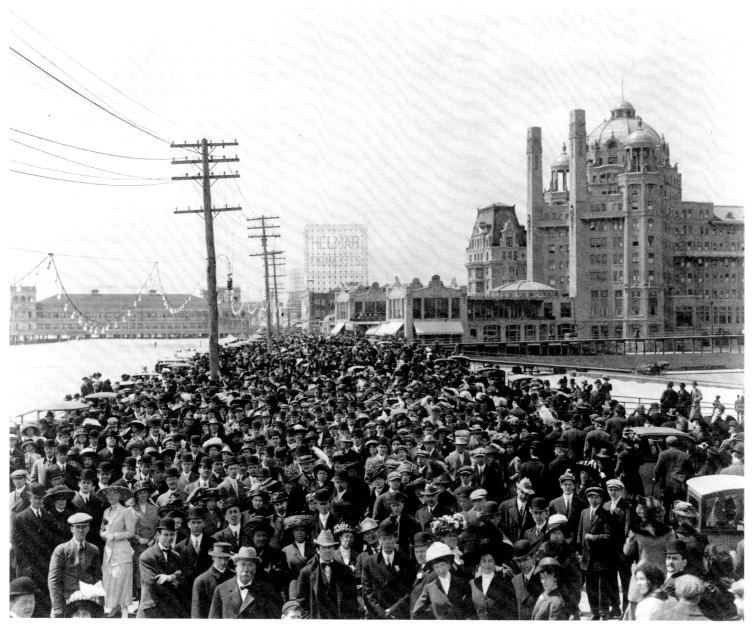

The Atlantic City Boardwalk was originally portable, and was conceived solely as a way for people to walk on the beach without getting sand on their shoes and tracking it into the city's fine hotels. But by 1911, the days of portability were long gone and the boardwalk was the main tourist attraction in town, outshining even the beach.

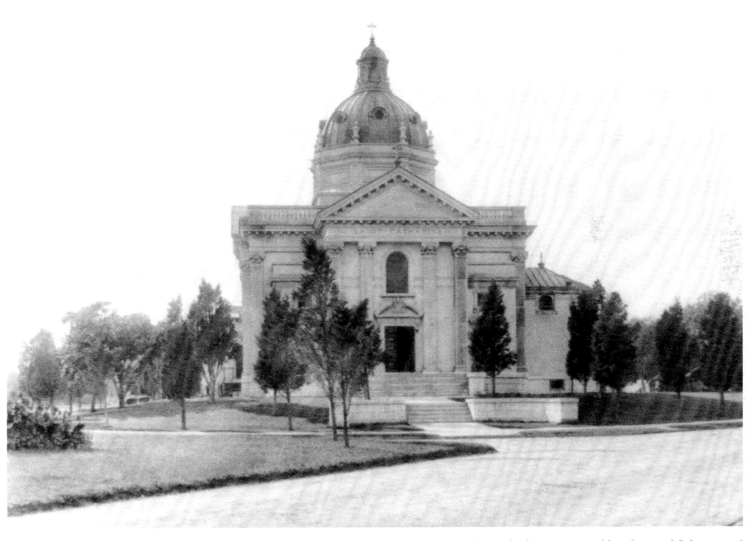

Saint Catharine's Church in the Monmouth County town of Spring Lake was built as a memorial by a bereaved father named Martin Maloney after his daughter Catherine died of tuberculosis at age 17 in 1900. The Maloney family were summer visitors to Spring Lake and eventually built an estate called Ballingarry there.

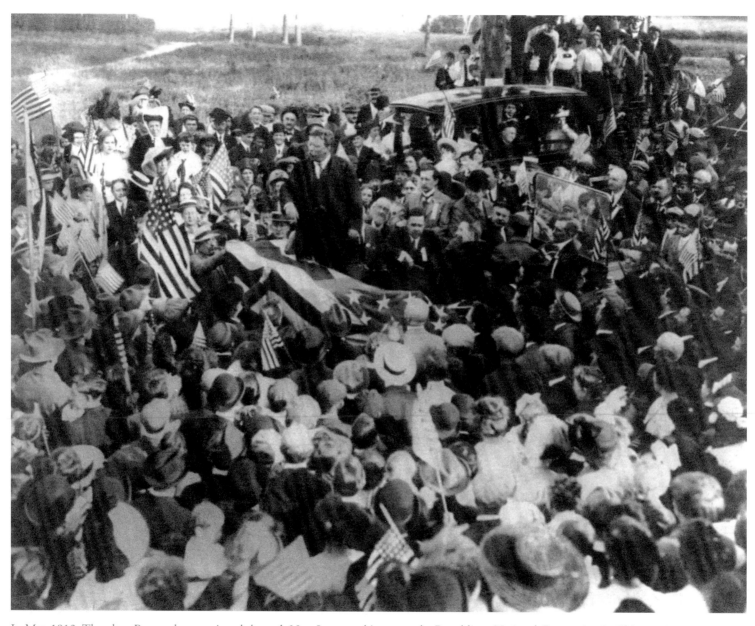

In May 1912, Theodore Roosevelt campaigned through New Jersey on his way to the Republican National Convention in Chicago. Among the towns he visited in New Jersey were Freehold, Farmingdale, Asbury Park, Long Branch, Red Bank, Phillipsburg, and Newton.

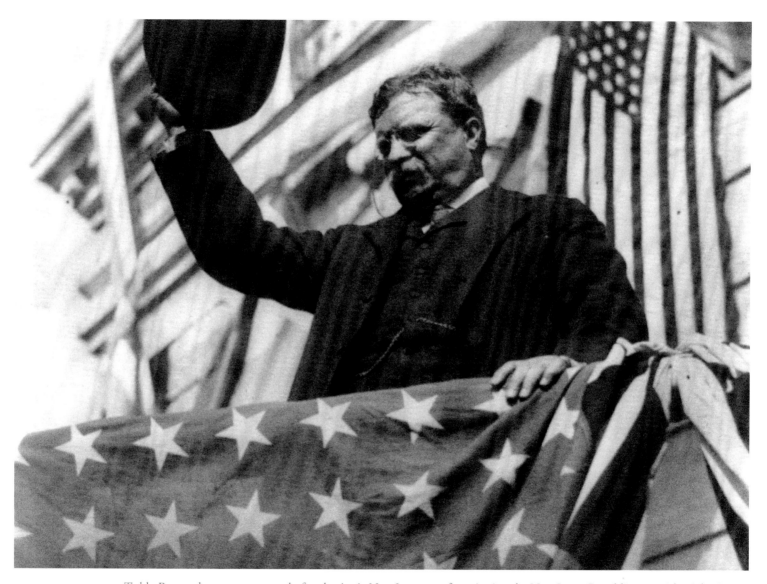

Teddy Roosevelt waves to a crowd of enthusiastic New Jerseyans after winning the New Jersey Republican presidential primary. Roosevelt was well familiar with the state. As a boy of 12 he went to Howell Township to cure his asthma, and as president he visited Sea Girt and Ocean Grove. Late in 1912, Roosevelt's reelection bid against incumbent William Howard Taft would split the Republican ticket and give the election to Democrat Woodrow Wilson.

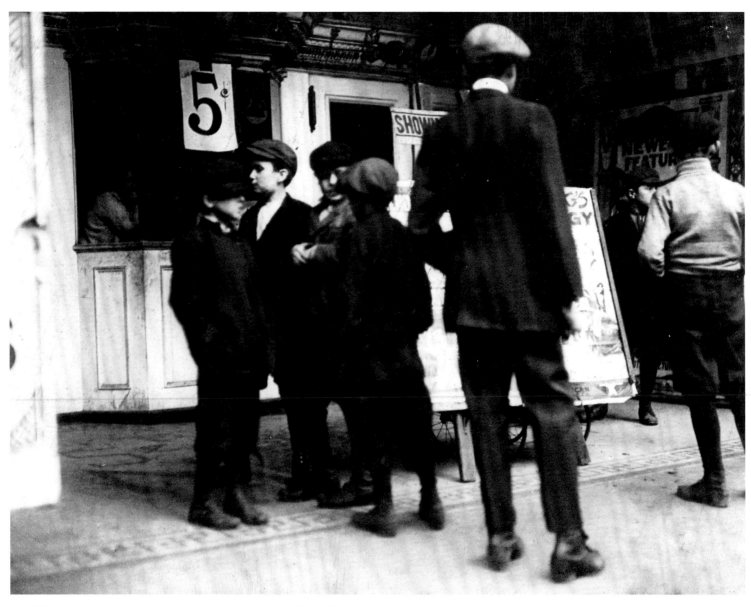

By 1912, going to the movies—as these boys are doing in Jersey City—was becoming quite popular, and they had quite a few locally produced movies to choose from. In that year French movie company Pathé Frères built a modern film studio at 1 Congress Street in the city, overlooking the Hudson River, and would produce silent films there for the next eight years.

This 1913 photograph shows the sixth county courthouse for Bergen County, in the northern part of New Jersey. This one, begun on July 6, 1910, was designed by noted architect of the day James Reily Gordon. Gordon designed 72 courthouses during his career. His specialty was constructing public buildings in the Romanesque Revival style. He also designed the county jail.

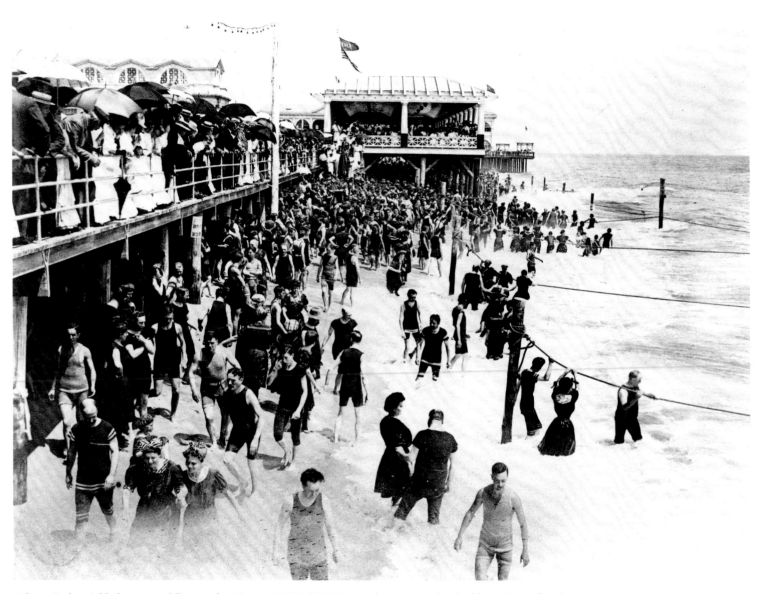

Asbury Park quickly became wildly popular. During 1883, 600,000 people came to what had been, just a few short years before, a desolate wilderness. Even though Asbury had a boardwalk (shown here), founder James A. Bradley insisted it be free of Atlantic City's carnival-style amusements so that strollers could receive the healthy sea air.

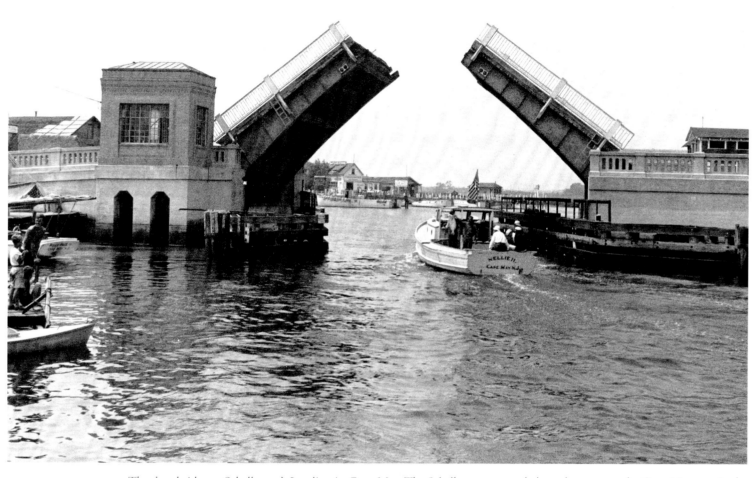

The drawbridge at Schellenger's Landing in Cape May. The Schellengers were whalers who came to the Cape May area in the 1600s from New England, and were some of the earliest settlers. Schellenger's Landing is the place at which boats come into Cape May Harbor. The bridge connected Cape Island to the mainland.

This is West Hoboken, New Jersey, in 1914. West Hoboken was incorporated in 1861. Formerly a pastoral resort region, the Hoboken area changed in the second half of the nineteenth century, developing into an industrial and shipbuilding center. The image indicates how well-developed the area had become by the early twentieth century.

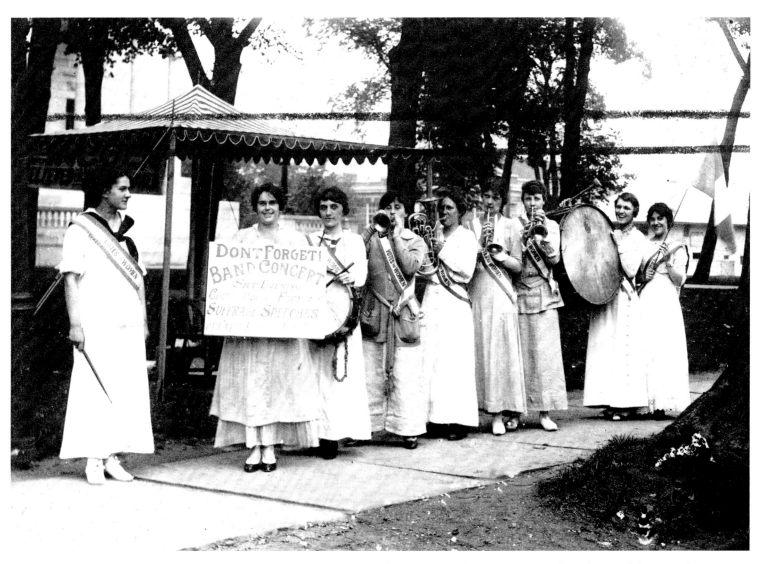

Ironically for these suffragettes shown here at a rally in Hackensack, New Jersey was the only one of the original 13 states to allow women the right to vote. But in 1807 the state legislature passed a law limiting the vote to white males, and women were barred from the voting booth for decades. Finally, in February 1920, the state ratified the Nineteenth Amendment to the Constitution, guaranteeing women the right to vote.

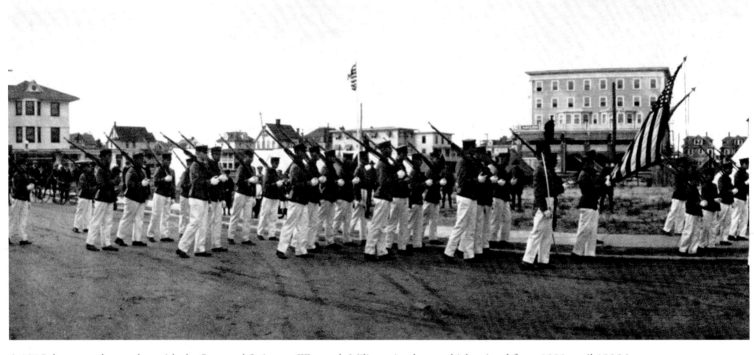

A 1915 dress parade marches with the Stars and Stripes at Wenonah Military Academy, which existed from 1902 until 1935 in Wenonah, Gloucester County. "Your Boy at Wenonah—A Storehouse of Fine Possibilities" the academy assured parents.

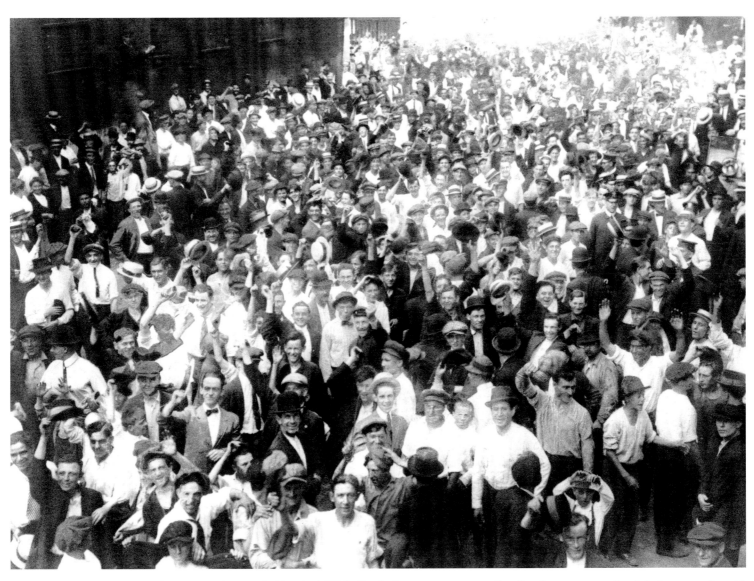

In July 1915, workers at the Standard Oil facility in Bayonne went on strike after the company refused their request for a 15 percent pay raise. For $1.75 a day in 1915 dollars, the workers endured temperatures as high as 150 degrees Fahrenheit to clean out oil sludge. The strike ultimately turned violent. Standard finally granted a 10 percent pay increase to almost everyone.

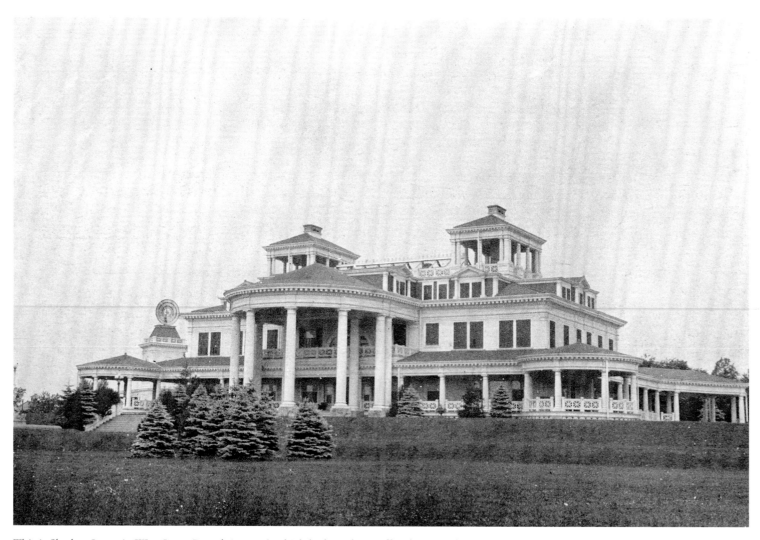

This is Shadow Lawn in West Long Branch in 1916, which had just been offered to President Woodrow Wilson as a summer White House. It was built on 40 acres by John A. McCall, the president of the New York Life Insurance Company, had 52 rooms, and was considered one of the most beautiful summer homes in the United States. Its grand staircase was 25 feet wide at the base. Shadow Lawn would be destroyed by fire in 1927.

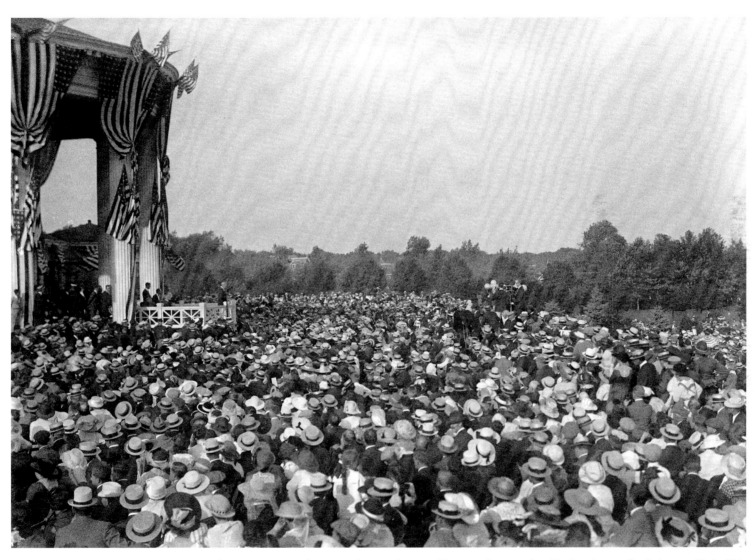

It is September 2, 1916. President Woodrow Wilson is addressing the crowd at Shadow Lawn after being notified of his nomination for a second term as president by the Democratic Party. Wilson subsequently made Shadow Lawn the base of his successful re-election campaign, frequently addressing crowds that had gathered at the estate.

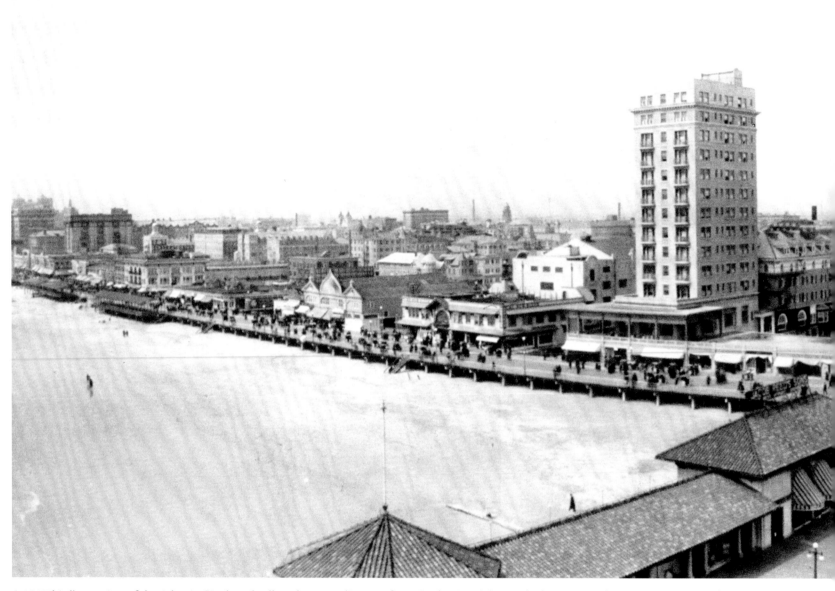

A 1917 bird's-eye view of the Atlantic City boardwalk and surrounding area from Garden Pier. The pier had just received its newest attraction the year before: a 14-ton Underwood typewriter that was 1,728 times the normal size. The typewriter's ribbon was 100 feet long and 5 inches wide.

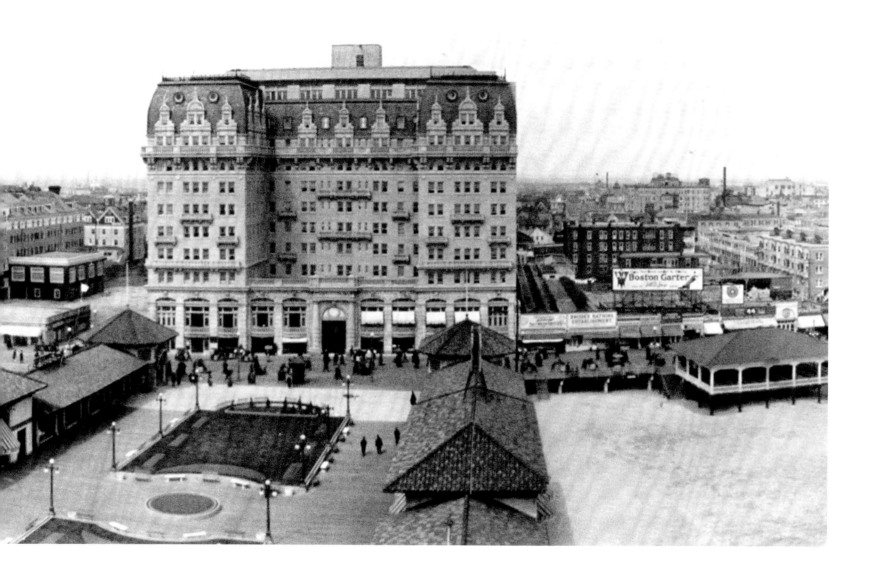

At two o'clock on the morning of July 30, 1916, an explosive roar erupted from the munitions dump on Black Tom Island in Jersey City. The explosions continued as the entire island was consumed by flame. Skyscraper windows were shattered, people thrown from their beds, and shrapnel hurled at the nearby Statue of Liberty and Ellis Island. Eventually it was discovered that German saboteurs were responsible.

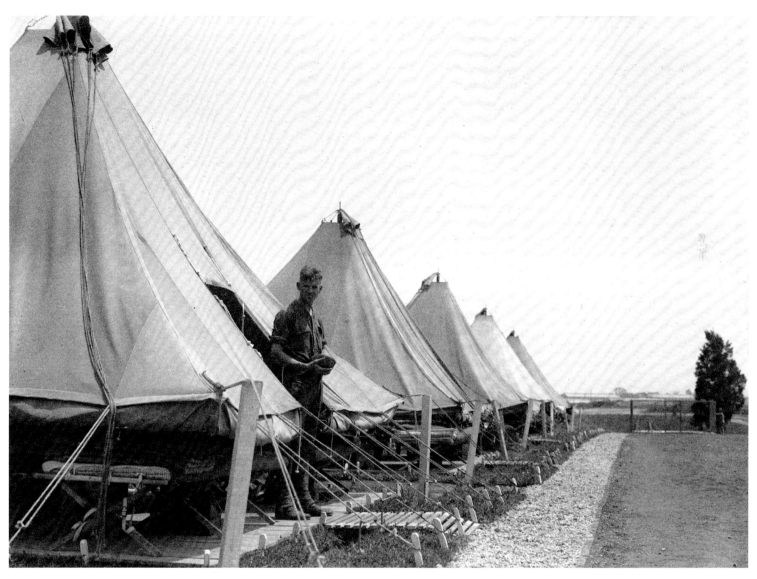

In 1917, a training and staging ground for doughboys called Camp Dix—named for War of 1812 and Civil War veteran John Adams Dix—was established in Burlington County. By 1918, the United States was playing a decisive role in the "War to End All Wars," and the camp was well on its way to becoming the largest military reservation in the northeastern United States.

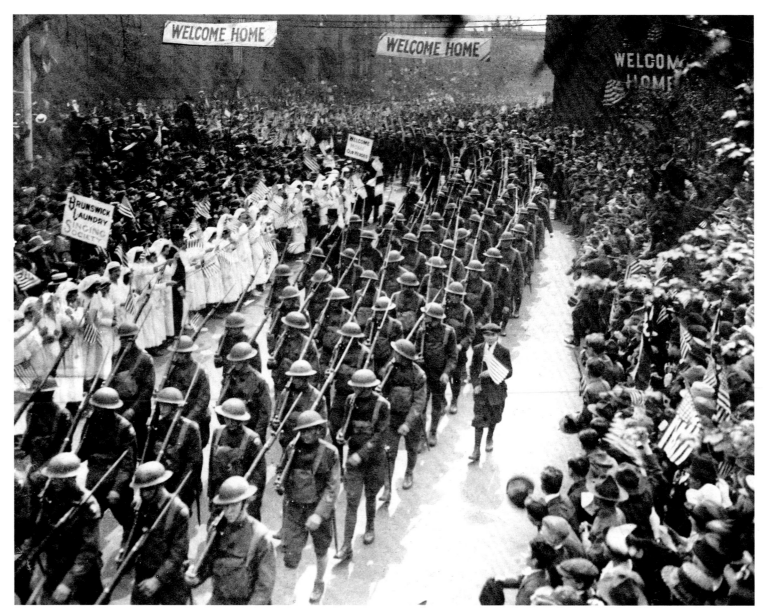

The 113th Infantry regiment marches in Jersey City on May 20, 1919, to celebrate their return from France to American soil. Five days earlier these troops had landed in New York City from the troop transport ship *Calamares* and were given such a loud and enthusiastic welcome it prompted queries from other parts of the city asking what all the noise was about.

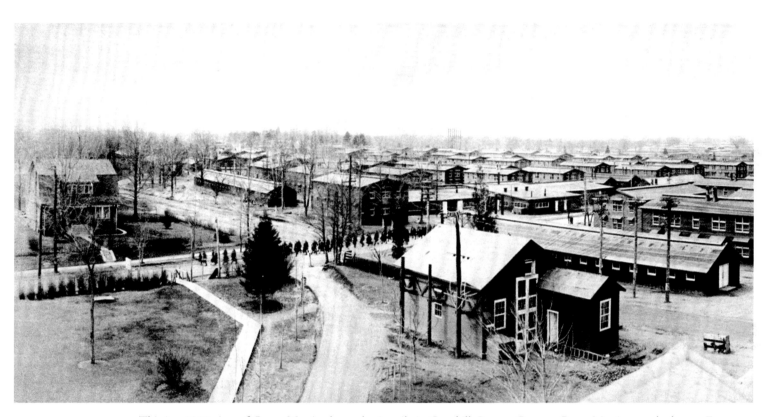

This is a 1919 view of Camp Merritt, located primarily in Cresskill, Bergen County. Camp Merritt was the largest European embarkation camp in the United States for the army during World War I. It contained 1,302 buildings spread over 770 acres. Decommissioned in 1919, the largely abandoned camp was swept by a spectacular fire in March 1921 that required fire fighters from a dozen towns to fight it.

Shown here is a bank building in Barnegat, Ocean County, during the early years of the twentieth century. Barnegat became famous during this period because it was the home of boat builder J. H. Perrine, who built the distinctive Barnegat sneak box, a boat known throughout the world. Barnegat was a popular center of commerce for the area, and boasted grocery stores, a cobbler, a coal yard, the bank, and numerous other commercial establishments.

ON A SEA OF UNCERTAINTY

(1920–1939)

When New Jerseyans came home from World War I in late 1919, they could at least recognize the state—even if a new player was rapidly taking over the game. The state's industry, superheated by war, had suffered a slight hiccup from 1919 to 1921 but then came roaring back with a vengeance. By 1926, New Jersey products ranked sixth nationally in value among all the states. The population was climbing too, surpassing the four million mark in 1930. Crowded big cities, lots of industry, and farms here, there, and everywhere—some things had not changed in New Jersey.

The one thing that had changed, and radically, was how people got around. The horseless carriage, or more commonly, the automobile, was here to stay and making as big an impact in the state as the railroad had made half a century before. Tunnels and bridges were being built at a furious pace to accommodate automobile traffic and link New Jersey by car to New York at one end and Philadelphia at the other: The Benjamin Franklin Bridge and the Holland Tunnel were only a few. Everywhere one looked these connecting arms of concrete and steel were being put into place.

In 1926, the New Jersey legislature got into the act, appropriating $300,000,000 to build a highway network in the state. In Newark in 1928, in another sign of the times, construction of the Newark Airport began. On the coast, resorts spruced up and built up, waiting for the inevitable flood of visitors.

All this cost money, but who could be worried? Successful prosecution of the war had yielded the promise of peace and prosperity without end. This was the Go-Go Twenties, and the decade roared. Until October 1929, the good times lured New Jerseyans everywhere to the party. And then the stock market crashed. Seventy-five percent of New Jersey residents lived in urban areas, and the slowdown in business and industry had a devastating effect on them.

Throughout the 1930s, New Jerseyans would float on a sea of uncertainty. Various New Deal federal programs aimed at economic recovery provided relief—for example, more than 6,000 miles of streets and highways were built in the state by Works Progress Administration workers—but there was still this nagging feeling that things were never going to be the same. By 1939, unemployment nationwide still averaged an astounding 19 percent. Then came another war, and people had to wonder, What would New Jersey be like after this one?

In 1899, department store magnate John Wanamaker established the John Wanamaker Commercial Institute Summer Camp in Island Heights. It was a free summer retreat for both male and female Wanamaker employees. Attendees, while enjoying typical summer pursuits, also wore uniforms and drilled in military fashion. The cadets—as they were called—formed a drum-and-bugle corps, as well as a 25-piece marching band, shown here serenading the locals.

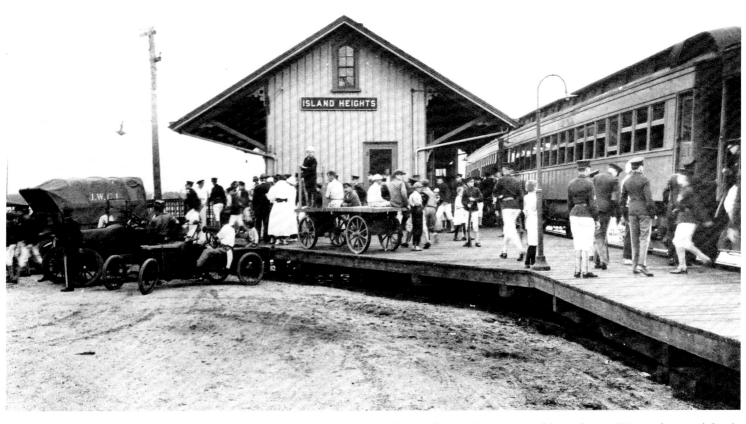

John Wanamaker's summer camp in Island Heights was intended to refresh and reinvigorate his employees (Wanamaker cared deeply about his employees' health and welfare). There, for two glorious summer weeks, young men and women who probably knew of no other life than that of the crowded city, got to frolic in the summer sun. They played baseball, football, swam, fished, fell in love, and likely wished that the train would never come to take them back.

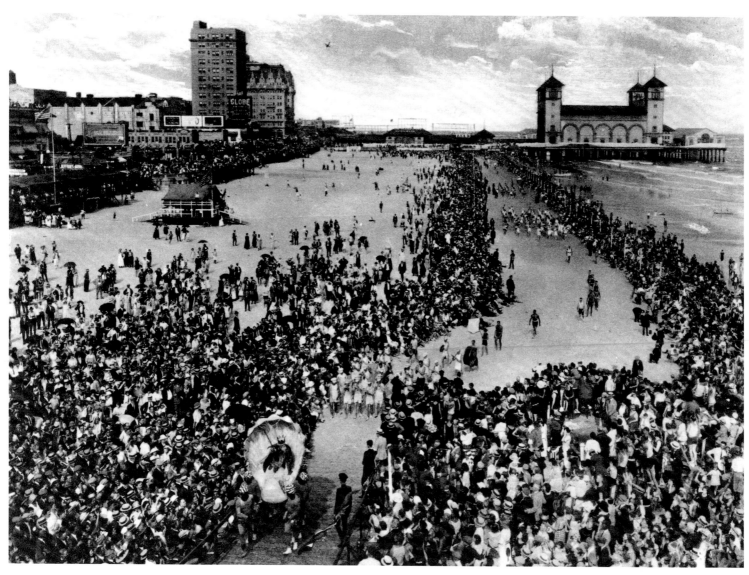

In the beginning, the Miss America Pageant wasn't the sleek, polished affair it became, but a bawdy girlie show in which anything went and usually did. The early pageants in the 1920s featured King Neptune on a clamshell, in view here at bottom-center.

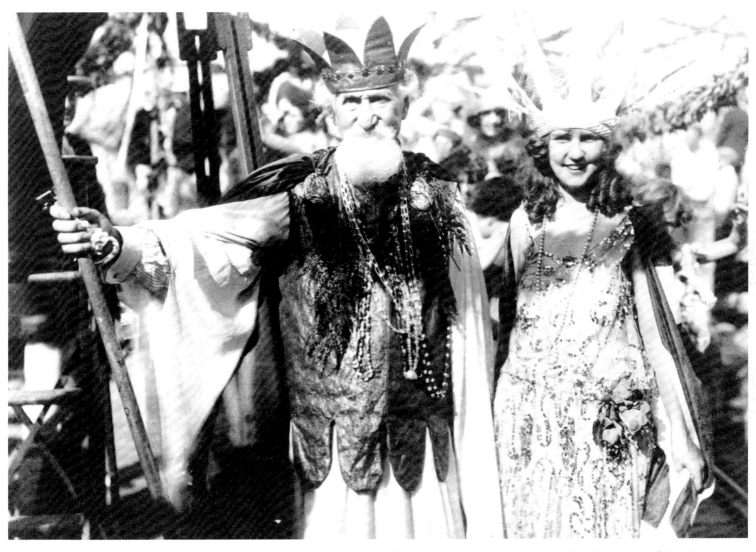

The original King Neptune, Hudson Maxim (the inventor of smokeless gunpowder) poses with the first winner of the Miss America Pageant, 16-year-old Margaret Gorman. Standing just over five feet tall, and with measurements smaller than Twiggy's, Gorman was the smallest Miss America ever. Her actual title was the far less glamorous Inter-City Beauty Contest Winner.

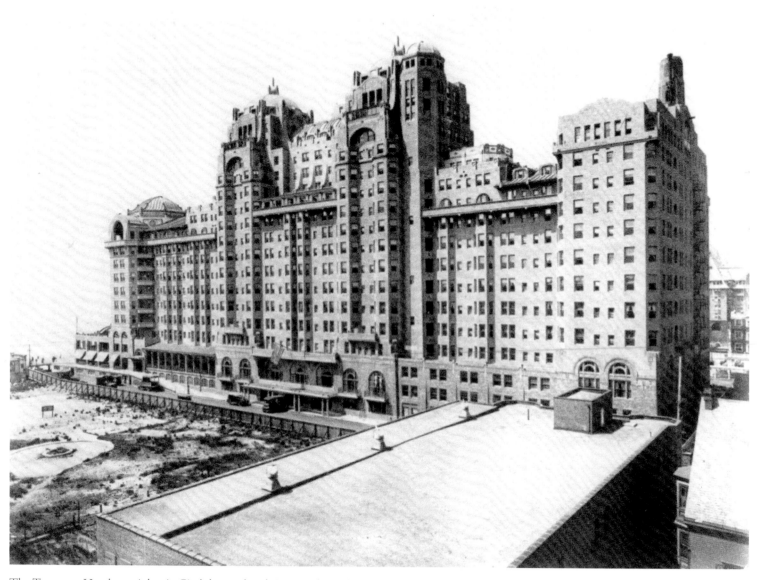

The Traymore Hotel was Atlantic City's largest hotel. It went through several incarnations, and is shown here in 1920, after its latest. Beginning right after Labor Day 1914, construction crews worked continuously to replace the old wood-framed Traymore with this massive concrete structure in time for the next season. With its tan brick finish and domes of yellow tile, the Traymore immediately became the city's architectural gem when it opened in June 1915. The Traymore would be demolished in 1972.

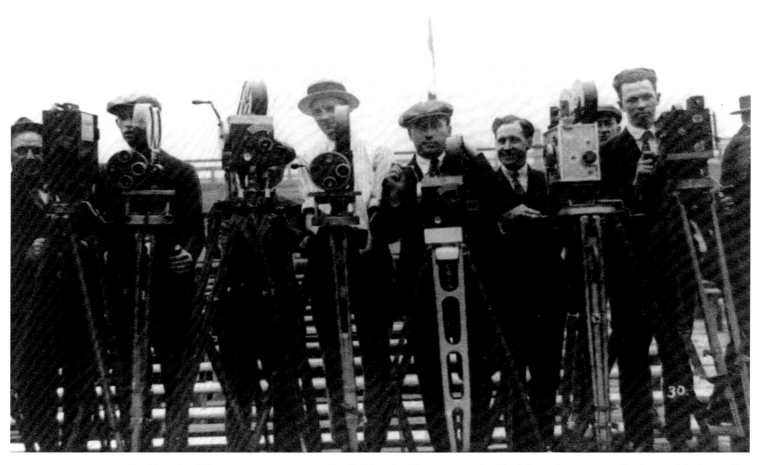

On Saturday, July 2, 1921, 90,000 people piled into hastily constructed makeshift seating on a patch of ground in Jersey City called Boyle's Thirty Acres to watch the biggest boxing match of all time: brawling Jack Dempsey versus urbane Frenchman Georges Carpentier. Held in New Jersey because New York's governor disliked professional prizefighting, the bout became the first boxing event to gross over $1 million. As these photographers recorded the contest, Dempsey slaughtered Carpentier, knocking him out in the fourth round.

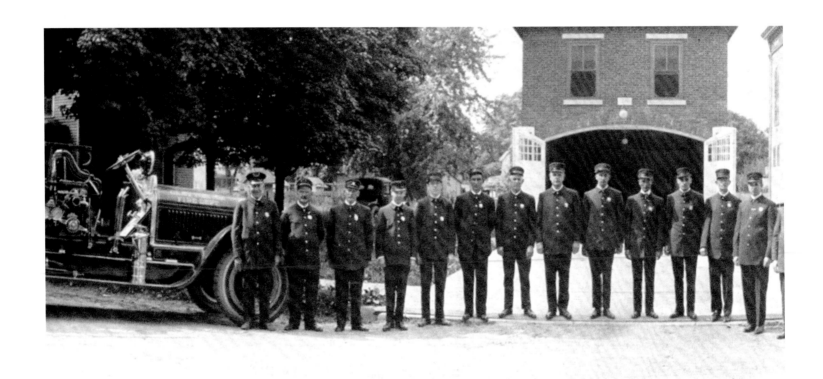

Members of the Clayton (Gloucester County) Fire Department proudly pose with a new motorized fire truck in 1920. Motorized fire-fighting equipment had begun to replace horse-drawn steam pumpers in recent years and was gaining in popularity.

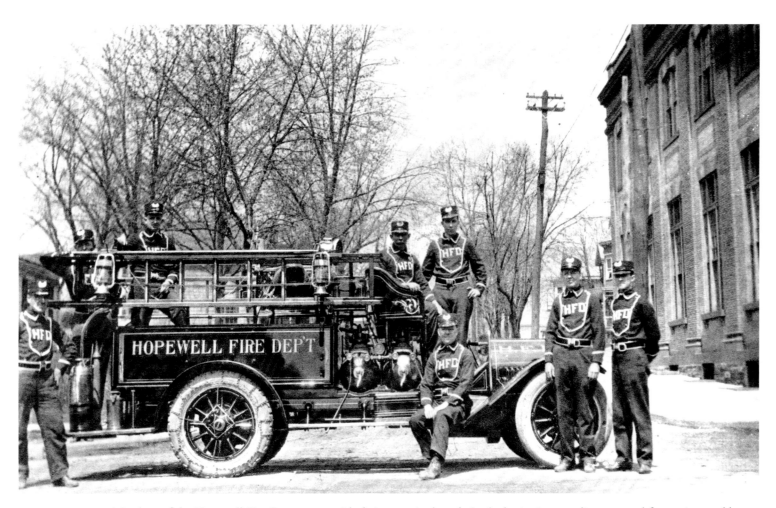

Members of the Hopewell Fire Department with their motorized truck. In the beginning, gasoline-powered fire engines and horse-drawn equipment worked alongside one another, sometimes racing each other to the site of the fire.

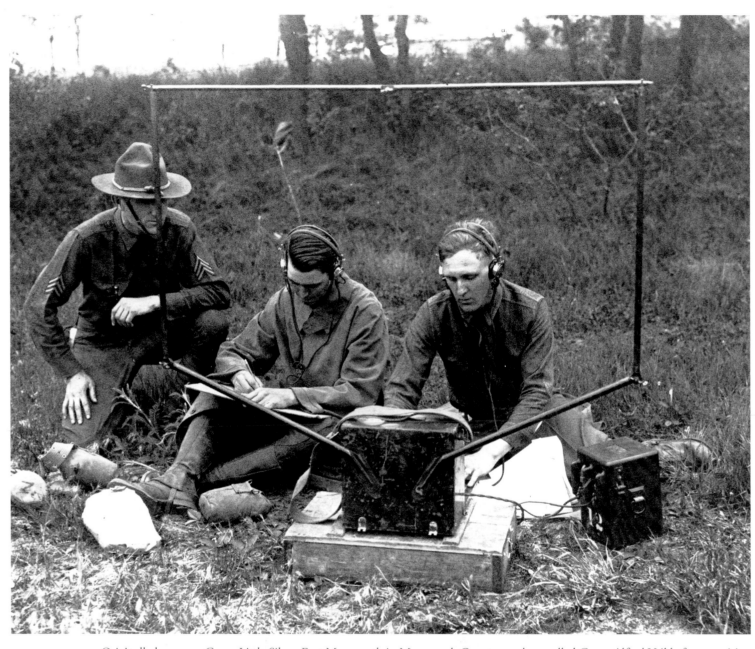

Originally known as Camp Little Silver, Fort Monmouth in Monmouth County was later called Camp Alfred Vail before acquiring its current name in 1925 in honor of the nearby pivotal Revolutionary War battle. The Signal Corps School relocated to Camp Vail in 1919 followed by the Signal Corps Board in 1924. Not far away is Twin Lights, where Marconi first proved the effectiveness of wireless communication to a doubting America, a fact no doubt appreciated by these Signal Corps men.

"Does anyone else have a ringing in their ears?" these Camp Dix soldiers might have quipped to one another. Twenty-five thousand soldiers are assembled in this photograph to form a living Liberty Bell complete with crack.

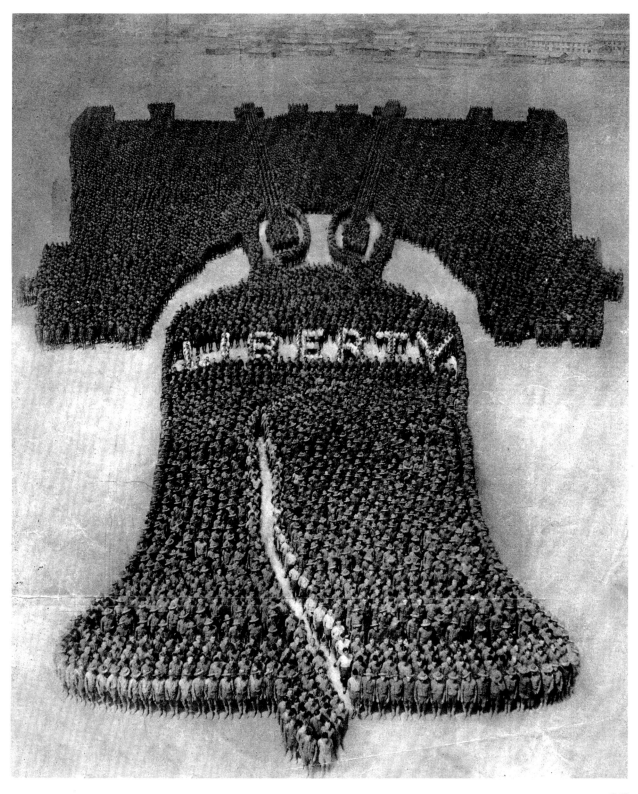

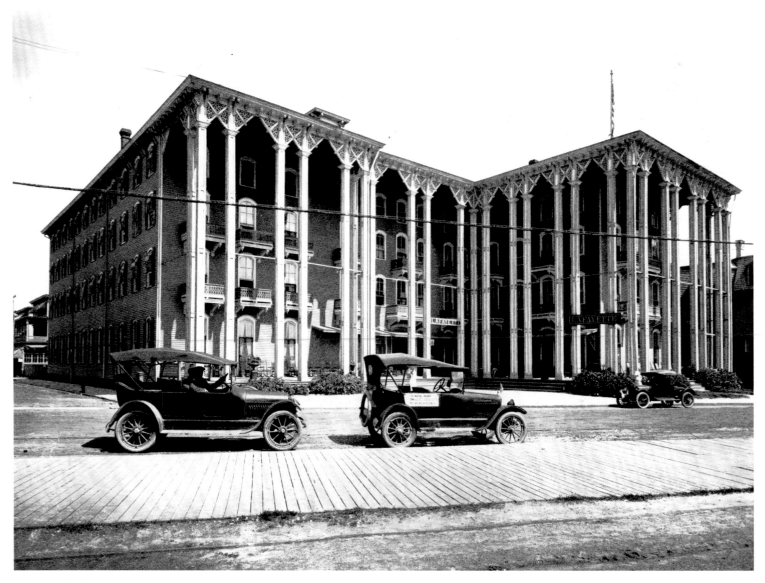

The Hotel Lafayette in Cape May was designed by Stephen Decatur Button to provide an ocean view to as many rooms as possible.
It suffered severe fire damage in the 1960s and was rebuilt on the same site and renamed the Marquis de Lafayette Hotel.

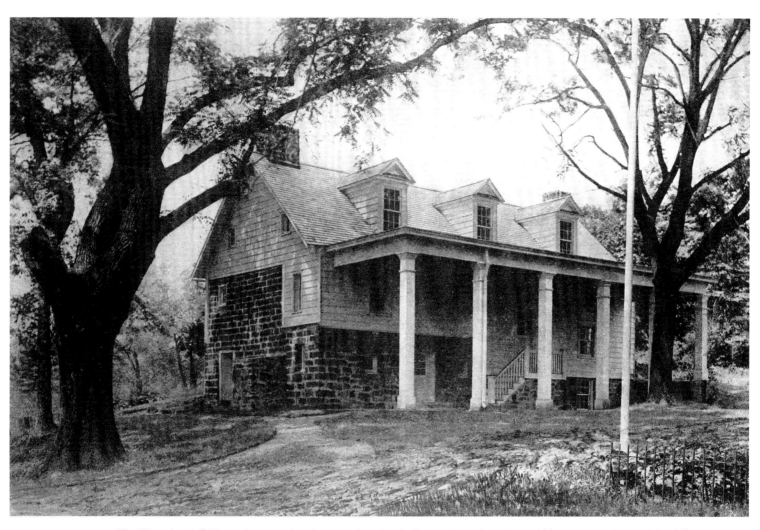

The Timothy Ball House in 1921, in what was then South Orange Township (it would become Maplewood the following year). Ball, a third cousin of George Washington, built the house in 1743. He died in 1758. While his army was stationed at nearby Morristown, Washington would sometimes come by the house to visit his relatives and observe the movements of the British Army. The house still stands today.

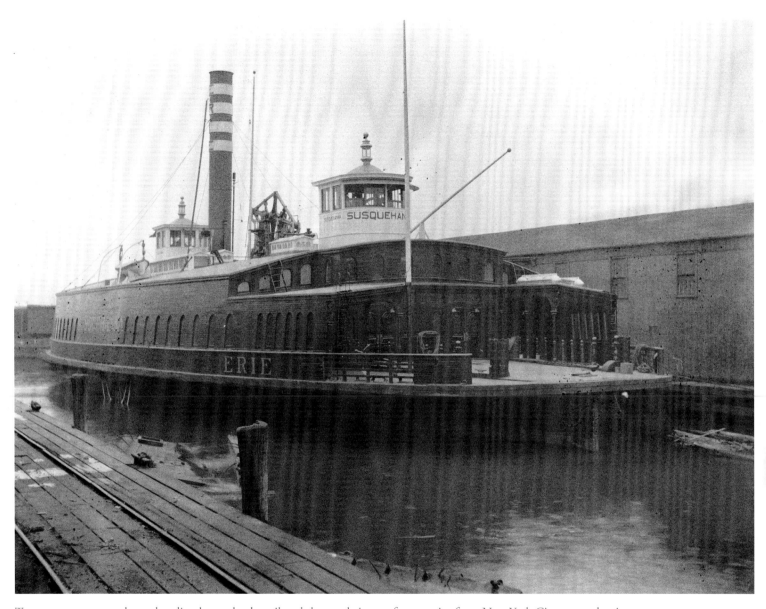

To meet passenger and merchandise demands, the railroads began their own ferry service from New York City across the river to New Jersey. By 1925, seven ferry routes crossed the river from cities like Hoboken and Weehawkin to land in Manhattan and elsewhere. The Erie Railway built a Jersey City terminal between 1886 and 1889 in the Pavonia section of the city and ran boats from there, among them the *Susquehanna,* shown here.

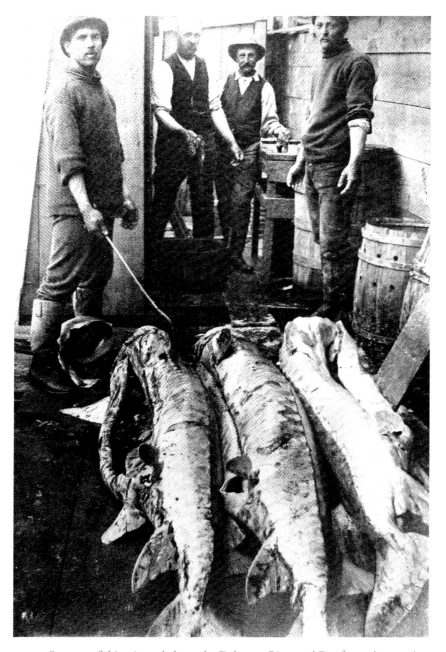

Sturgeon fishing in and about the Delaware River and Bay for caviar canning began in the 1870s. By 1877, a Cumberland County plant had become the largest caviar-maker in New Jersey, and reportedly along the East Coast. So many people fished those waters for sturgeon—like the fishermen shown here in 1923—that the species was depleted. Only 1,000 pounds of caviar were produced in 1925, sounding the death knell for canning operations.

Americans were suspicious of the claims of a young Italian named Guglielmo Marconi that he had perfected wireless communication. So Marconi erected a receiving tower on the Navesink Highlands at Twin Lights Lighthouse, established himself on a ship out at sea, and for several days broadcast events from there, proving that radio was truly feasible. By 1923, radio had become well-established in American lives, including such innovations as the makeshift antenna.

These youngsters are shown working in Newark in 1923. In 1931, it was reported by the U.S. Department of Labor's Children's Bureau that 25 percent of youth ages 14-15 in Newark were at work, helping families make ends meet as the Great Depression worsened.

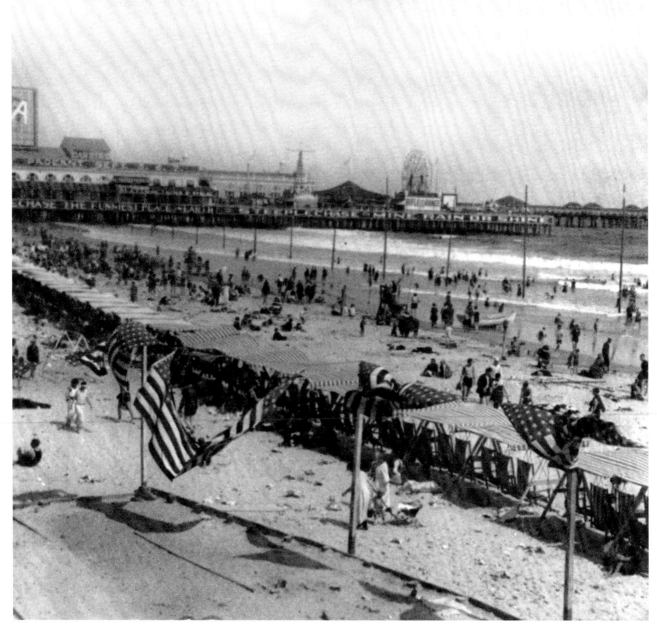

Atlantic City, seen here in 1924, was kept crowded by trumpeting the resort's beneficial health effects. As one brochure stated: "There is here . . . an unseen, indescribable something, in the air or in the sea, on the sands . . . which acts as a tonic, invigorating alike to the old and to the young, to the feeble and the strong, which robs idleness of its ennui and makes it rest indeed."

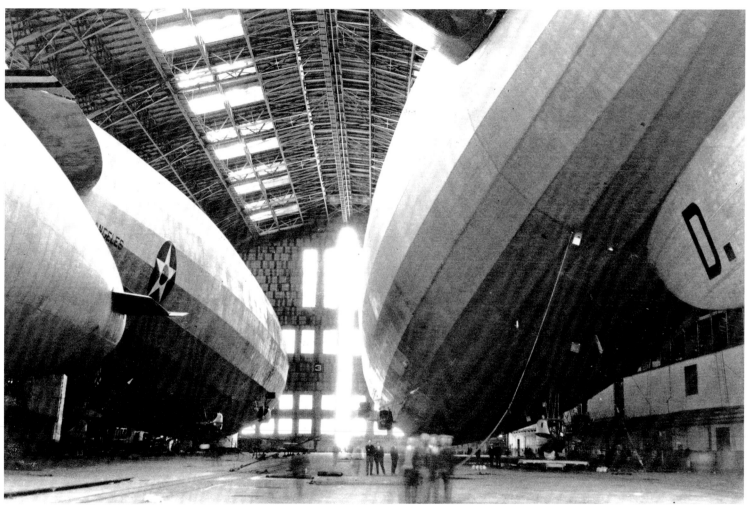

Two airships—the *Graf Zeppelin* and the *Los Angeles*—are shown housed together in a hangar at Lakehurst Naval Air Station. The *Graf Zeppelin* was the most successful airship ever built, flying more than a million miles and carrying 34,000 passengers without injury. The *Los Angeles* was the most successful of the U.S. Navy's rigid airships.

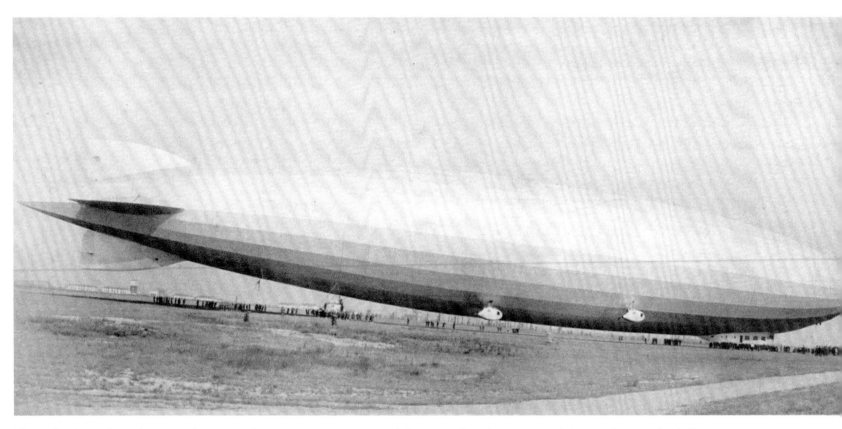

The airship ZR-3, better known as the *Los Angeles,* enters Hangar No. 1 at Lakehurst Naval Air Station in 1924. Longer than two football fields, at 656 feet the ZR-3 would safely log more than 170,000 nautical miles before its final decommissioning in 1939. The airship's hangar was also impressive. Each of its four massive doors weighed 1,350 tons, was 136 feet in width, and 177 feet in height.

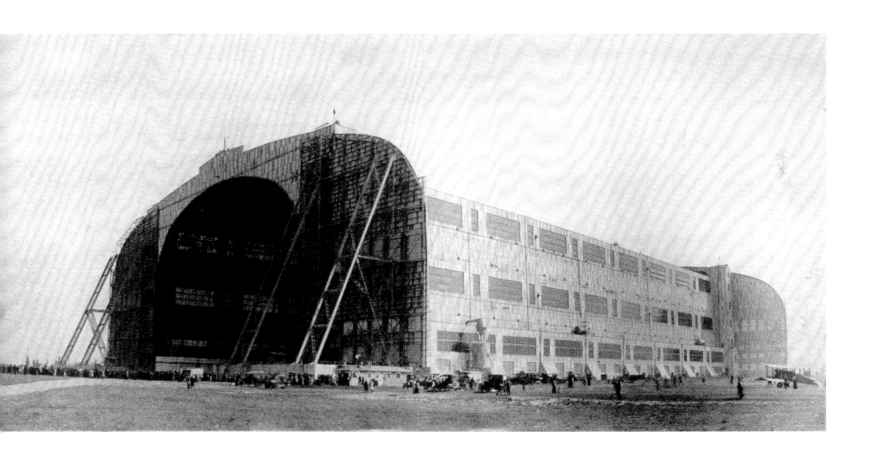

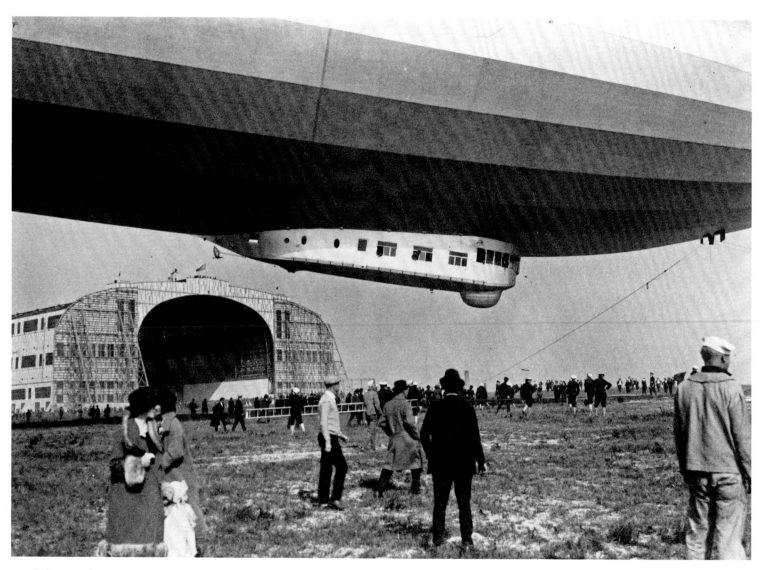

Funded in part by war reparations following World War I, the ZR-3 was built in 1923-24 by Germany and given to the United States. In 1927, atmospheric conditions at Lakehurst would cause the tail of the moored ship to rise until the craft was at an incredible 85-degree angle—nearly perpendicular to the ground! Fortunately, it suffered little damage. The *Hindenburg*, the largest aircraft ever to fly, would not be so fortunate. While trying to land at Lakehurst in 1937, it caught fire and exploded into flames, killing 35 people aboard and sparking the end of air travel by dirigible.

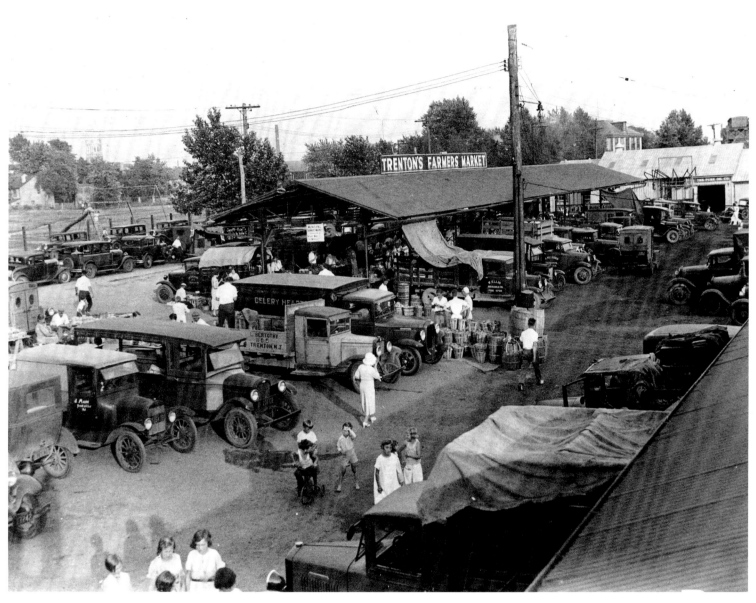

The Trenton Farmers' Market has been in existence since the early 1900s, when farmers would travel by horse and buggy into the city to sell their produce along what is now Route 29. In 1939, the farmers incorporated into the Trenton Market Growers Co-op Association. The market moved in 1948 to a new indoor facility on Spruce Street with overhead doors that could be opened when weather permitted so that the market could keep its outdoor character. The market still exists today, as full of choices now as it was then.

James A. Garfield was among a group of American presidents in the second half of the nineteenth century who found the coastal town of Long Branch a pleasant place to vacation. After being shot in 1881, Garfield was brought to the house shown above, in the Elberon section of Long Branch, in the hope that the shore air would help him recuperate. Unfortunately, he died in Elberon on September 19.

This Newark piano studio was the receiving point in 1927 of "the first public demonstration of synchronized sight and sound (talking moving pictures) being transmitted over radio without the use of land wires." In other words, television. The transmissions originated from Jersey City and Passaic.

This is the Morris Canal, which became nationally famous upon its completion in 1831 because it was the first man-made waterway in the United States to use the inclined plane. In its peak year of operation (1886), the canal transported 459,775 tons of coal and 290,165 tons of iron ore. By the early twentieth century, the railroads had made the canal obsolete.

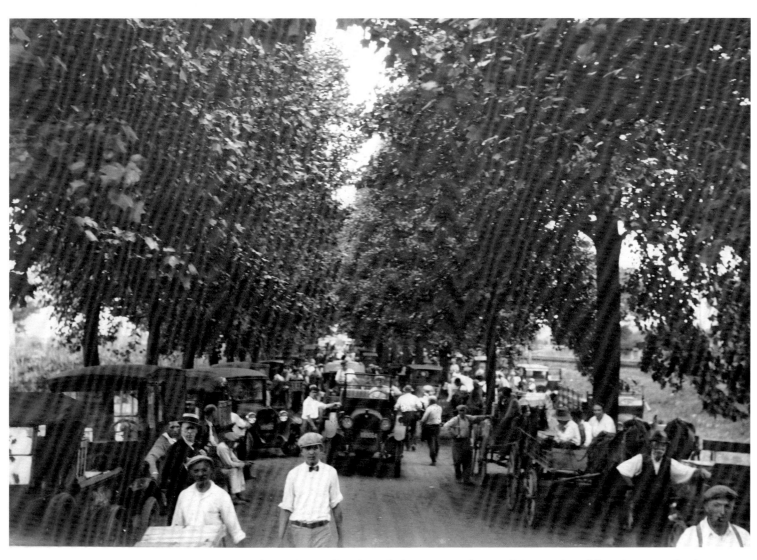

Hammonton in Atlantic County has always had a strong produce tradition, as these folks going to market in 1927 are demonstrating. Indeed, today Hammonton is known as "the Blueberry Capital of the World."

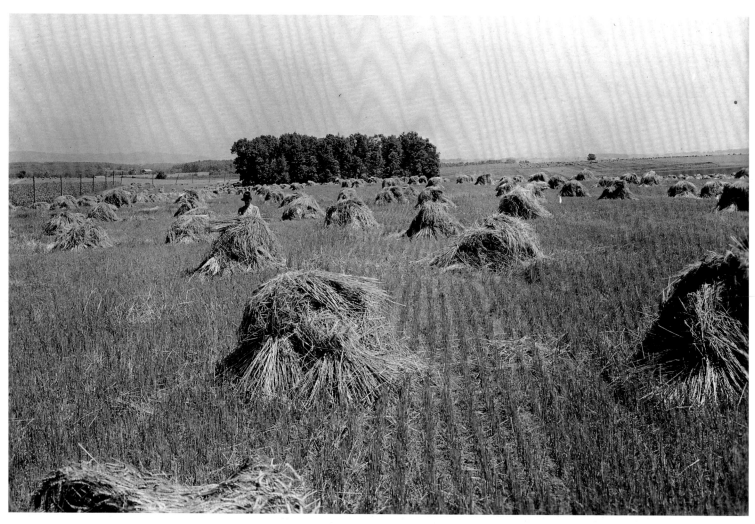

New Jersey is sharply divided into two growing regions: the north (New Brunswick and northward) and the south (from Trenton south), which lend themselves to diversification. Most of the pure alfalfa, for example, is grown in the south. In view here are shocks of wheat, gathered and bound and ready for threshing, a mechanical process for separating the grain from the straw relied on in the nineteenth and early twentieth centuries.

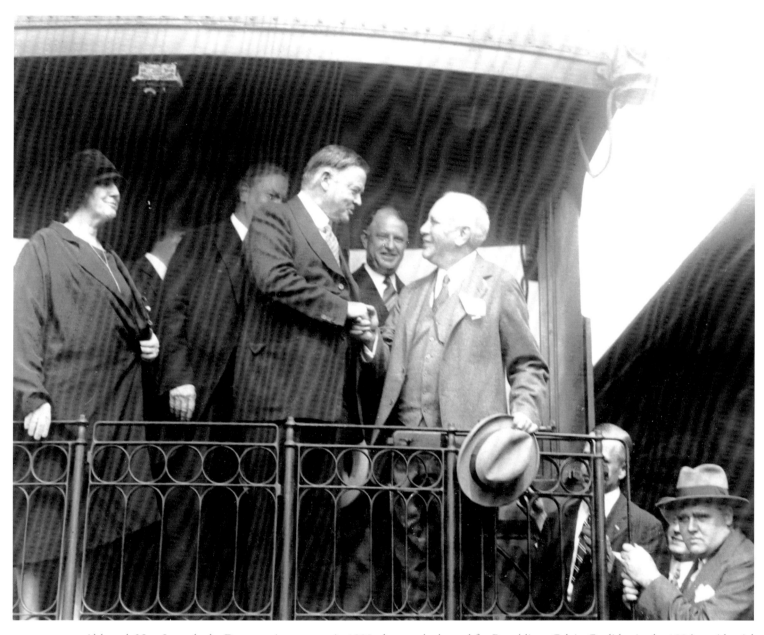

Although New Jersey had a Democratic governor in 1928, the state had voted for Republican Calvin Coolidge in the 1924 presidential election. So Herbert Hoover, the Republican candidate for president in 1928, probably felt there was reason for campaigning in Newark that year. Hoover is shown shaking hands with other dignitaries from the observation platform of a passenger train.

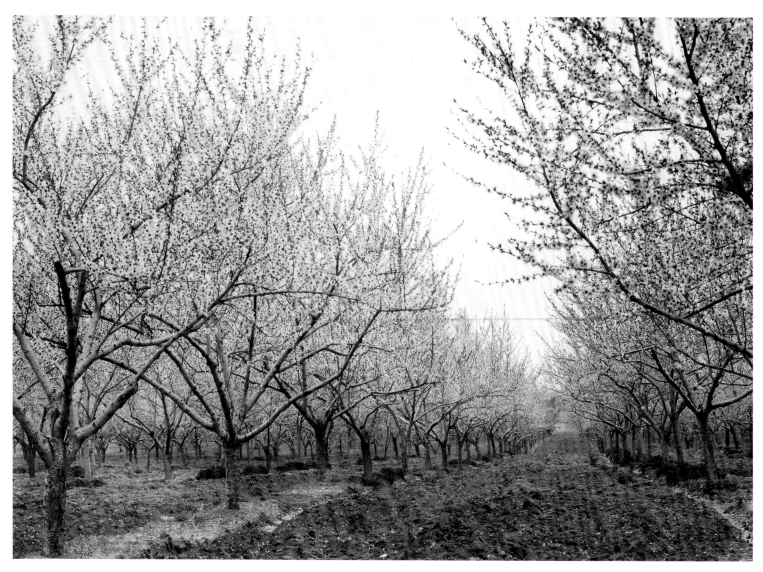

World-famous Jersey peaches begin with peach trees in blossom. Peach orchards were planted in New Jersey in the early 1600s. It was quickly discovered that the fruit thrived in this soil and climate. By the latter nineteenth century, the peach industry had reached its zenith in New Jersey, with more than four million trees in the state under cultivation.

When Walt Whitman bought this house on Mickle Street in Camden near the end of his life, he didn't much care for it, calling it a "shanty." With his flowing white hair and long white beard, Whitman made an interesting impression on the streets of the city.

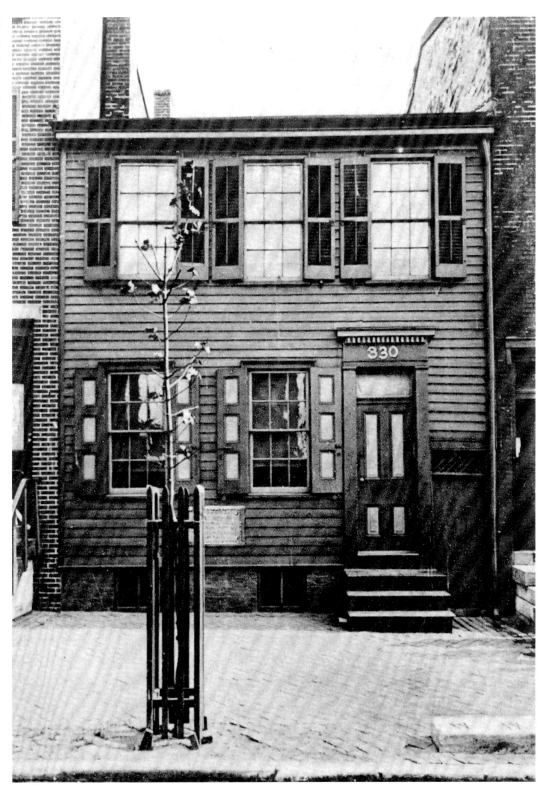

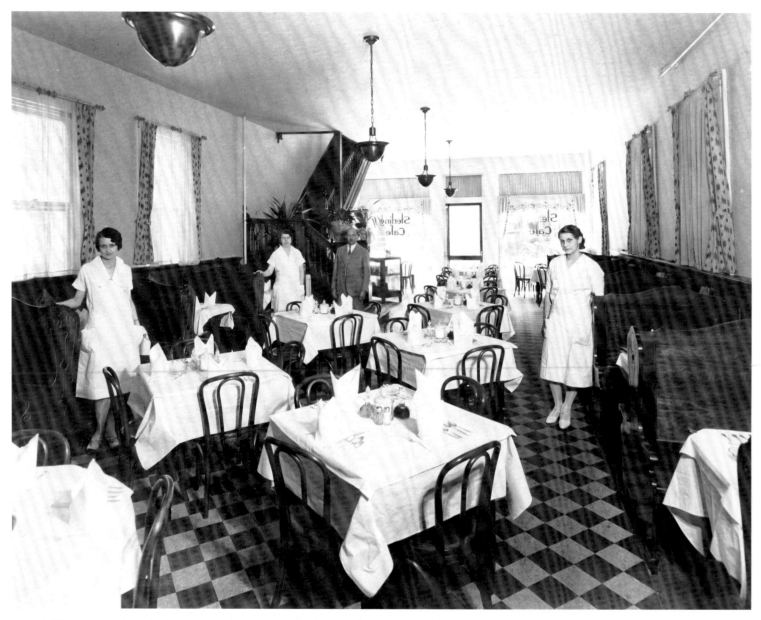

Founded by a group of Methodist ministers in 1879 on a piece of land formerly known as Peck's Beach, Ocean Beach had a ban in place on the sale of alcohol within city limits, a ban that remains in effect today. Here employees at the Sterling Cafe await mealtime crowds, surrounded by cozy wooden booths and fresh table linens.

At a section of Trenton known as the Five Points, Colonial troops placed their artillery during the Battle of Trenton in the American Revolution. These guns dominated the city, preventing Hessian troops from counterattacking American forces. Today this critical battle of the war is commemorated by this 150-foot-tall monument in Trenton, which includes a 13-foot-tall figure of George Washington at the top.

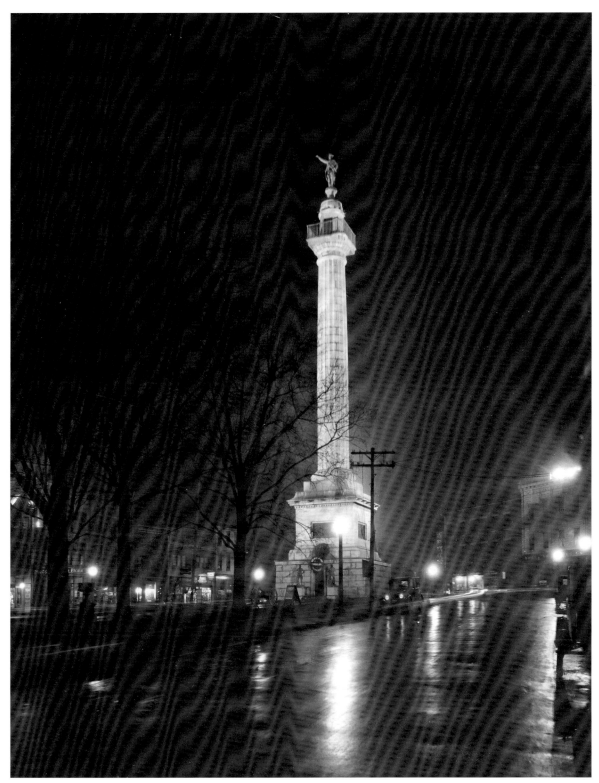

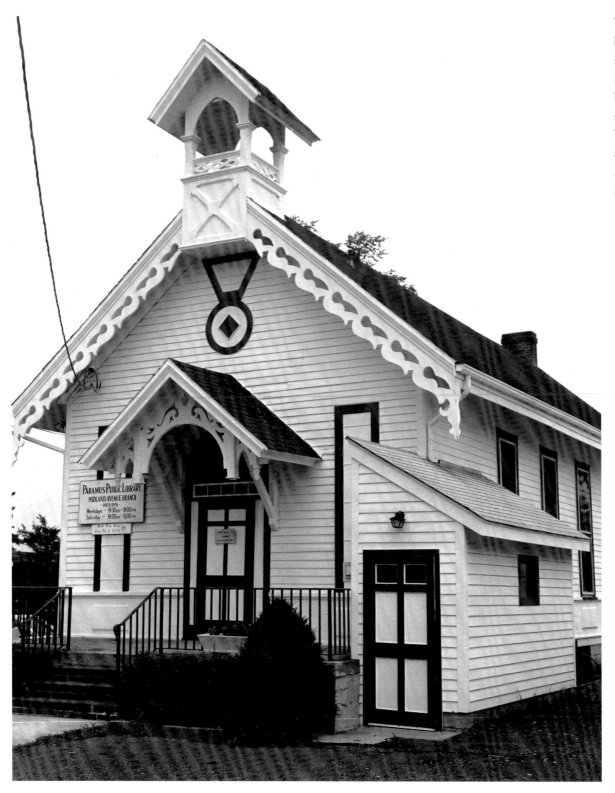

This building is the oldest building in Paramus. Built in 1876, it has served Paramus as a schoolhouse, borough hall, police station, and public library. Today it is still going strong and serves as the Charles E. Reid branch of the city's main public library.

120

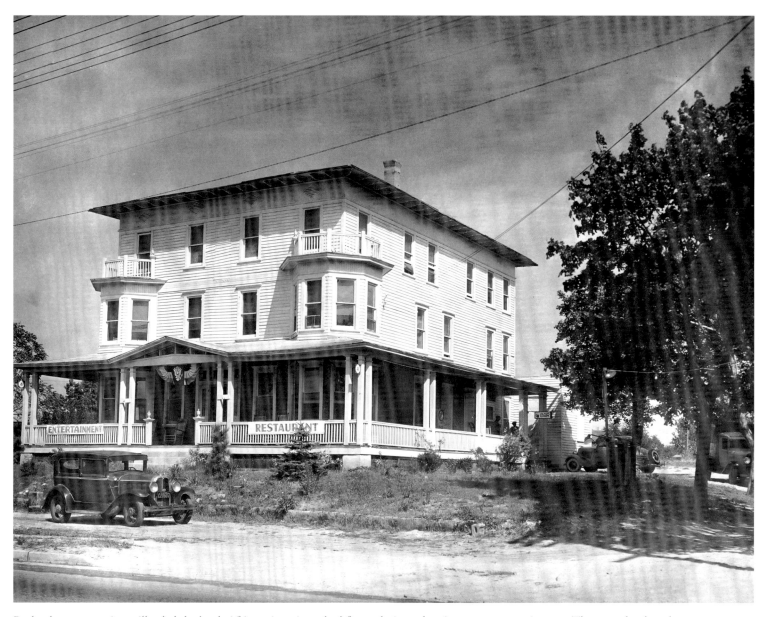

Back when segregation still ruled the land, African-Americans had fewer choices when it came to entertainment. Thus was developed Lawnside Park in Lawnside, Camden County (the state's oldest incorporated African-American township)—an entertainment area for African-Americans that included swimming pools, an amusement park, restaurants, and nightclubs.

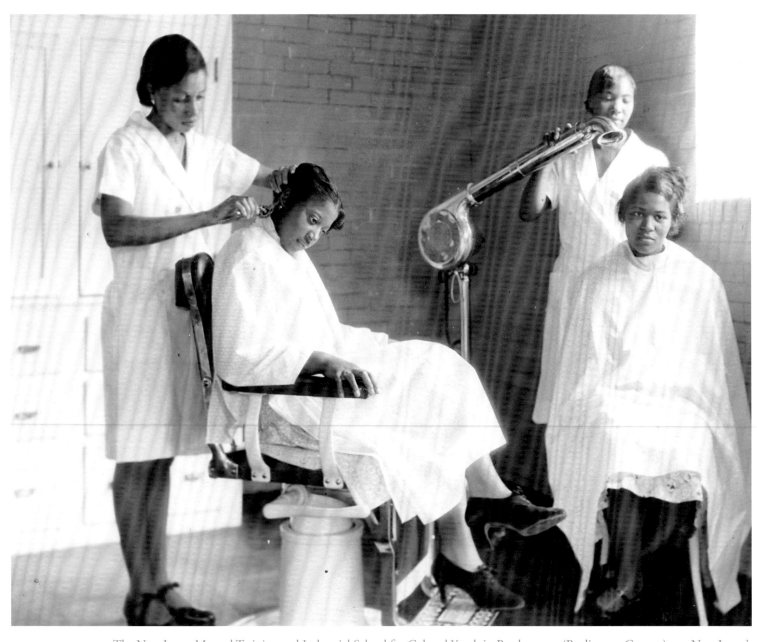

The New Jersey Manual Training and Industrial School for Colored Youth in Bordentown (Burlington County) was New Jersey's co-educational vocational school for African-Americans from 1894 to 1955. A student had to complete the academic curriculum and master a particular trade—such as beauty and hair care, as these students are doing—in order to be eligible to graduate.

Together, both the students and staff of the New Jersey Manual Training and Industrial School for Colored Youth operated the entire school facility, which eventually encompassed a 400-acre campus that included two working farms and more than 30 buildings. Many of the school's staff resided on the facility's campus and participated in activities with the students.

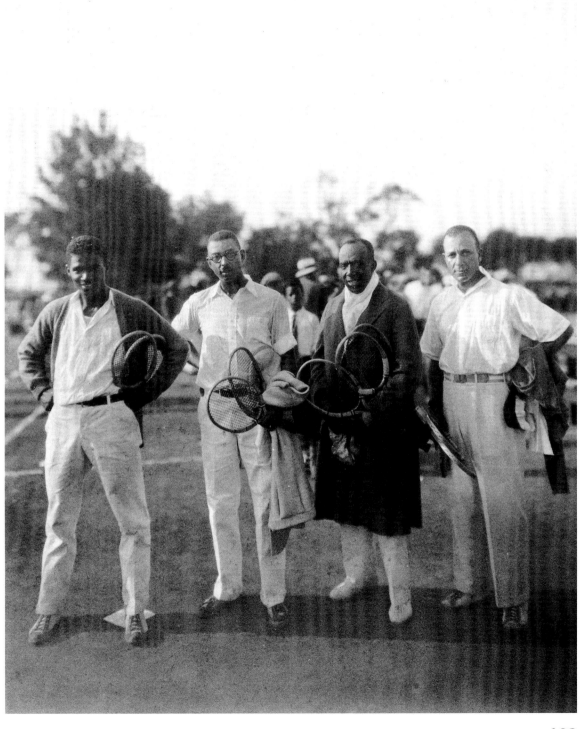

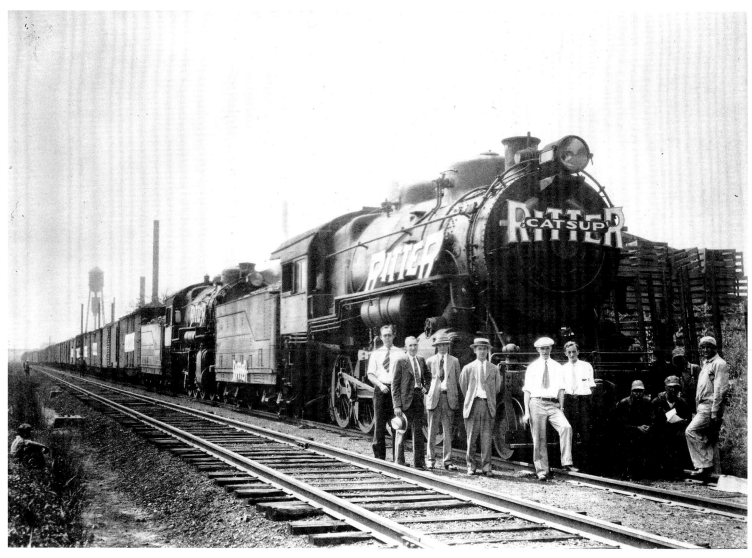

At one point, the P. J. Ritter Company of Bridgeton in Cumberland County offered 240 different canned food items for sale. With so much inventory in need of transport, trains provided the obvious logistical answer.

Opposite: One of the reasons that Ocean City was—and still is—America's Favorite Family Resort is that they had, and continue to have, many great restaurants. Hand-lettered signage advertises this favorite eatery of bygone days, the Creole Donut and Waffle Shop on the boardwalk.

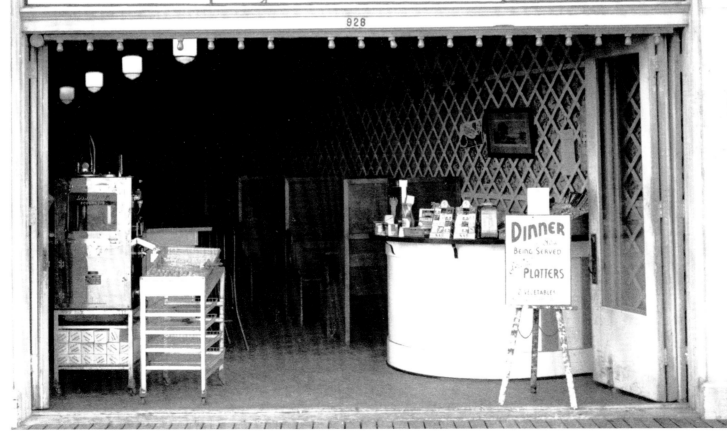

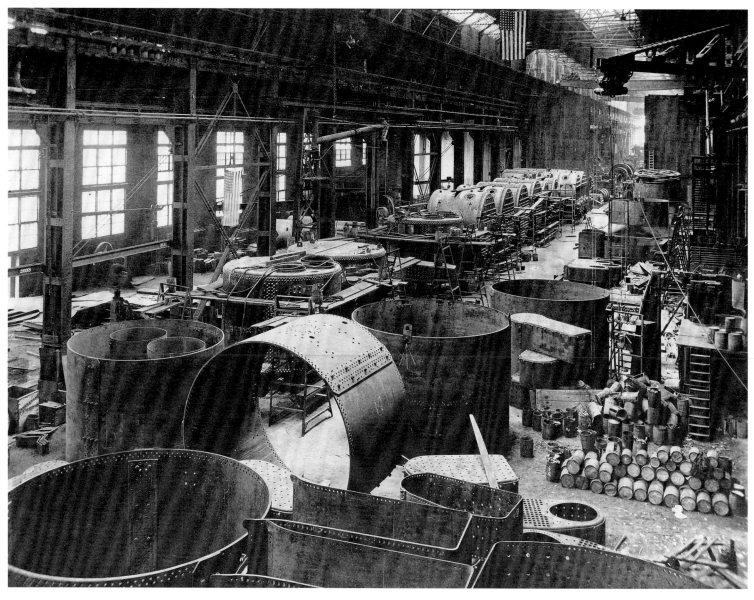

Camden was a leading shipbuilding center in the first half of the twentieth century. The center of it all was the New York Shipbuilding Company, a massive complex spread over 100 acres in South Camden that at one point employed 47,000 people. Here is just one of their enormous facilities.

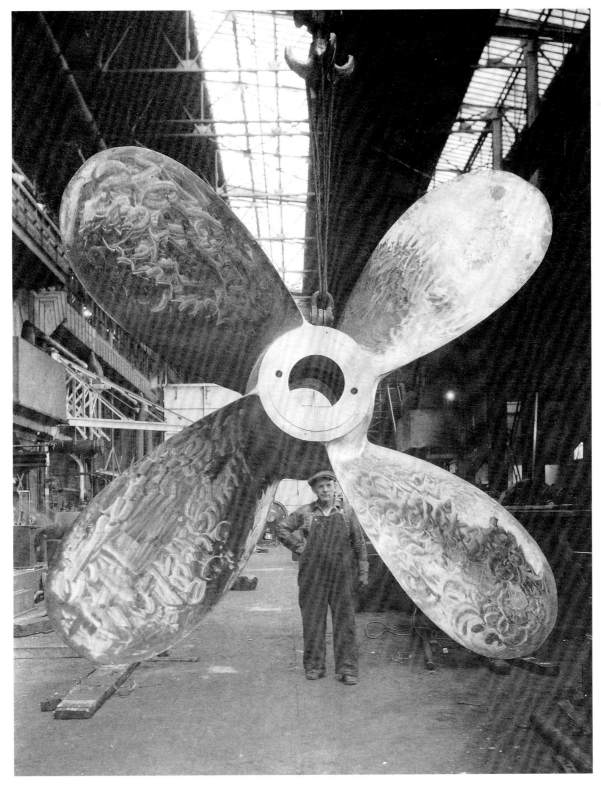

The New York Shipbuilding Company produced a staggering variety of ships, from fireboats to riverboats to steamships and massive military ships, such as the 15,712-ton U.S. Navy cruiser *Washington,* the battleship *Moreno* for Argentina, and even a cruiser for China called the *FEI-hung.*

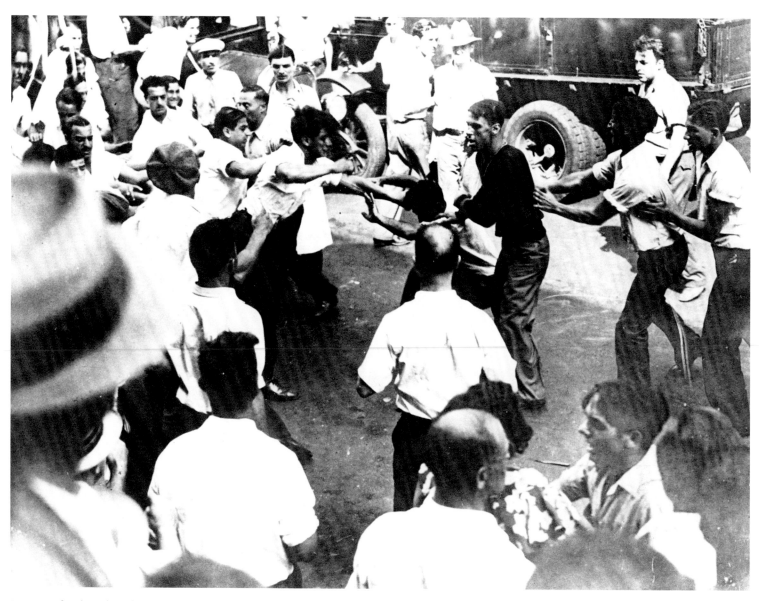

Because of its heavily industrial character, Paterson was always at the forefront of labor movements, unions, strikes, and the like. In the autumn of 1934, a textile workers strike involved 400,000 people in many areas, from New England to the South, including Paterson.

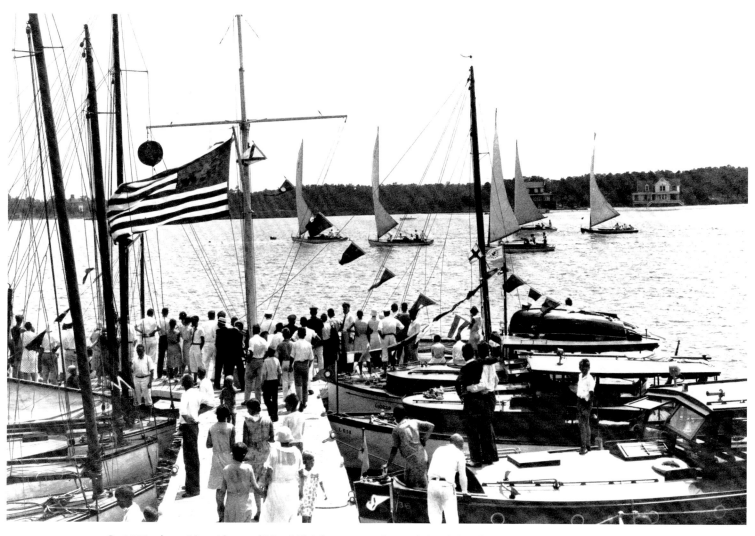

In 1898, about 30 residents of Island Heights got together and decided to form a yacht club. The entrance fee for races was set at fifty cents. Race spectators would sometimes watch the contest from specially chartered railroad cars. The club is still in existence today, and has gained a reputation for organizing and managing national and international regattas.

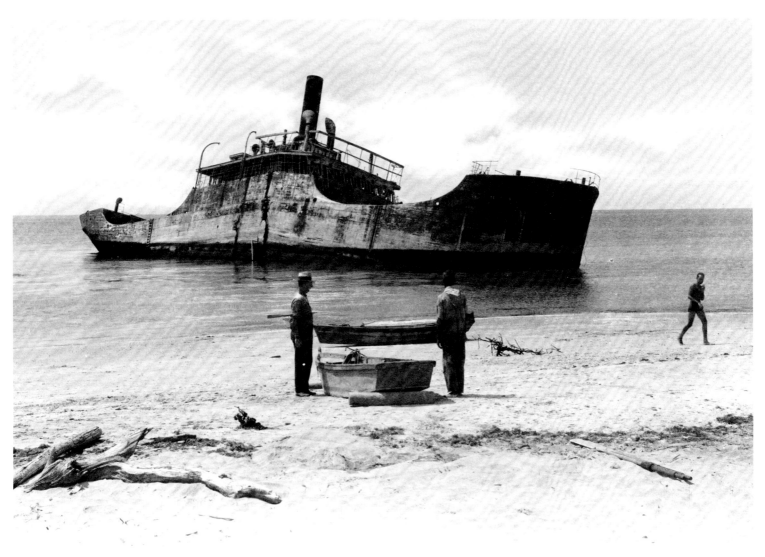

The concrete ship *Atlantus* was built because of a shortage of steel during World War I. Proving as adept in the water as—well, concrete—the *Atlantus* was towed to Cape May in 1926 to form the base of a pier. But the ship snapped its moorings during a storm, wandered out into the water, and stopped. There it remains to this day, only a bit of it still visible as it gradually sinks into the sand.

If two heads are indeed better than one, then all these heads must be outstanding in their field. But seriously, lettuce has never been a leading New Jersey crop.

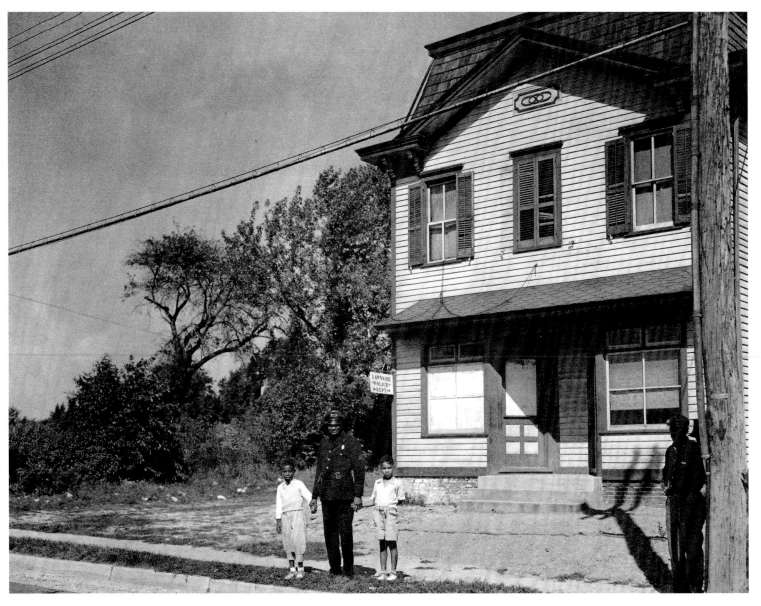

In March 1926, a bill was signed in Trenton incorporating the Borough of Lawnside in Camden County. One month later, Lawnside became the first independent and self-governing African-American community north of the Mason-Dixon Line, as these proud residents were undoubtedly aware.

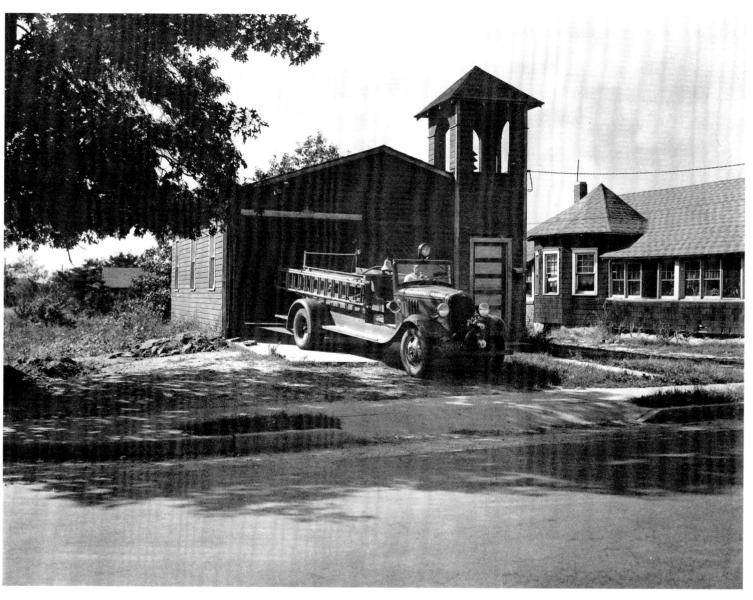

Lawnside was a place where African-Americans could do anything and be anything, such as fire fighters.

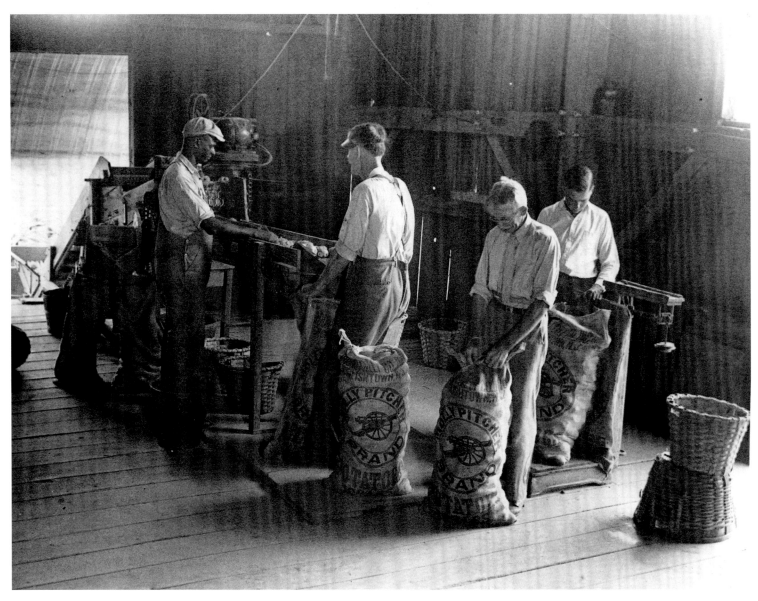

Workers at a Hightstown farm package potatoes around the 1930s. A potato-growing cooperative was tried at Hightstown a few years earlier, but was unsuccessful.

Mechanization replaced horsepower on New Jersey farms as the twentieth century progressed. The time and labor the farmer saved, however, was offset by higher equipment costs. By the 1970s, the high costs of equipment, land, fuel, and pesticides across the nation forced those who could to begin farming more acreage, and those who could not to rent their acreage or consider selling the family farm.

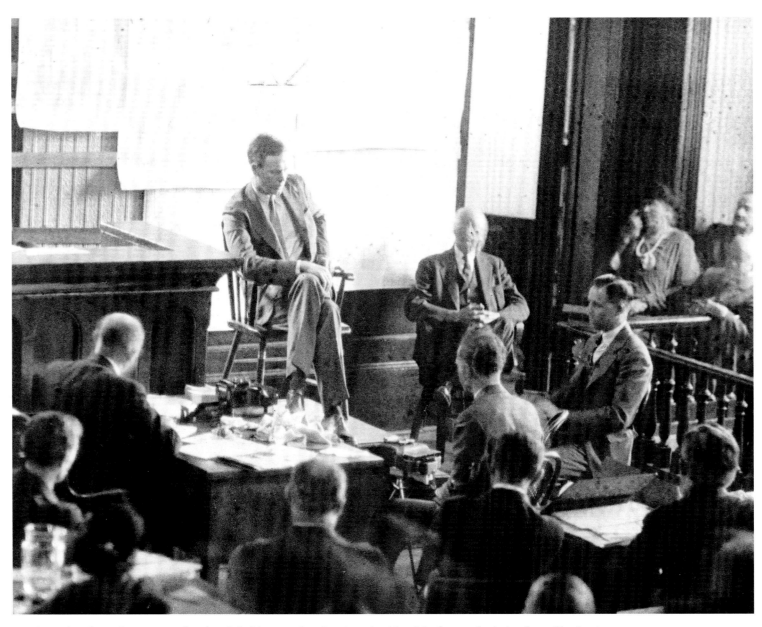

On the night of March 1, 1932, a handmade ladder was placed against the side of the home of aviation hero Charles A. Lindbergh and his wife Anne in the Sourland hills near Hopewell. A person climbed into the nursery of their baby, Charles Lindbergh, Jr., and abducted him for ransom. Although the ransom was delivered, the infant was not returned. His remains would be discovered sometime later in a woods not far from the home. On January 1, 1935, Bruno Richard Hauptmann was put on trial in Flemington for the crime. Here Charles Lindbergh testifies at the trial.

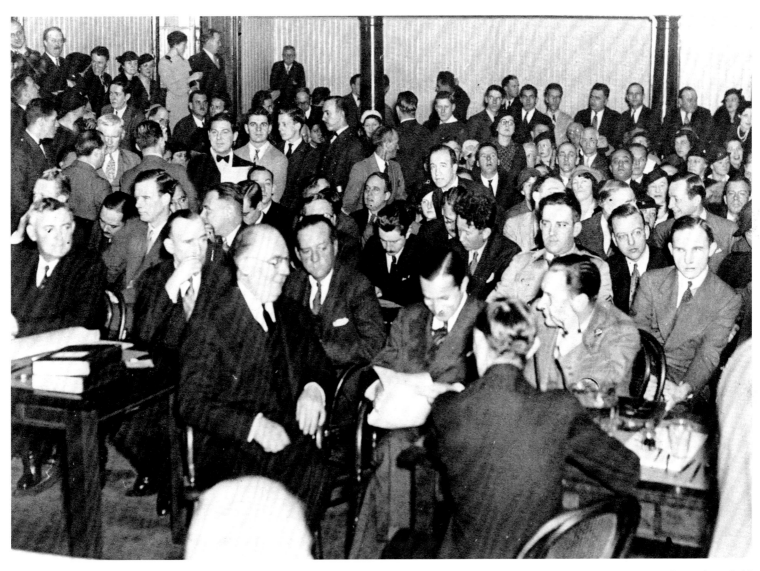

Writer H. L. Mencken called the Lindbergh Baby kidnapping and trial "the biggest story since the Resurrection." The trial was held in Flemington, and quickly all of the available hotel rooms in town were snatched up as everybody tried to attend the sensational trial, leading to the overflowing courtroom shown here.

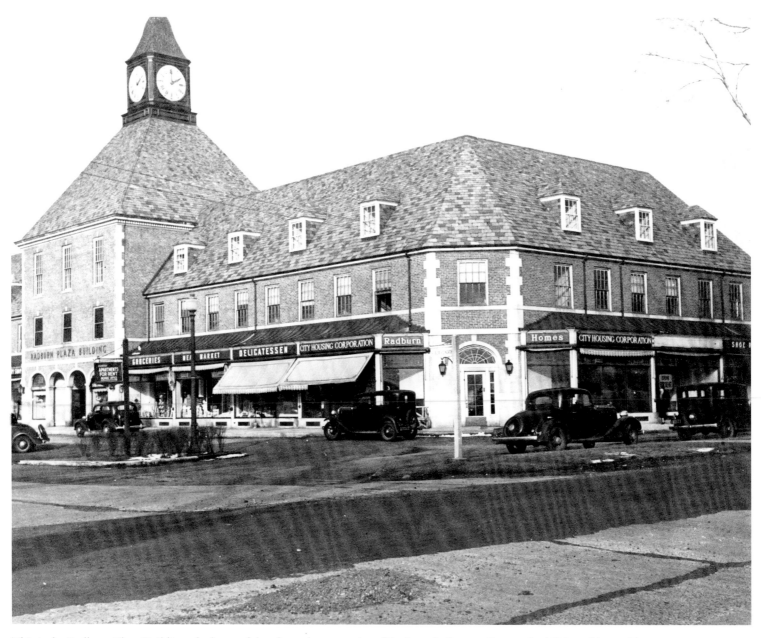

This is the Radburn Plaza Building, the heart of the planned community of Radburn in Bergen County. In 1928, architects Clarence Stein and Henry Wright announced plans for a "town for the motor age" that would separate pedestrian and vehicular traffic. The sour economy of the Great Depression caused Radburn's builder to go bankrupt before completing the town, leaving it a smaller community than originally conceived.

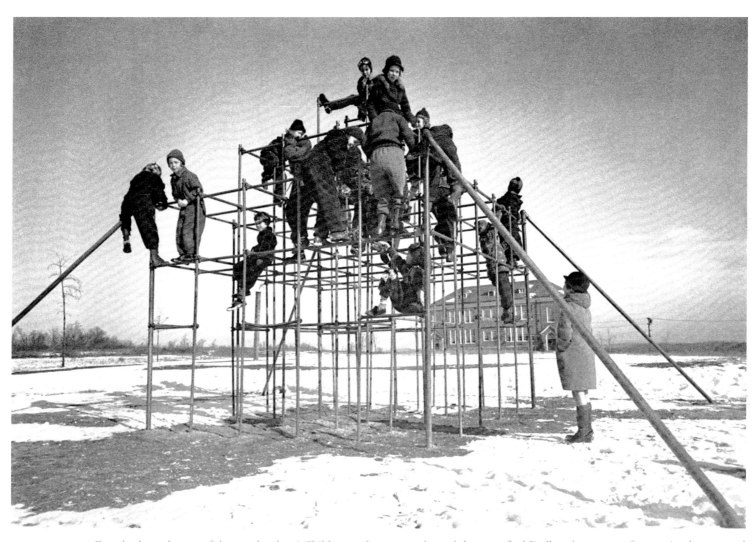

Everybody to the top of the monkey bars! Children perhaps more than adults must find Radburn's concept of separating human and motorized traffic enjoyable, since the town's core Green Area allows them to play without having to constantly stop for passing cars.

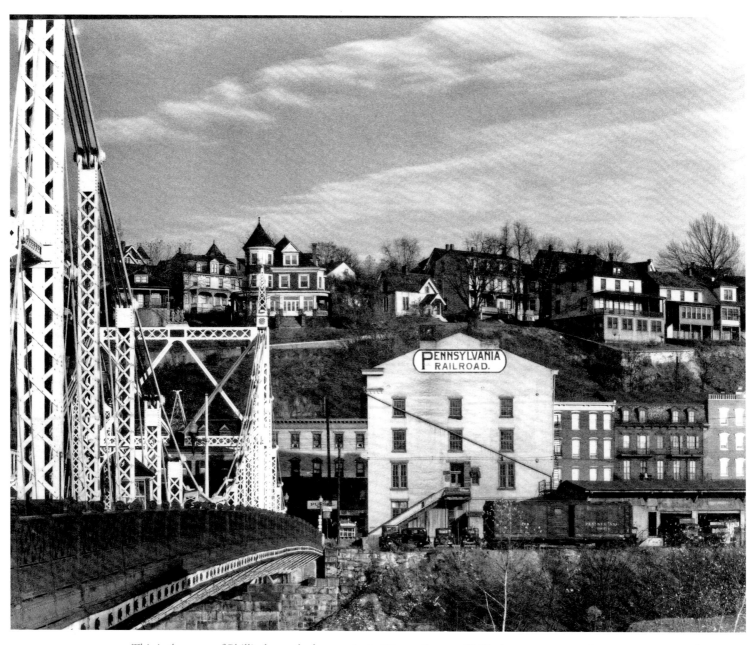

This is the town of Phillipsburg, the largest city in Warren County. Phillipsburg was once an important transportation center and was served by five railroads, including the Central Railroad of New Jersey. The town is just across the state line from Easton, Pennsylvania—home of the "Easton Assassin," heavyweight boxing champion Larry Holmes.

This is historic Trinity Cathedral Church in downtown Newark. The site of the church is on the north end of the training ground, now Military Park. The original church, built in the 1740s, was destroyed by fire in 1804 and rebuilt. Its landmark white steeple is 168 feet tall. In 1966, the church was united with St. Philip's Episcopal Church.

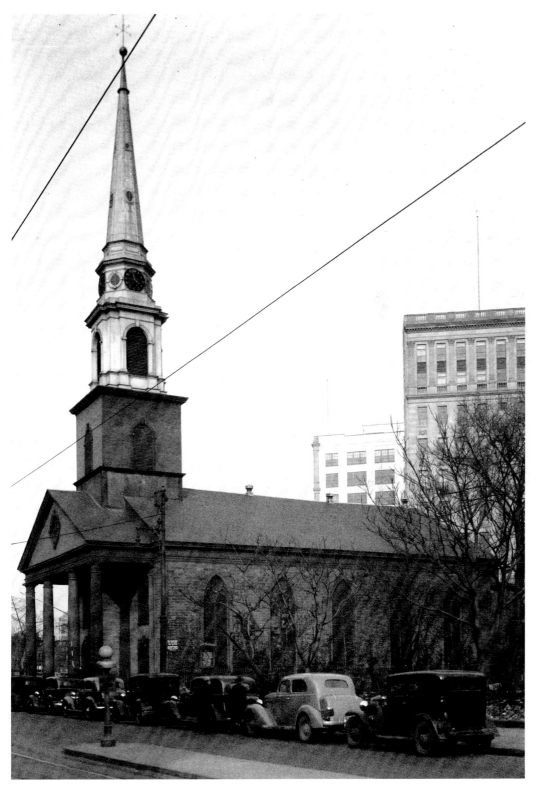

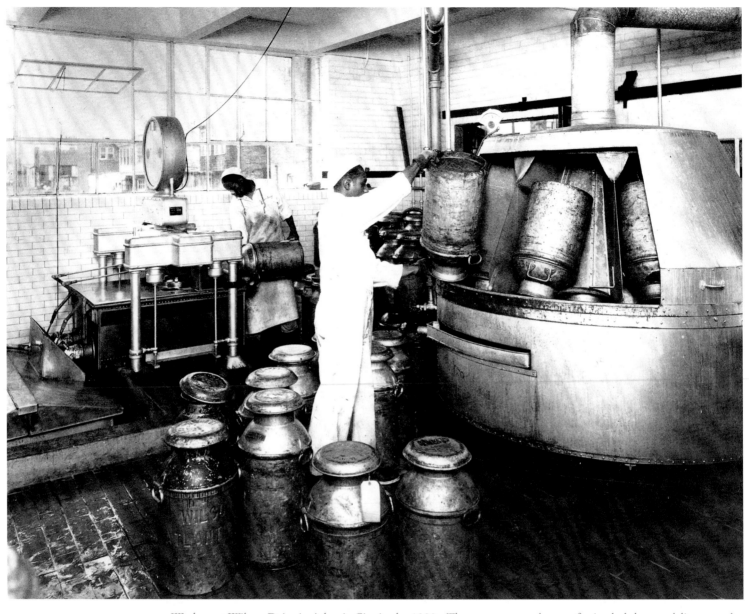

Workers at Wilson Dairy in Atlantic City in the 1930s. The company was known for its dark-brown delivery trucks. Eventually the company was bought out.

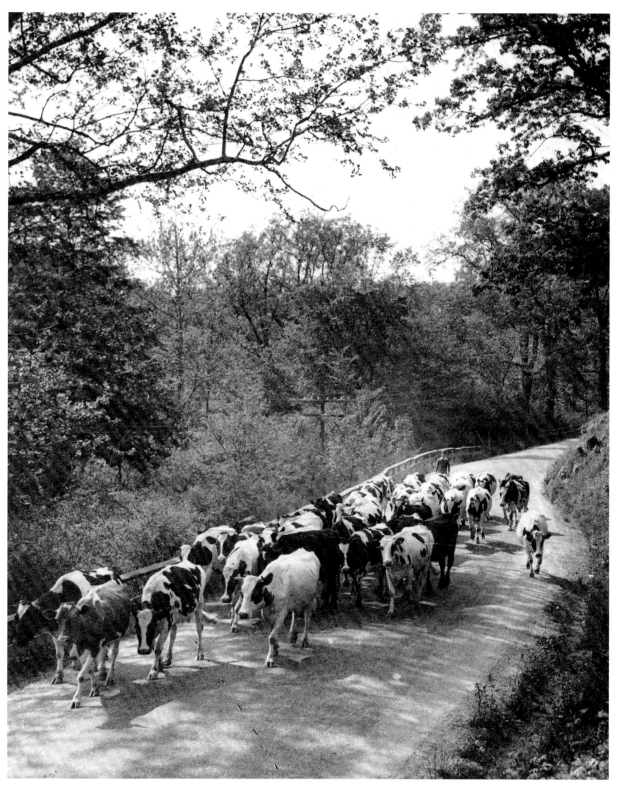

Bucolic scenes like this one used to be much more common in New Jersey. Sixty years ago there were 3,500 dairy farms in the state. Today, owing to urban sprawl, escalating production costs, and encroaching government regulation, there are fewer than 100. Similar situations have sprung up in many states across the nation.

The Trenton War Memorial was built to honor the Americans from Trenton and Mercer County who served in World War I. Construction began in 1930. A truly civic undertaking, New Jersey schoolchildren and teachers raised nearly $80,000 toward the cost of the project. At one time, the 2,000-seat building was the largest professionally equipped theater between New York–Newark and Philadelphia. In the 1940s, Duke Ellington, Paul Robeson, Spike Jones, Lionel Hampton, the Trenton Symphony Orchestra, Frank Sinatra, and many other celebrities performed here, and a generation of bobby-soxers came here to dance. The War Memorial would be completely restored in the 1990s.

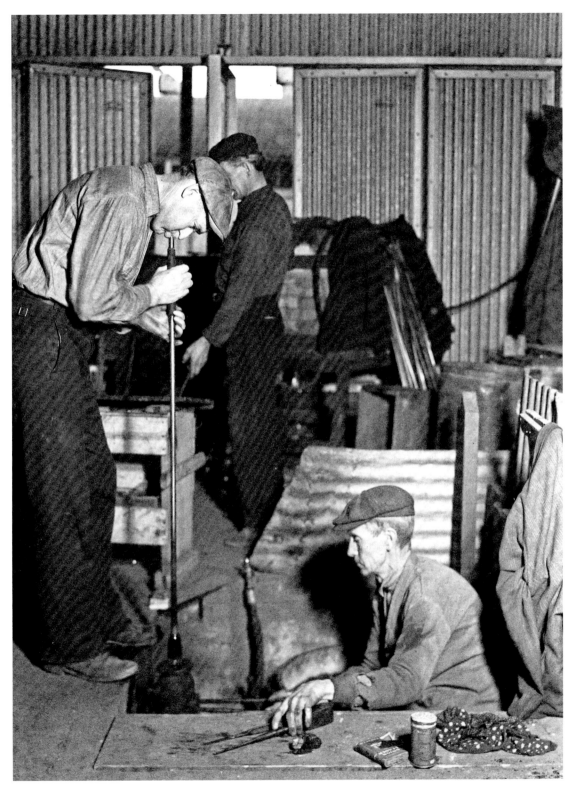

Millville in Cumberland County was once the home of a far-flung glass-making industry, thanks in part to the sandy soil of the region. (Glass is made primarily of sand.) At its peak, more than a dozen companies in Millville cranked out glass night and day, as this worker is doing. Carl Sandburg mused, "By day and by night, the fires burn on in Millville and bid the sand let in the light."

This library in the town of Burlington still serves book lovers today—and has done so since 1757—making it New Jersey's oldest library in continuous operation.

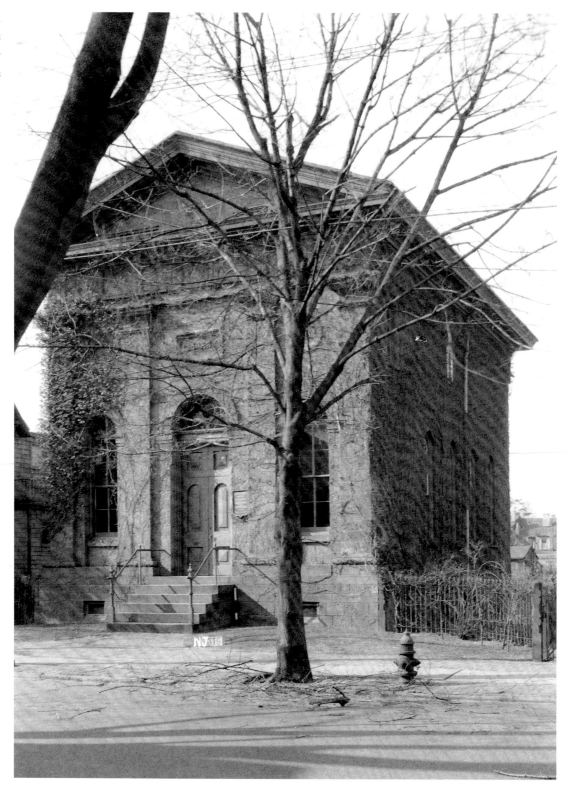

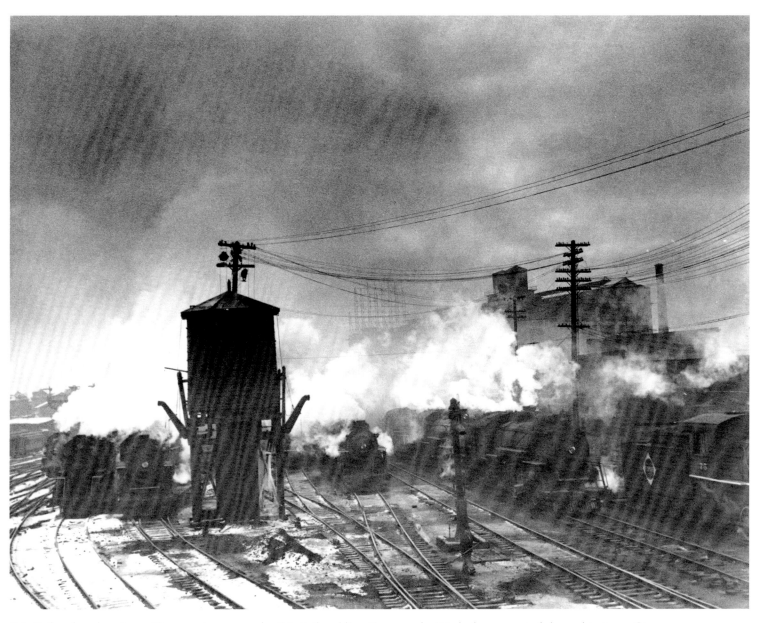

Erie Railroad yards at Jersey City, a main stop on the Erie Railroad line. For years the Erie had two terminals located in Jersey City. The one in the city's Pavonia section was three stories tall, with a clock tower and a waiting room that measured 66 by 1,000 feet. Train service to the terminals would end by the early 1960s.

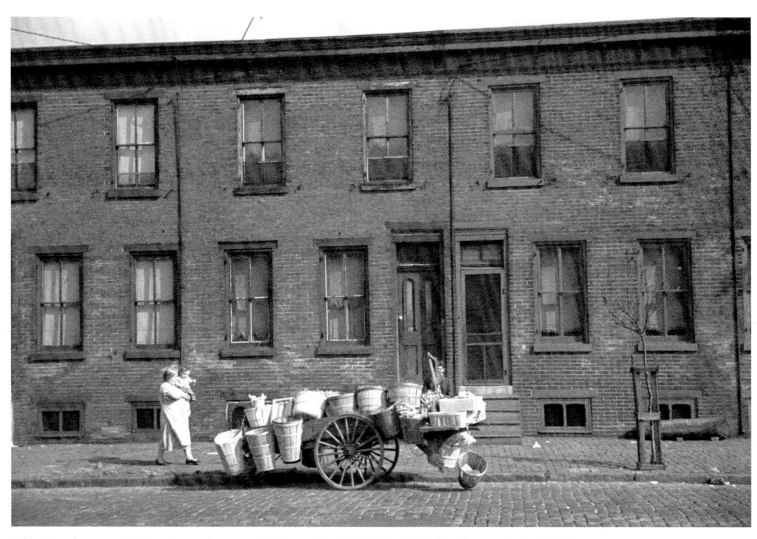

When Camden was an industrial powerhouse—a 1917 report listed 365 industries in Camden, employing 51,000 people—many workers lived in the city in homes like those shown here.

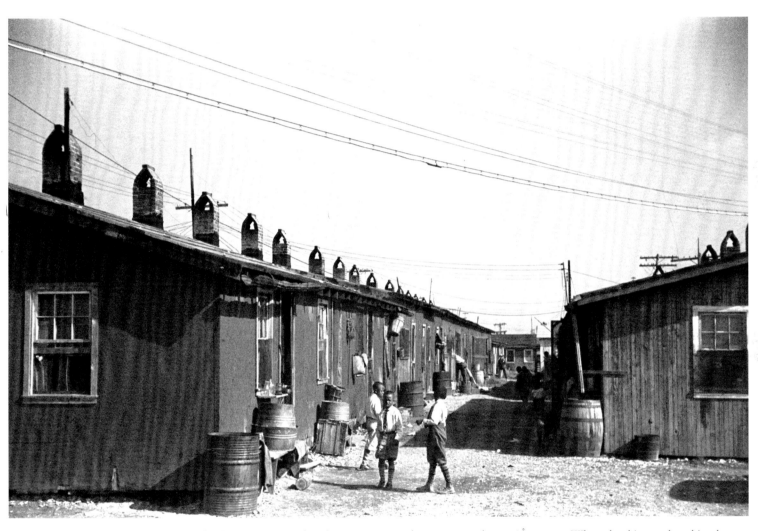

Shellpile in Cumberland County once played an important role as an oyster harvesting center. When shucking and packing houses were built there in the mid-1920s, many African-Americans were hired to fill the jobs created. The oyster industry would be devastated by the parasite MSX in the late 1950s.

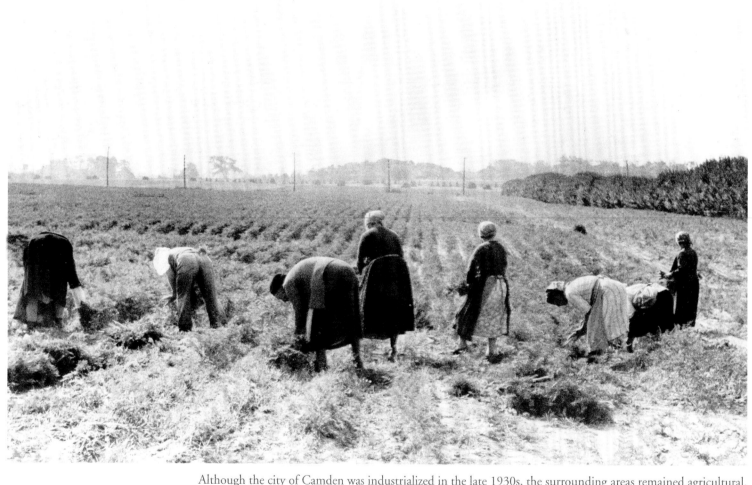

Although the city of Camden was industrialized in the late 1930s, the surrounding areas remained agricultural. Vegetables in large quantities were needed by the Campbell Soup company in Camden and by other food-oriented companies. These women are harvesting carrots.

Burlington County cranberries are checked in the late 1930s. When this photograph was taken, the wet method of harvesting the crop, which consists of flooding cranberry bogs with water, had yet to be invented. Cranberries were dry-picked, often using cranberry scoops—rakes with long fingers to pull the ripe fruit off the bush.

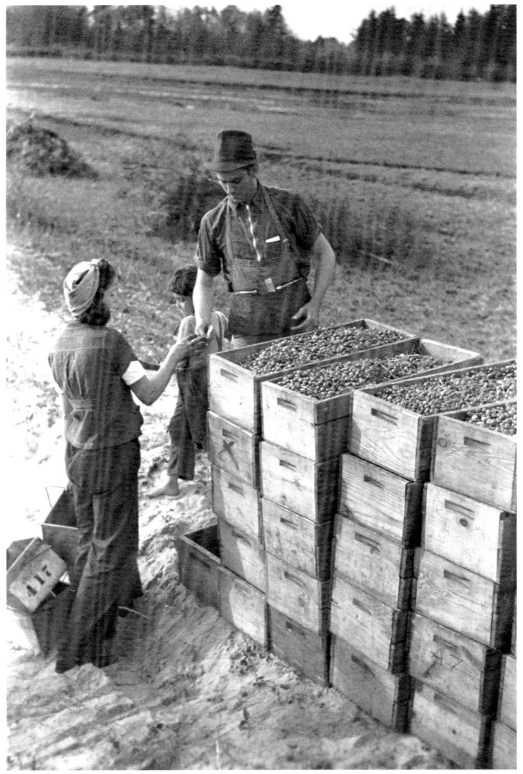

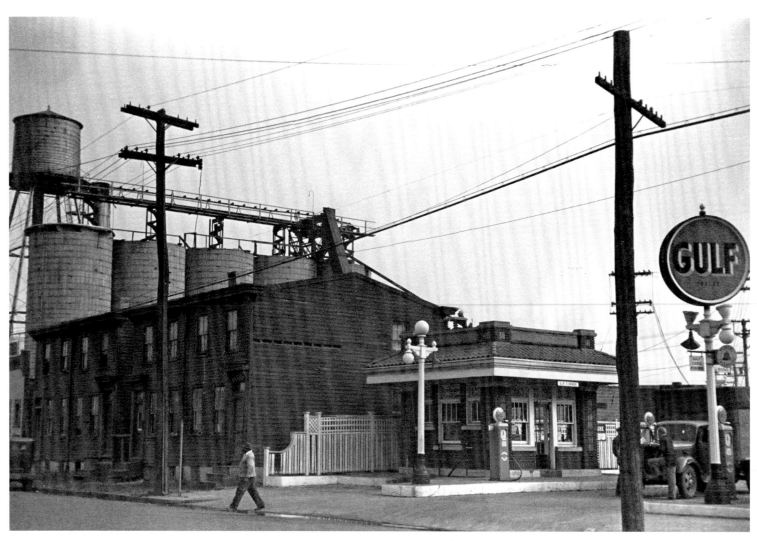

Walt Whitman called Camden "a city invincible," and at one time it was, with bustling street corners like this one shown in 1938 reflective of its relentless industrial might.

Oyster fishing boats at Bivalve, like those in view here in the autumn of 1938, were a common sight when oyster fishing was in its heyday there. Often the oyster schooners would be lined up six-deep at the piers.

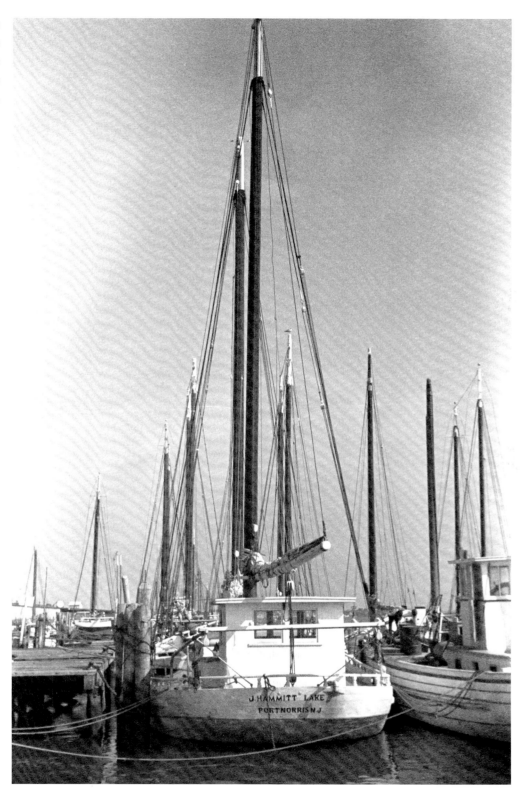

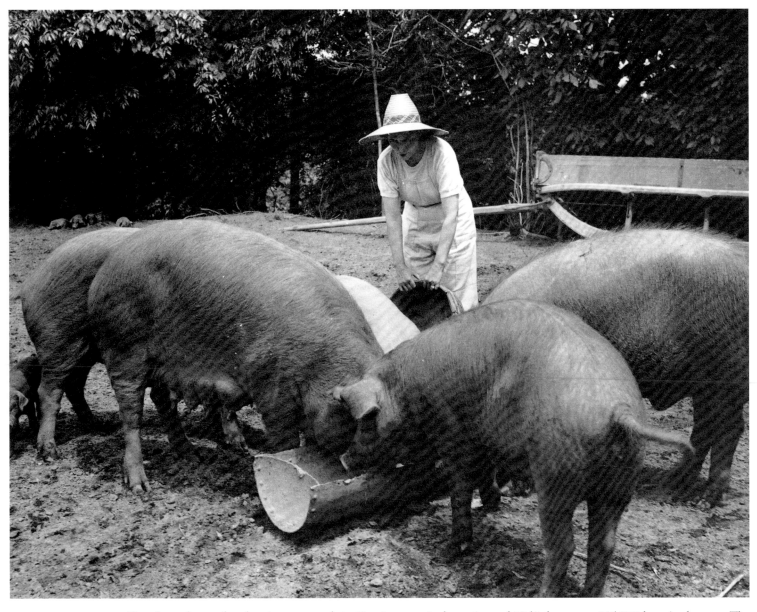

Hogs have always played an important role in New Jersey agriculture. Around 1940 there were 124,000 hogs in the state. The demands of World War II would soon send that number soaring.

The Old Order Crumbles

(1940–1970s)

Orson Welles' 1938 radio broadcast of an imaginary Martian invasion beginning at Grover's Mill, New Jersey, frightened audiences even as it foreshadowed a real world conflict that would engulf the United States only three years later. Of the 560,000 New Jerseyans who marched from the Garden State to defend the United States in the Second World War, more than 12,000 of them became casualties of the conflict, many giving their lives in service to the nation.

Previous wars had led to wholesale changes in New Jersey, and World War II proved to be no exception. In 1947, the state discarded its constitution dating from 1844 in favor of a new one. Other changes became apparent as well—momentous changes. For one, when the GI's came home, they didn't gravitate to the cities and urban areas like before. Instead, they headed to colleges on the GI Bill and built lives in the up-and-coming suburbs. Their departure is shown in declining urban population figures. Heavily urban Hudson County went from 652,000 people in 1940 to 610,000 by 1960. Newark dropped from 429,000 to 405,000 in the same 20-year span. In contrast, formerly remote areas began adding folks as people flocked to the wide-open spaces. The Shore county of Ocean surged from 37,000 in 1940 to 108,000 by 1960—with thousands more to come. Roadways helped speed the migration. First came the Turnpike in 1951, then the Garden State Parkway a few years later. The Parkway was the real game-changer; it opened up the entire Atlantic Coast, and people responded. The old familiar resorts like Atlantic City and Asbury Park were being replaced by towns with names like Point Pleasant, Seaside Heights, Ocean City, and Wildwood. Thanks to the improved access provided by the Parkway, Cape May went from sleepy to spectacularly busy almost overnight as it provided a world of Victorian beauty.

New Jersey without Newark or Atlantic City as two of its main focal points? The most densely populated state in the nation emphasizing its wide-open spaces? The idea was revolutionary, as incongruous as suggesting that a ragtag army of colonial farmers could beat a superbly professional military force. Yet it was happening. Even agriculture was dwindling, as developers gobbled up precious land to build suburban homes and shopping centers.

The state was transforming; the old order in New Jersey was crumbling. The question was, What would replace it? Or perhaps, more critically, Would it still be recognizable as New Jersey?

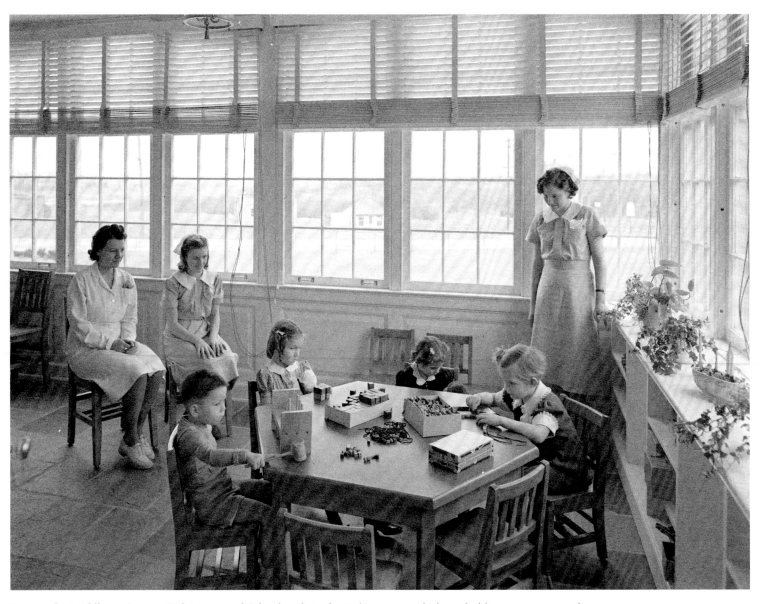

Here at the Middlesex County Girls Vocational School, girls in the 1940s were taught household management, such as looking after young children at play. Other subjects included food selection, dressmaking, hygiene, and household accounts—in short, all the things essential to becoming an ideal American homemaker.

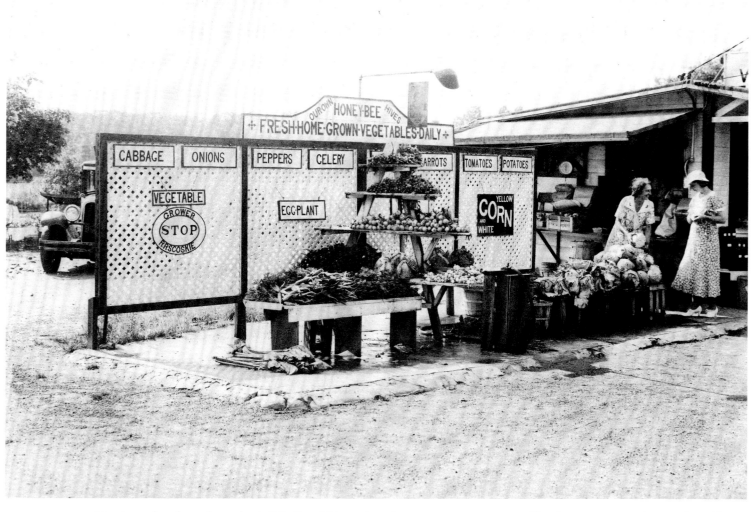

New Jersey has always been chock-full of roadside markets that pop up every summer selling home-grown produce, such as this one in Bergen County. Jersey sweet corn and world-famous Jersey tomatoes, including the renowned Rutgers variety, have long been staples of these stands, and people often cruise the state's back roads this time of year, searching for just such a market.

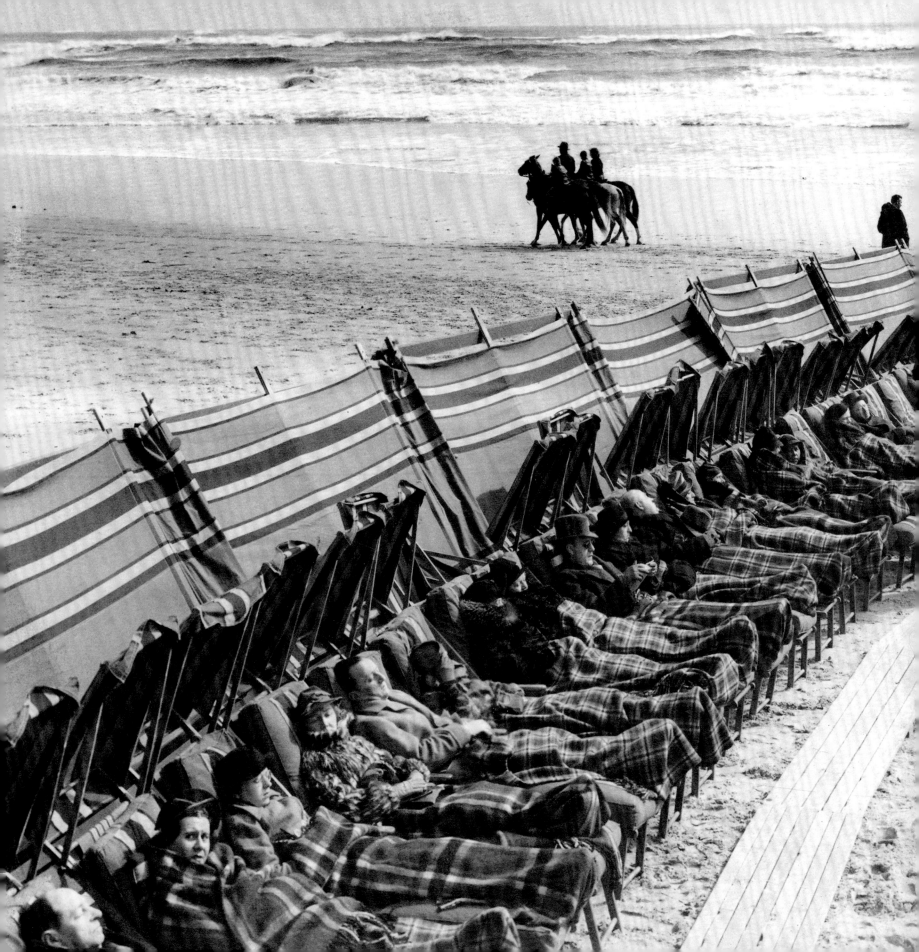

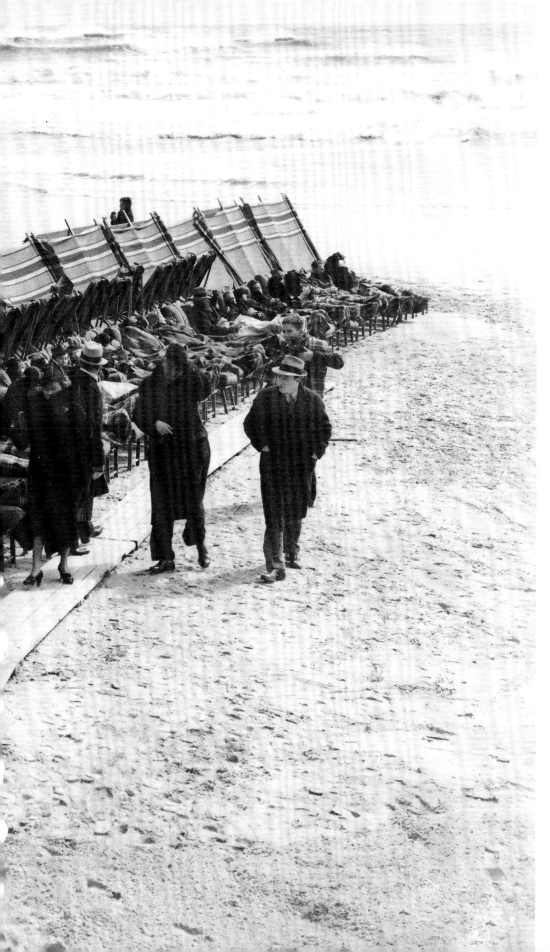

Even though it seems too cold here in 1940 to go swimming, the Atlantic City beach was still attracting visitors no matter the season.

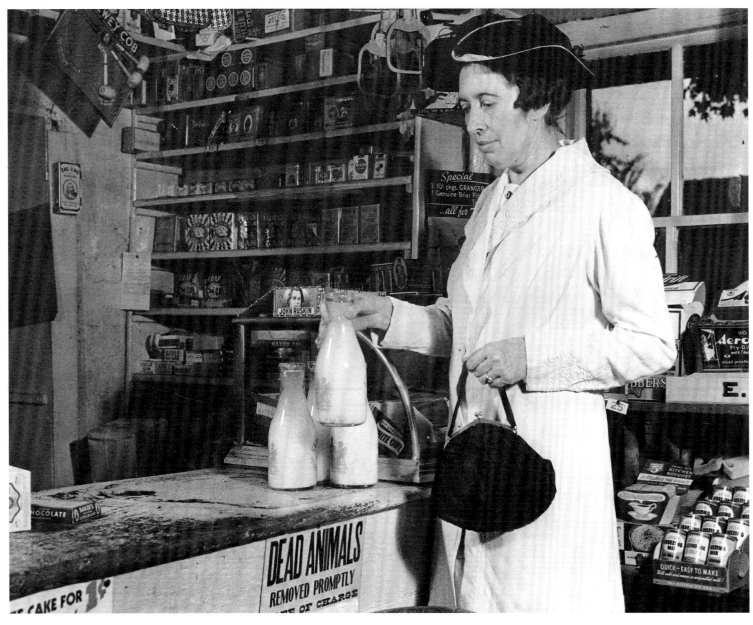

A woman buys milk in 1940. Few people know that the Walker-Gordon Farm in New Jersey was the home of world-famous Elsie the cow. The Borden Company used Elsie—whose real name was You'll Do Lobelia—to gain mountains of publicity, sending her touring around the country in her custom 18-wheeler known as the "Cowdillac." Fatally injured in a 1941 traffic accident, Elsie is buried in Plainsboro.

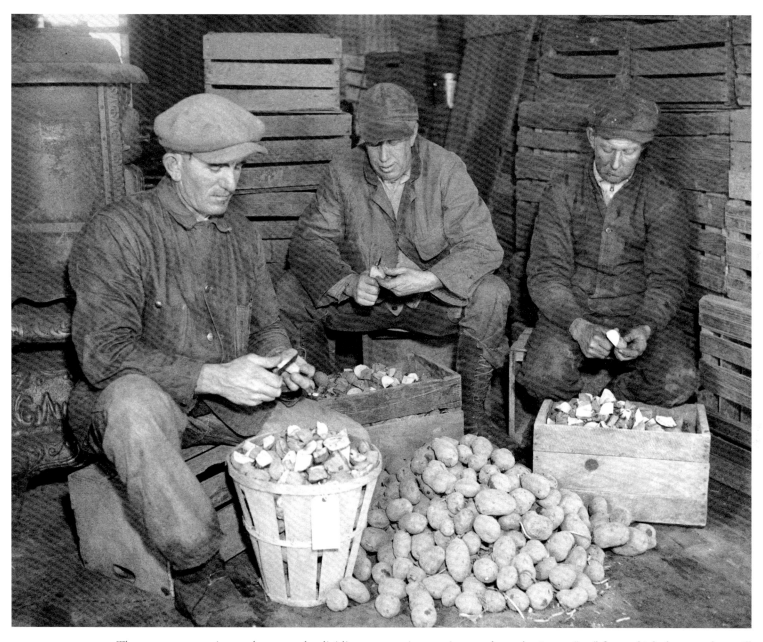

These men are creating seed potatoes by dividing potatoes into sections, each one having an "eye" from which the new plant will sprout. The pieces would next be planted to yield the new season's crop. Potatoes were declining as a mainstay crop in New Jersey in the 1940s, but still accounted for more than 6 percent of the average farmer's total income.

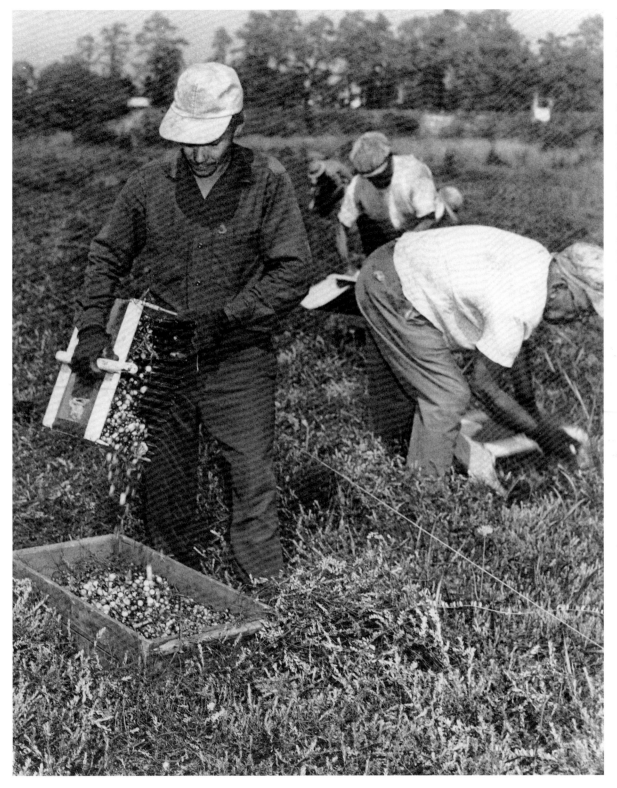

An old-fashioned cranberry scoop in action in the 1940s at Double Trouble in Berkeley Township, Monmouth County. Today a state park, Double Trouble reportedly got its name from a dam muskrats gnawed into, causing leaks and raising the cry "Here's trouble." One day a worker discovered two leaks and shouted "Here's double trouble."

By the 1940s, Lucy the elephant had been serving as a tourist attraction for six decades and was beginning to show her age. Her paint was fading badly, her structure was decaying, and holes were appearing in her metal skin. She seemed destined for the elephant graveyard. But today she is hale and hearty—completely restored.

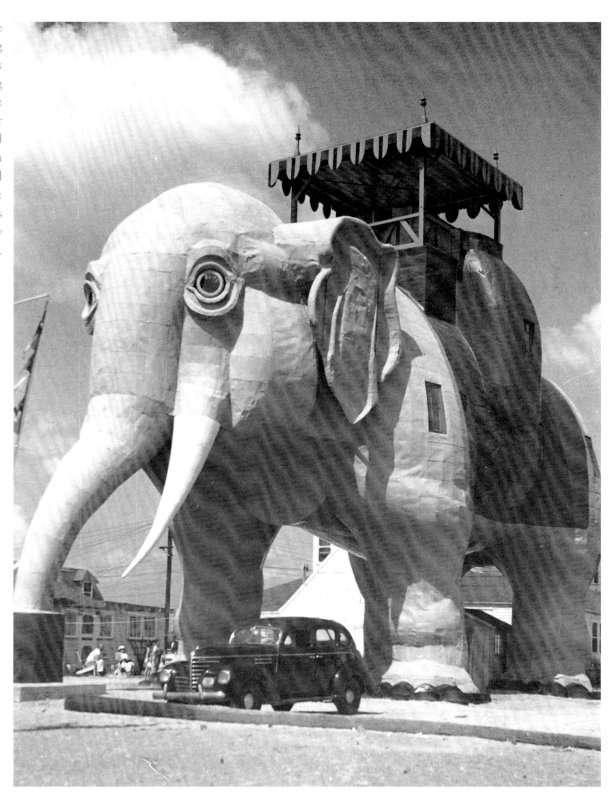

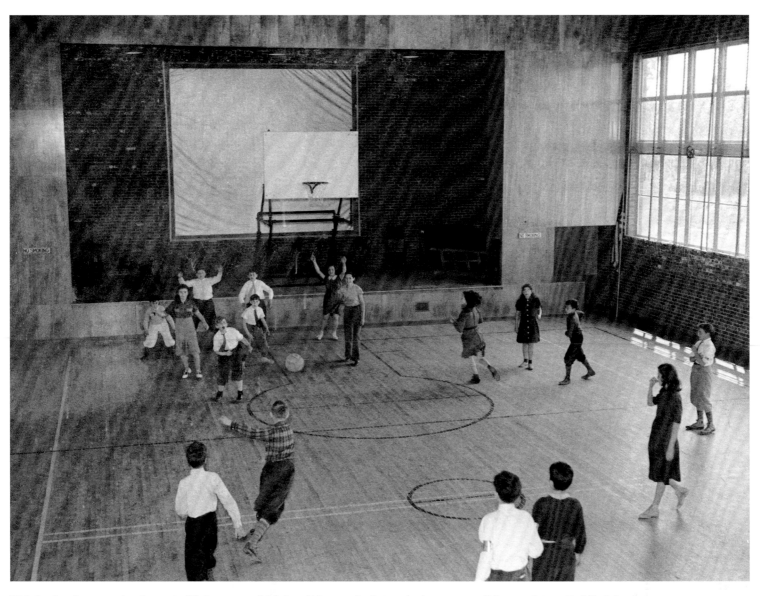

Kids having fun at a school gym in Hightstown, which is well known for being the hometown of the prestigious Peddie School.

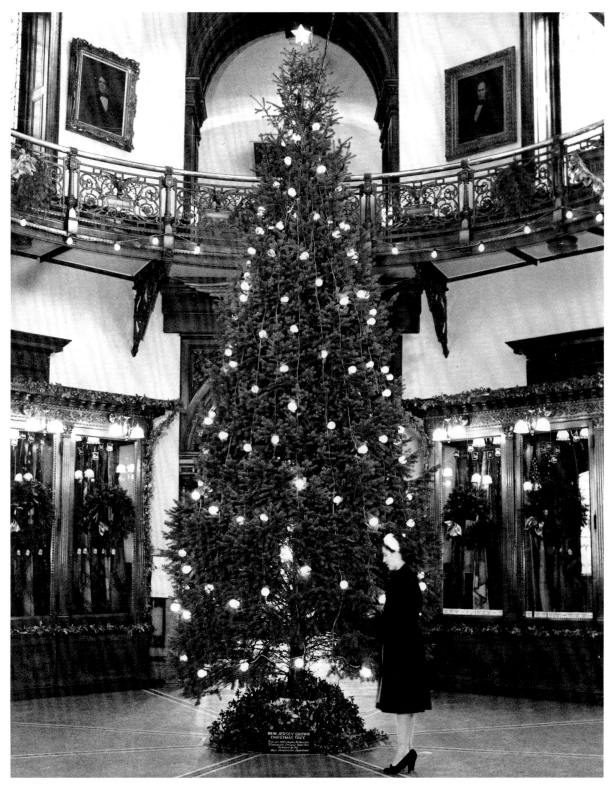

A New Jersey–raised Christmas tree adorns the historic New Jersey Statehouse in Trenton around 1940. Built in 1792, the New Jersey Statehouse is the second-oldest state capitol in continuous use in the United States. It is recognizable for miles around by its distinctive gold dome.

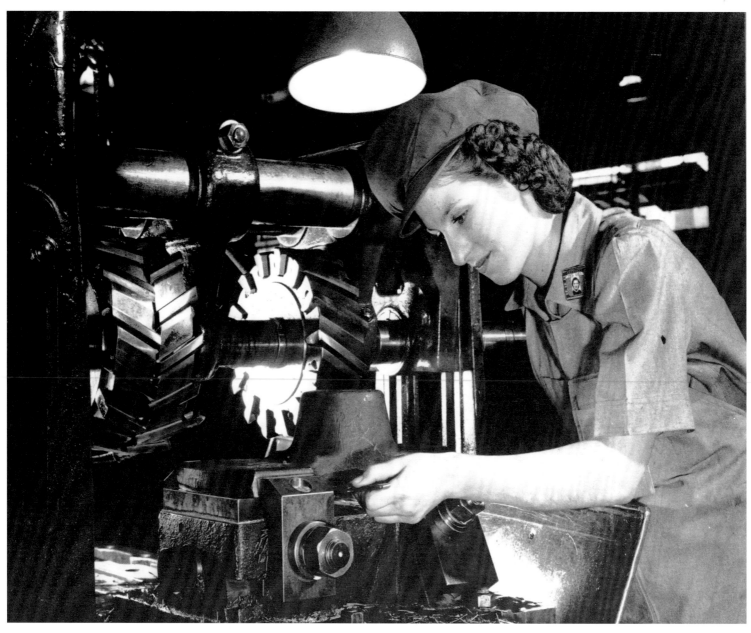

A factory worker on the line at Wright Aeronautical Corporation in Paterson around 1940. Paterson became known as the Aviation City early in the mid twentieth century because of its output of airplane engines. Charles Lindbergh's historic nonstop flight across the Atlantic in the *Spirit of St. Louis* relied on a 200 horsepower J-1 air-cooled Whirlwind Engine custom-made in Paterson.

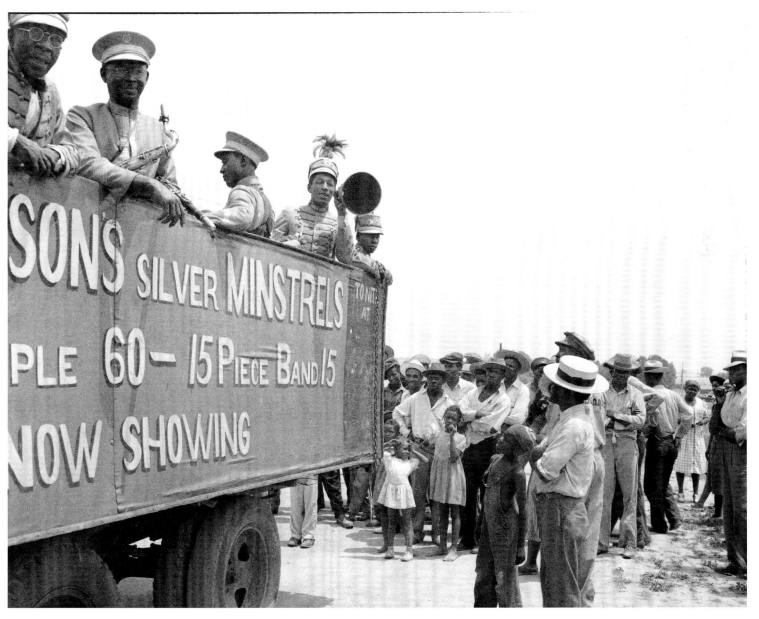

New Jersey was one of the first states in America to bring in large numbers of seasonal workers to help harvest crops. Many African-Americans from the South came to New Jersey as seasonal truck farming (farming for large urban markets, like Camden, Philadelphia, and New York) developed. Diversions from the rigors of work have always found an audience, and minstrels have come to Bridgeton in 1942 to entertain these folks.

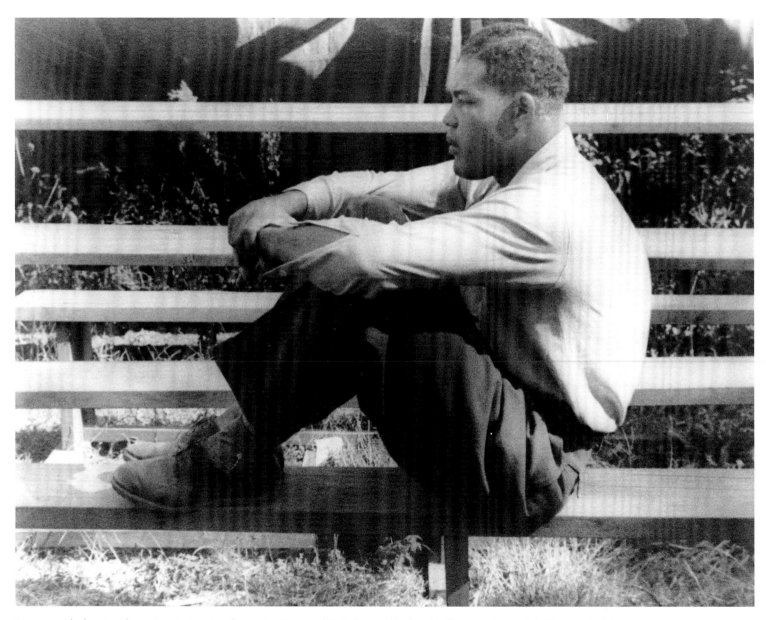

Heavyweight boxing champion Joe Louis relaxes. Louis trained in Lakewood before his first epic bout with Germany's Max Schmeling in 1936. According to reports, Louis did little training and played a lot of golf, which is probably why he bogeyed the fight. Schmeling beat Louis in the contest, handing Joe his first defeat. A jubilant Adolf Hitler would have less reason to celebrate when Louis thrashed Schmeling in a 1938 rematch.

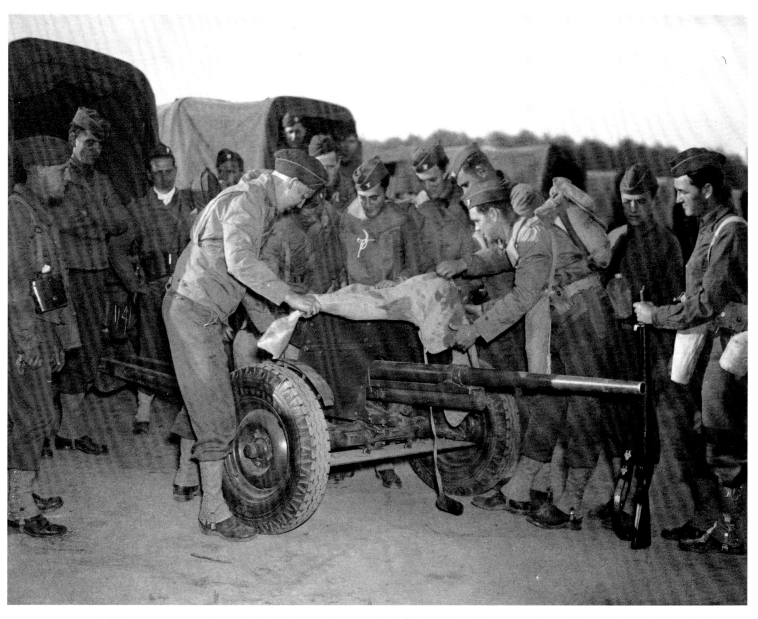

Soldiers cover a gun at Fort Dix in May 1941, just months before the United States was plunged into World War II by the Japanese attack on Pearl Harbor. Camp Dix became Fort Dix in March 1939 and also became a permanent Army facility. During both world wars, the fort served as a training and staging ground for troops.

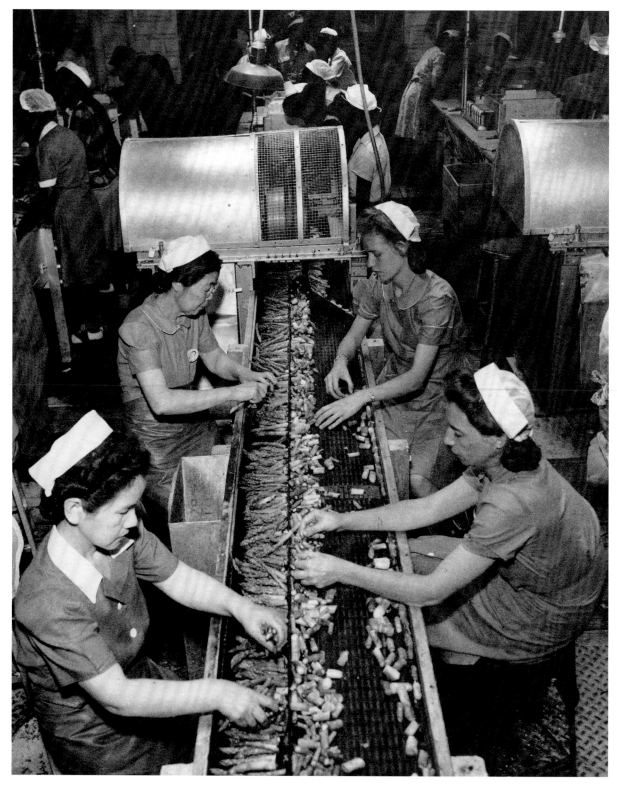

Employees process asparagus at Seabrook Farms in the early 1940s. Seabrook Farms was started by A. P. Seabrook in 1870. Located in Cumberland County, it was reportedly the first big farm to unionize in the United States. The company employed many Japanese-Americans after they were released from internment and relocation camps during World War II and beyond (2,500 arrived between 1943 and 1946).

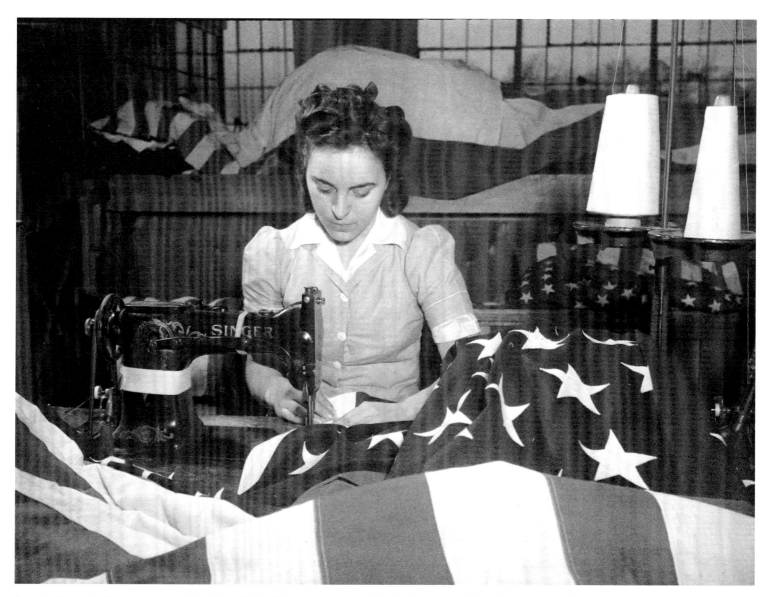

Some believe that Bordentown resident Francis Hopkinson was responsible for the design of the first American flag. This woman is working on a flag at a facility in Verona in 1943. The Stars and Stripes carried 48 stars for most of the twentieth century up to 1959, when Alaska and Hawaii joined the union.

Seabrook Farms racked up several firsts. Among them are the first use of a gasoline-powered tractor and the first use of overhead irrigation. Here crop dusters prepare to dust the company's fields in 1942.

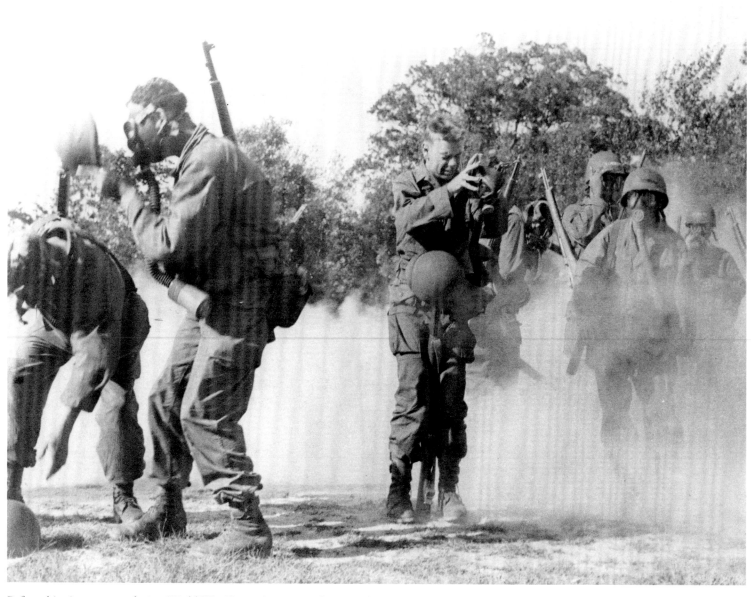

Before shipping overseas during World War II, ten divisions and many other smaller military units trained and staged at Fort Dix, including the troops shown here drilling with gas masks. At war's end, more than one million soldiers would return through Fort Dix on their way back to civilian life.

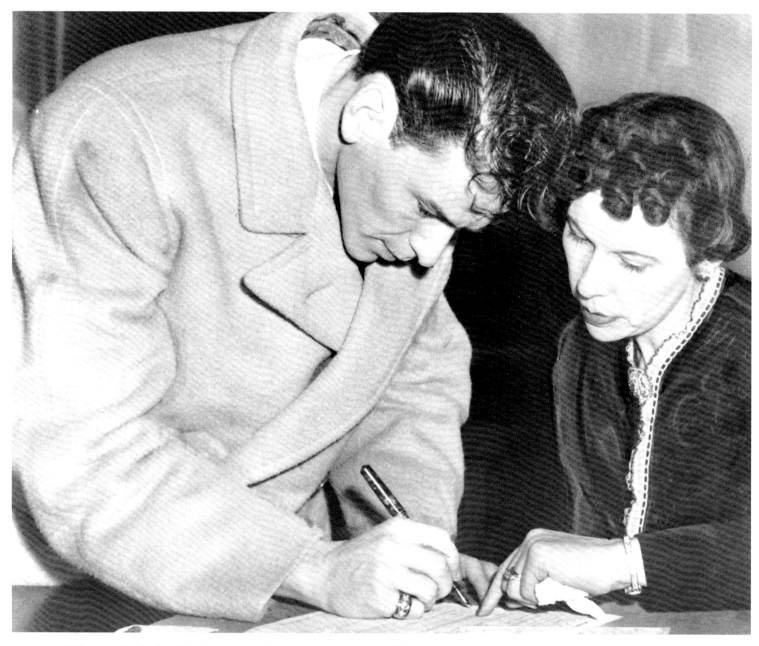

What would a look at New Jersey be without at least one photo of the original Jersey Guy, Frank Sinatra? Born in Hoboken, Ol' Blue Eyes got his start with a local group, the Hoboken Four. Before you could say "he did it his way," he was one of the biggest stars in the world. Here he fills out his induction papers for service in World War II, but ultimately Sinatra would not see duty with the armed forces.

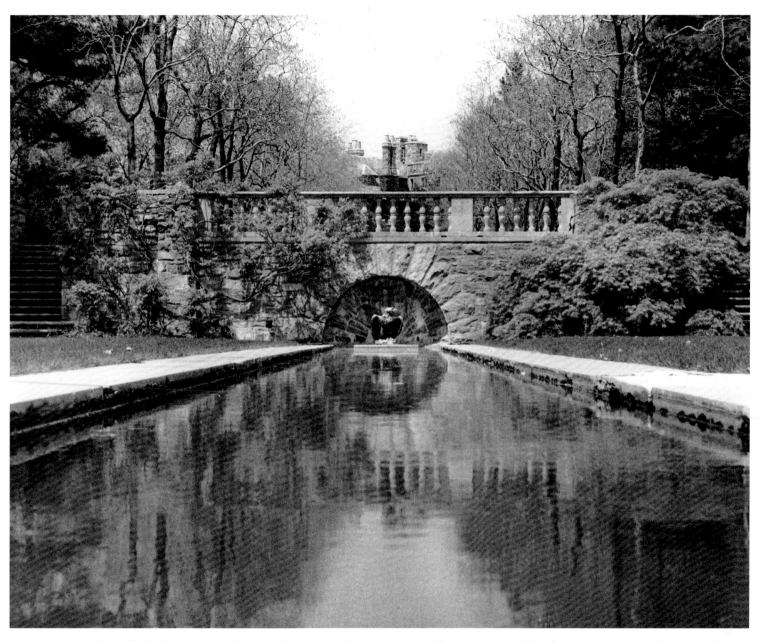

This is Skylands in Ringwood in the 1940s, when the property was still a private estate. The first owner was New York lawyer Francis Lynde Stetson. In 1922, Skylands was acquired by Clarence McKenzie Lewis, an amateur horticulturist and trustee of the New York Botanical Gardens, who greatly increased the estate's plantings. In 1966, the state bought Skylands as its official botanical garden. It contains more than 5,000 varieties of plants in formal and informal gardens.

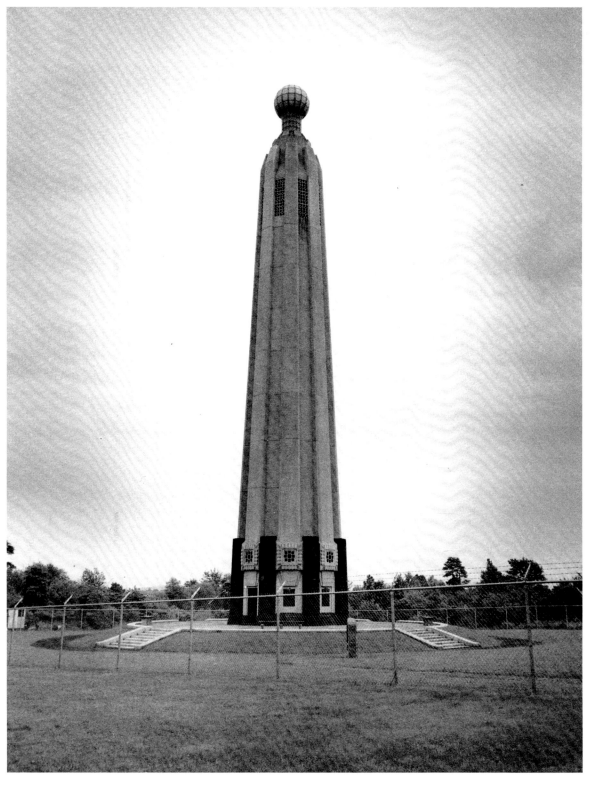

The Edison Memorial Tower at the Thomas Edison Historic Site in Menlo Park was built in 1937-38 and dedicated on February 11, 1938. Standing 134 feet tall, the tower is topped by a replica of Edison's first practical incandescent bulb. Edison's invention had been commemorated with a series of U.S. postage stamps in 1929, and a stamp commemorating the centenary of Edison's birth was issued in 1947.

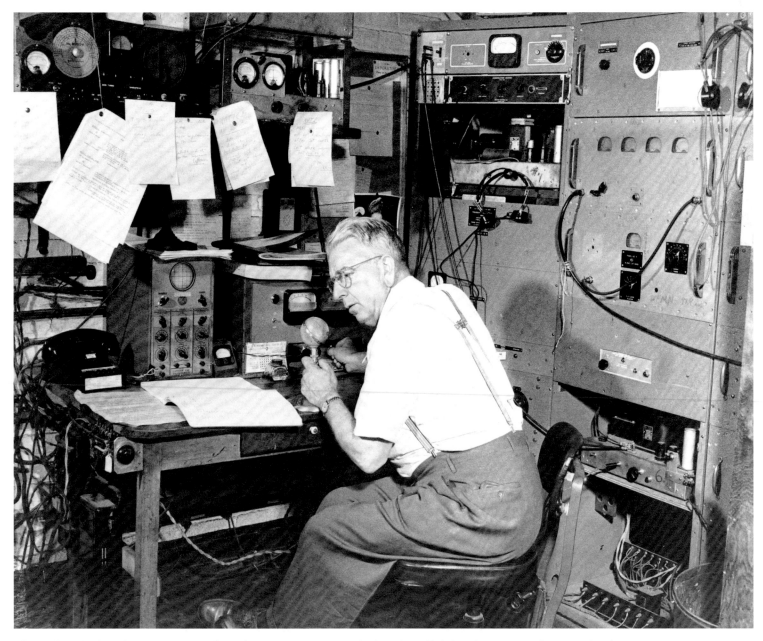

This 1948 radio broadcast is emanating from the Armstrong Tower, which is also called the Alpine Tower (because of its location in the town of Alpine). The 400-foot broadcast tower was built in 1938 by Edwin Armstrong, the inventor of FM radio, after his work on FM got him exiled from RCA's New York City facilities. Alpine is commonly considered the birthplace of FM radio.

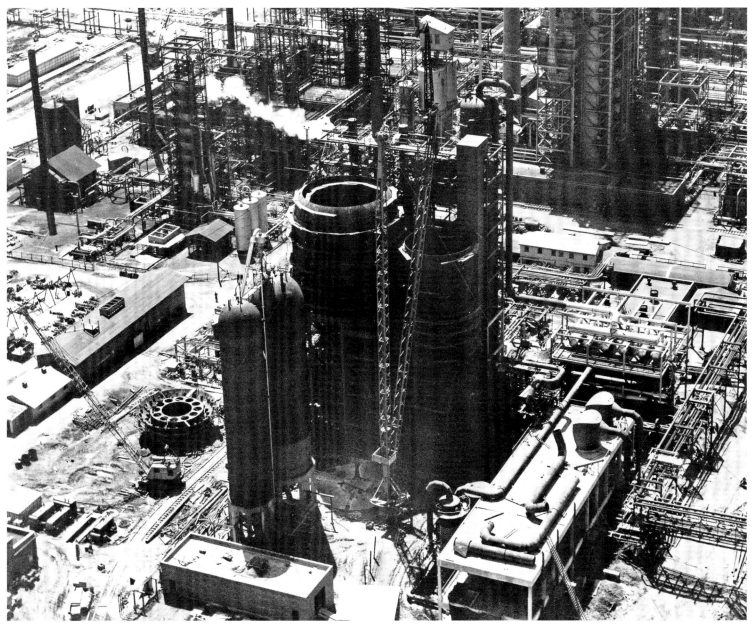

People's image of New Jersey often includes refineries such as this one, which at the time this photograph was made was Standard Oil's Bayway refinery. Here in 1920 scientists produced the world's first petrochemical: isopropyl alcohol.

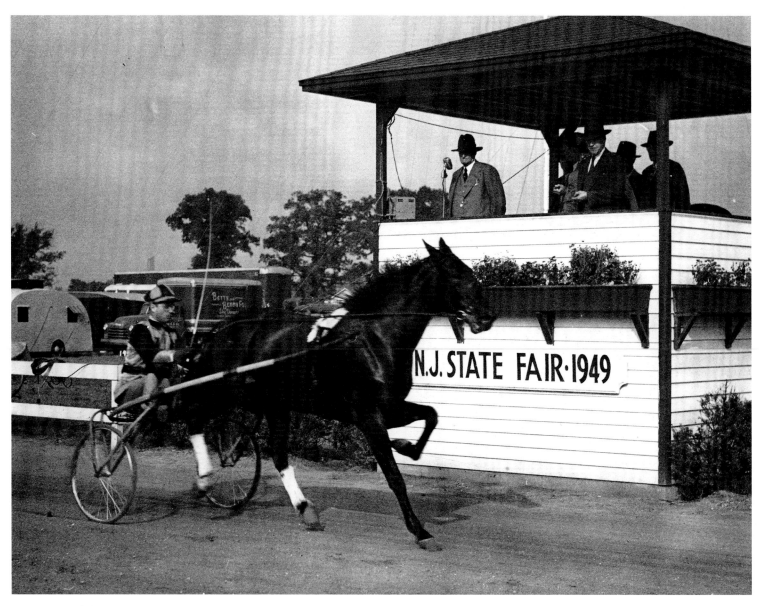

The origins of the New Jersey State Fair in Trenton date back to New Jersey's colonial period. Although the fairs always had an agricultural theme, they included other events to attract spectators, such as daredevil stunts, shooting matches (Annie Oakley took part one year), and horse racing, such as this harness race at the 1949 fair. The fair was held on its Trenton site for the last time in 1980.

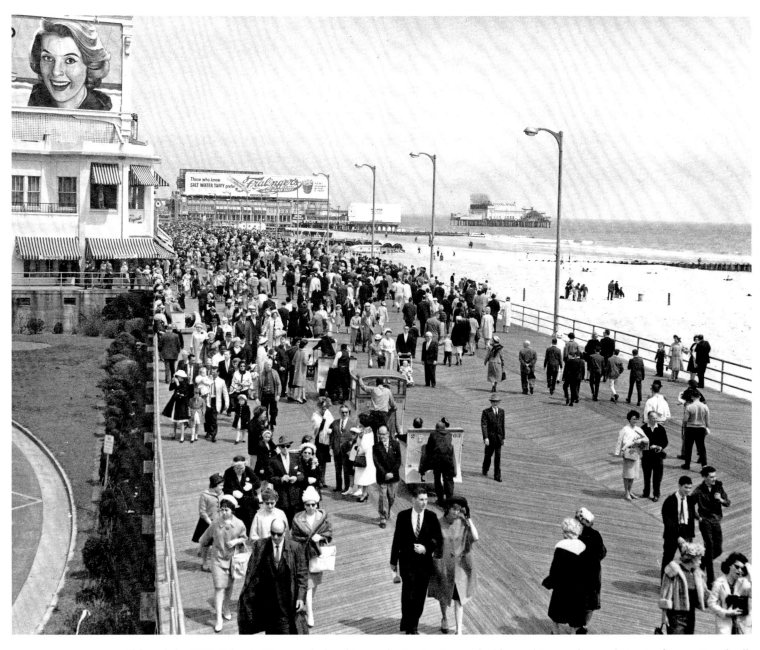

Although by 1950 Atlantic City wasn't the ultimate destination it once had been, this crowd meandering its famous Boardwalk doesn't seem to mind the anonymity. (The city formally adopted the word *boardwalk* as a proper name, so a capital "B" is always used when writing about it.)

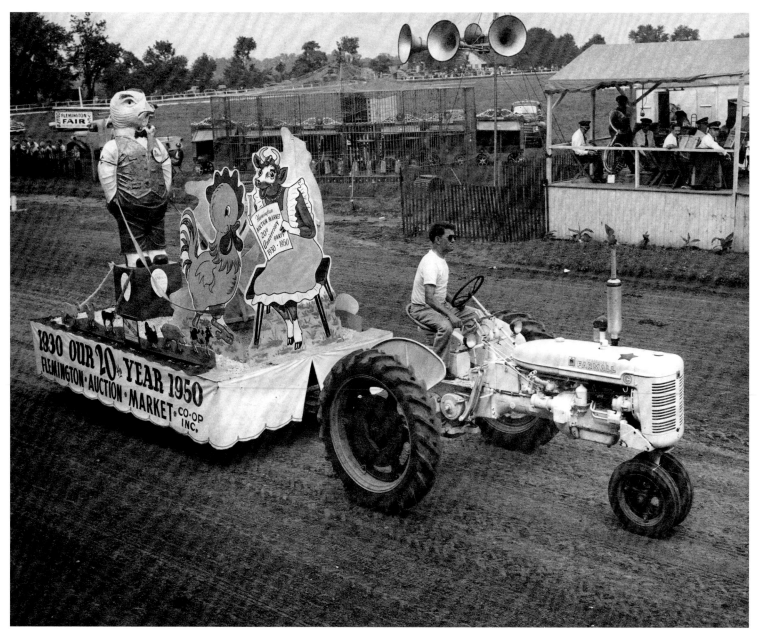

The Flemington Fair originated in the mid nineteenth century. It was considered one of the best little agricultural fairs in the United States, a sentiment undoubtedly shared by these farm characters on a float at the fair in 1950. The land it took place on was eventually sold and the fair lingers on only as a memory.

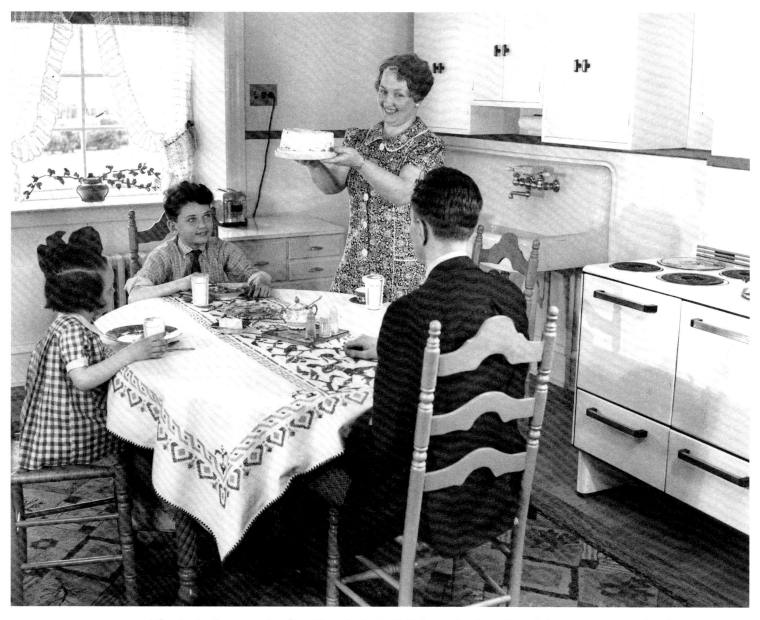

A family sits down together for milk and cake in 1950. It was thanks to Newark doctor Henry Coit that the Essex County Medical Milk Commission was formed in 1893 to oversee the pathogen-free production of milk, through pasteurization and other measures. Dr. Coit's son had died from drinking contaminated milk two years before.

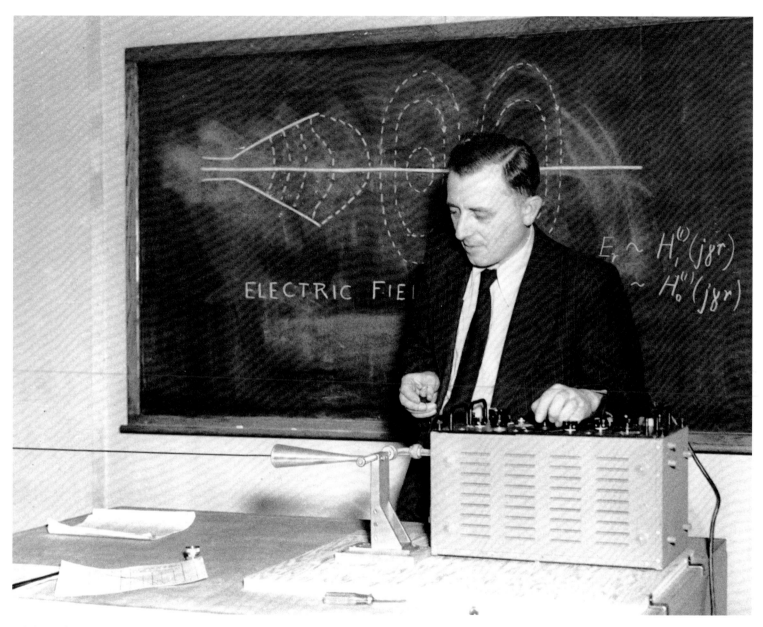

While working at Fort Monmouth, Dr. George Goubau invented the Goubau Line or so-called G-line, a type of single-wire transmission line intended for use at UHF and microwave wavelengths. He is shown here giving a demonstration.

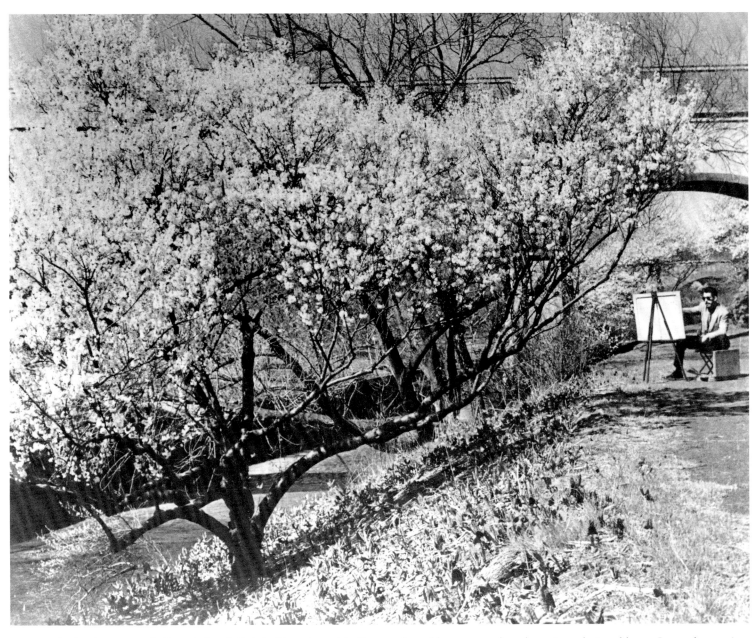

Spring has sprung in Branch Brook Park in Newark, and its famous cherry blossom trees have burst into glorious bloom. Located on a piece of ground originally called Old Blue Jay Swamp, the park was the first county park in the United States. Thousands of people annually flock to the park just to see its more than 3,500 pink and white cherry trees in blossom—more cherry trees than in Washington, D.C.

Since 1966, the official residence for the New Jersey governor has been at Drumthwacket estate in Princeton, shown here in 1950. The estate is named for two Scottish Gaelic words that mean "hill" and "woods." It contains 12 beautifully manicured acres and public rooms filled with art and antiques with an emphasis on New Jersey history.

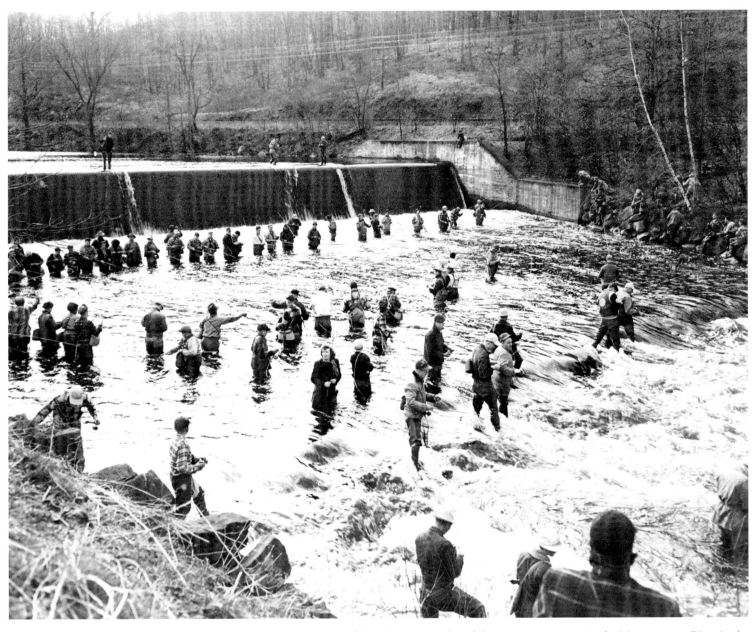

Some major league fish stories undoubtedly came of this, the opening day of the 1951 trout season in the Musconetong River in the northern part of the state. The Musconetong flows southwesterly for 42 miles, from Lake Hopatcong to the Delaware River.

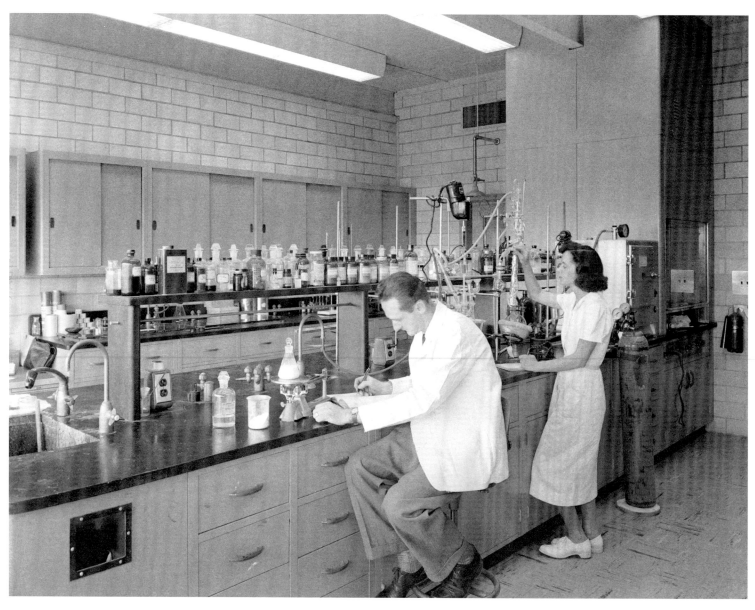

In 1886, three brothers—Robert Wood Johnson, James Wood Johnson, and Edward Mead Johnson—got together with 14 others in New Brunswick and started a medical supply company on the fourth floor of a former wallpaper factory. From those humble beginnings emerged the pharmaceutical giant Johnson & Johnson, with their headquarters still in New Brunswick. Pictured is part of the company's research facilities in 1951.

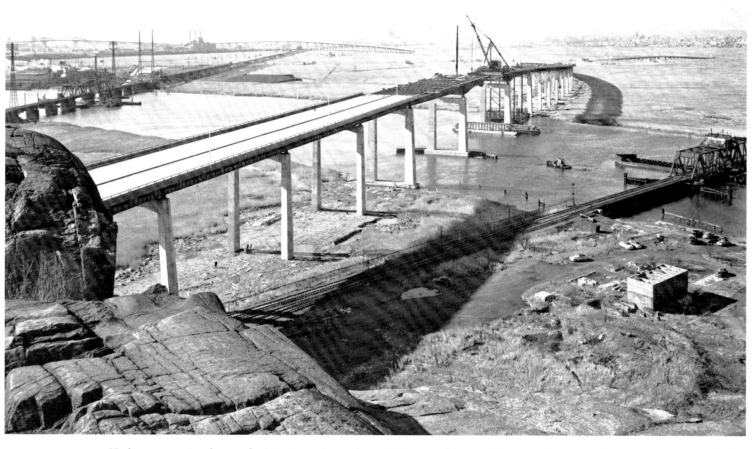

Under construction here is the New Jersey Turnpike in 1951, one of the world's most picked-on and least-understood roads. The 148-mile Turnpike was built at a blistering pace, and was completed in just two years. When opened, it significantly alleviated traffic congestion in the state.

More than 2,000 area farmers grew tomatoes for the Campbell Soup Company in Camden. The produce reached the company by all means—lined up in delivery wagons up and down the roads leading to the plant, by train, and by boat.

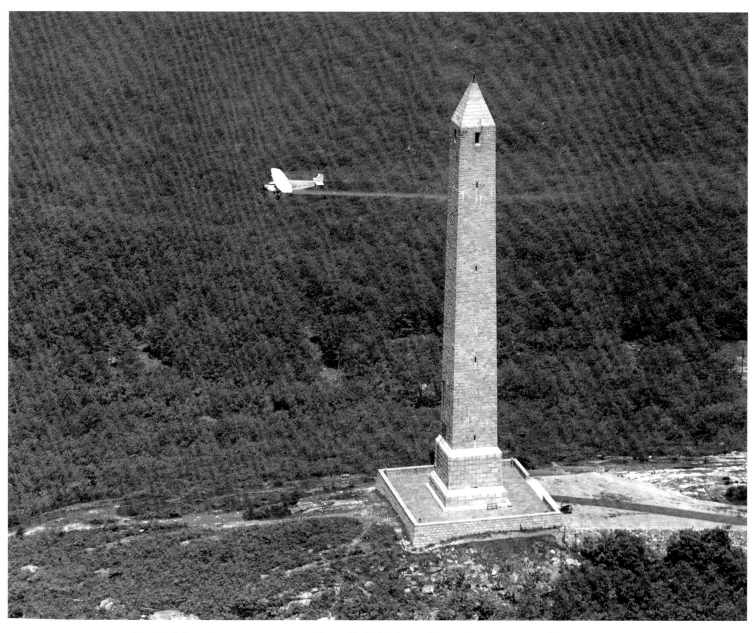

The High Point Monument is a 221-foot-tall obelisk located in High Point State Park in Sussex County. At 1,803 feet, High Point is situated at the highest elevation in New Jersey. The monument was a gift from the Kuser family in 1928, intended to serve as a veteran's memorial.

This woman admires a June Is Dairy Month (now known as National Dairy Month) sign in 1955. The certified milk movement begun by Dr. Henry Coit of Newark in 1893 helped to raise standards for the entire dairy industry throughout the first half of the twentieth century, enabling events like Dairy Month to become popular.

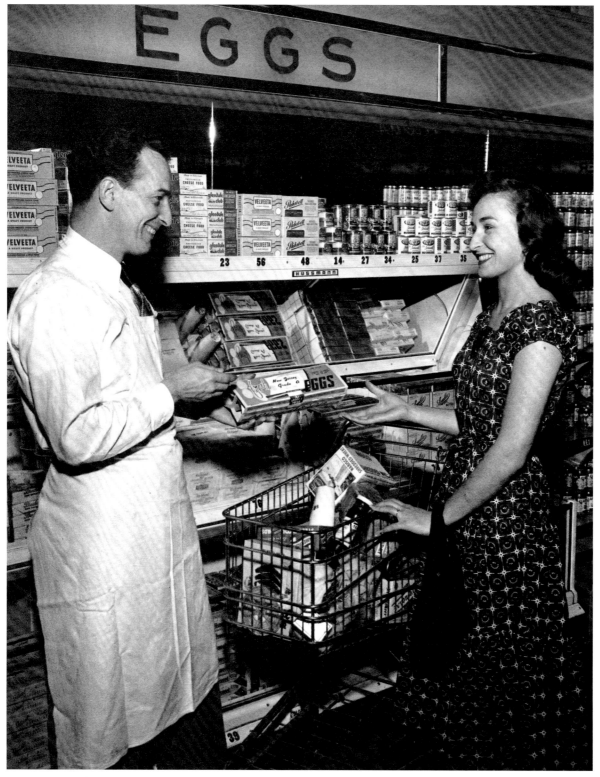

In 1955, when this woman was shopping for eggs at the grocery, New Jersey ranked fifth in the United States in egg production. At this time, Monmouth County produced more eggs than any other county in the country. In the 1920s, Vineland produced so many eggs that they were known as the "Egg Basket of the East."

The years 1945-1964 in Puerto Rico have sometimes been called the Great Migration because more than 20,000 islanders were permitted into the United States each year as migrant farm workers, like the parents of the children shown here in 1956. Some workers returned home after the season ended, but others stayed. The workers established communities in urban areas near their agricultural work, in places like Camden. Today, the population of Puerto Ricans living in the states has exceeded the number living in Puerto Rico.

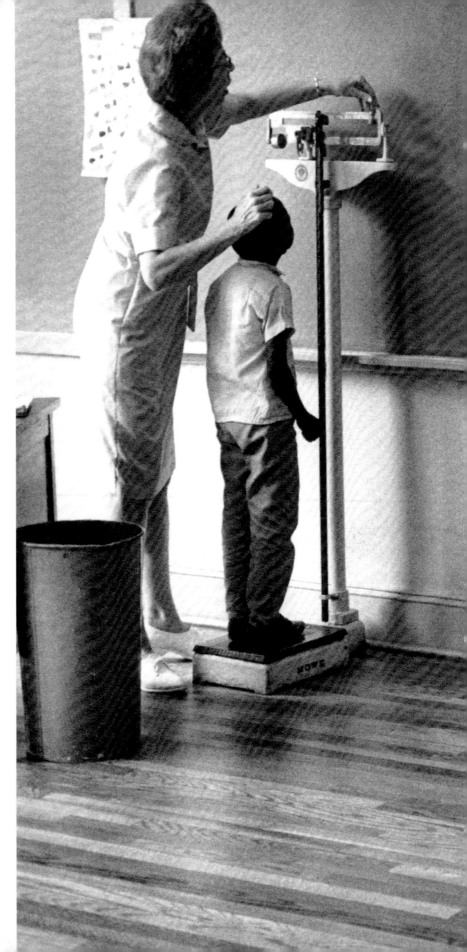

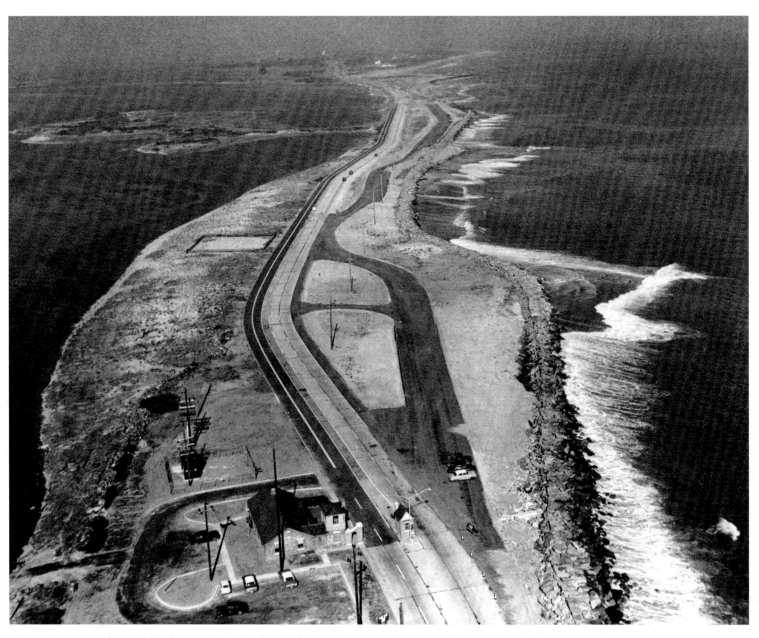

This perilous 11-mile spit of land is Sandy Hook, the northernmost section of the Jersey Shore. Sandy Hook is constantly imperiled by hurricanes, nor'easters, and erosion, which routinely sever its thin attachment to the mainland, making it a true island. In the summer, the Hook's miles of beaches are enjoyed by thousands.

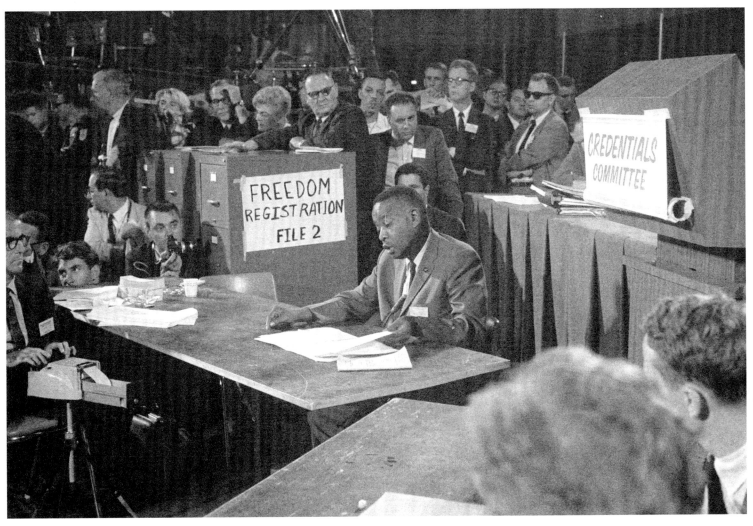

The Mississippi Freedom Democratic Party was formed in 1964 to include African-Americans who were being shut out of the electoral process in Mississippi. The Democrats held their national presidential convention in Atlantic City that year, and FDP supporters from all over the country converged on the city to lobby for the party's recognition. Here Aaron Henry, chair of the FDP's delegation to the convention, speaks before the Credentials Committee.

Workers lift one of the Trenton Battle Monument's three bronze plaques onto its base. The plaques are titled "The Continental Army Crossing the Delaware River," "The Opening of the Battle," and "The Surrender of the Hessians."

By the 1970s, both Atlantic City and the Miss America Pageant were becoming tarnished shadows of their former selves, as changing tastes and new distractions combined to diminish the once-shining stars of both institutions and cool the adoration of the public. The pageant finally left the city of its birth in 2006.

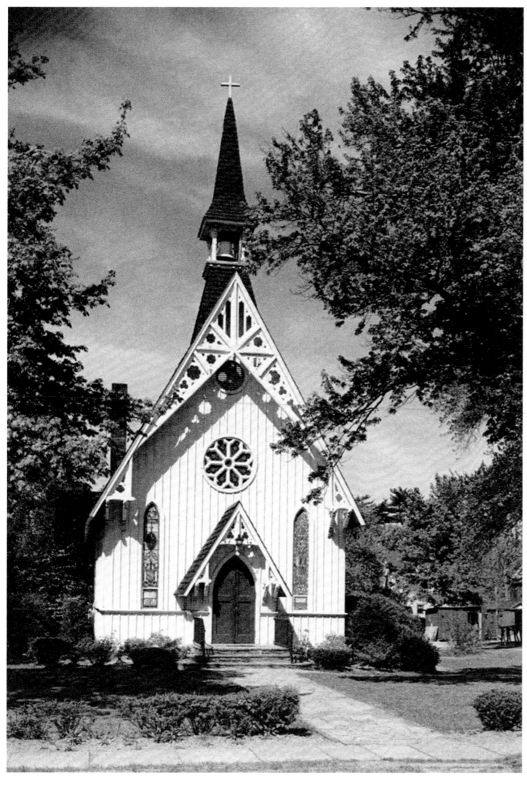

Built in 1868, St. Luke's Episcopal Church in Metuchen in Middlesex County has changed little over the years. Poet Joyce Kilmer was married here, and Mark Twain, Helen Keller, and Ogden Nash all attended worship services here. The church continues to hold services today.

NOTES ON THE PHOTOGRAPHS

These notes, listed by page number, attempt to include all aspects known of the photographs. Each of the photographs is identified by the page number, photograph's title or description, photographer and collection, archive, and call or box number when applicable. Although every attempt was made to collect all data, in some cases complete data may have been unavailable due to the age and condition of some of the photographs and records.

57 AIR SHOW AT ATLANTIC
CITY, 1910
Library of Congress
3b46157u

58 PRINCETON UNIVERSITY
CAMPUS
Library of Congress
6a07906u

59 PRINCETON UNIVERSITY
CAMPUS NO. 2
Library of Congress
6a07929u

60 BOWLING ALLEY PIN
SETTERS
Library of Congress
03368u

61 NEWARK NEWSIES
Library of Congress
03359u

62 LAKE HOPATCONG
YACHT CLUB
Library of Congress
19079u

63 BACKYARD BASEBALL AT
MADISON
Library of Congress
18472u

64 THE BOARDWALK
ROLLING CHAIRS
Library of Congress
3c20492u

65 BURLINGTON COUNTY
CRANBERRY HARVEST
Library of Congress
00079u

66 CROWD ON THE
BOARDWALK, 1911
Library of Congress
3c26575u

67 SAINT CATHARINE'S
CHURCH AT SPRING
LAKE
Library of Congress
3b45940u

68 ROOSEVELT CAMPAIGN
STOP, 1912
Library of Congress
3b17319u

69 ROOSEVELT TRIUMPHANT
Library of Congress
3b36761u

70 GOING TO THE MOVIES
IN JERSEY CITY
Library of Congress
03814u

71 BERGEN COUNTY
COURTHOUSE
Library of Congress
6a07792u

72 ASBURY PARK AT THE
BEACH
Library of Congress
3c07267u

73 DRAWBRIDGE AT
SCHELLENGER'S
LANDING
Library of Congress
LC-USZ62-057517

74 PANORAMA OF WEST
HOBOKEN
Library of Congress
6a16557u

75 HACKENSACK
SUFFRAGETTE RALLY
Library of Congress
LC-USZ62-7092

76 DRESS PARADE AT
WENONAH MILITARY
ACADEMY
Library of Congress
6a27753u

77 STANDARD OIL
EMPLOYEES AT BAYONNE
Library of Congress
3c17096u

78 SHADOW LAWN IN WEST
LONG BRANCH
Library of Congress
01864a

79 WILSON ADDRESS AT
SHADOW LAWN
Library of Congress
08038a

80 ATLANTIC CITY FROM
GARDEN PIER
Library of Congress
6a07963u

82 EXPLOSION AT BLACK
TOM ISLAND
Library of Congress
3c30626u

83 TENTS AT CAMP DIX
Library of Congress
11014a

84 SALUTE TO THE 113TH
INFANTRY AT JERSEY
CITY
New Jersey State Archives;
Department of State
SDENG010-A280

85 CAMP MERRITT, 1919
Library of Congress
6a33457u

86 ON THE STREET AT
BARNEGAT
Library of Congress
LC-USZ62-052978

88 WANAMAKER CAMP
CADET BAND
Library of Congress
LC-USZ62-053354

89 ISLAND HEIGHTS DEPOT
Library of Congress
LC-USZ62-085261

90 MISS AMERICA PAGEANT
PARADE
Library of Congress
3c26574u

91 KING NEPTUNE
AND MISS AMERICA
MARGARET GORMAN
Library of Congress
3c02577u

92 THE TRAYMORE HOTEL,
1920
Library of Congress
3b14352u

93 SCENE AT THE BOYLE'S
THIRTY ACRES FIGHT
Library of Congress
3b39312u

94 CLAYTON FIRE
FIGHTERS WITH
EQUIPMENT
Library of Congress
6a26202u

95 HOPEWELL FIRE
FIGHTERS WITH
EQUIPMENT
Library of Congress
LC-USZ62-058359